Painter X Creativity

Painter X Creativity Digital Artist's Handbook

Jeremy Sutton

AMSTERDAM • BOSTON • HEIDELBERG • LONDON • NEW YORK
OXFORD • PARIS • SAN DIEGO • SAN FRANCISCO
SINGAPORE • SYDNEY • TOKYO

Focal Press is an imprint of Elsevier

Acquisitions Editor: Emma Baxter
Publishing Services Manager: George Morrison
Project Manager: Mónica González de Mendoza
Assistant Editor: Valerie Geary
Marketing Manager: Christine Degon Veroulis
Cover Design: Dennis Schaefer

Focal Press is an imprint of Elsevier
30 Corporate Drive, Suite 400, Burlington, MA 01803, USA
Linacre House, Jordan Hill, Oxford OX2 8DP, UK

∞ Recognizing the importance of preserving what has been written, Elsevier prints its books on acid-free paper whenever possible.

Library of Congress Cataloging-in-Publication Data
Sutton, Jeremy.
Painter x creativity: digital artists handbook/Jeremy Sutton.
 p. cm.
Includes index.
ISBN-13: 978-0-240-80929-8 (pbk.: alk. paper) 1. Digital art—Technique. I. Title.
N7433.8.S862 2007
776--dc22

2007020296

British Library Cataloguing-in-Publication Data
A catalogue record for this book is available from the British Library.

ISBN: 978-0-240-80929-8

For information on all Focal Press publications
visit our website at www.books.elsevier.com

07 08 09 10 11 12 13 10 9 8 7 6 5 4 3 2 1

Typeset by Charon Tec Ltd (A Macmillan Company), Chennai, India
www.charontec.com

Printed in Canada

Working together to grow libraries in developing countries

www.elsevier.com | www.bookaid.org | www.sabre.org

ELSEVIER BOOK AID International Sabre Foundation

Contents

6 Going for it with Color 201

7 Collage Portraiture 223

8 Replay 255

Foreword

A Personal Creative Odyssey

Each of us is on a personal creative odyssey, seeking a unique expressive voice. For some, creativity is realized through words or music. For others, it is articulated via images. Whatever medium this voice takes, tools are necessary to create the expression. The more flexible the tool, the greater the potential range of expression.

In 1992, I had the good fortune of becoming involved with the creation and development of Painter. Previously, Mark Zimmer and Tom Hedges had written both the groundbreaking Letraset *ImageStudio* and *ColorStudio* graphic applications for the Macintosh. I had been involved with Time Arts *Oasis*, the first Mac application to exploit the expressive pressure-sensitive capabilities of the Wacom tablet. While on our individual, yet remarkably similar quests, we repeatedly crossed paths at various trade shows until our shared vision brought us together. At that point, our individual creative odysseys became one and the result was Painter.

Painter was envisioned to be the ultimate image-making tool enabling personal expression. Mark, Tom and I were passionate about transplanting the vocabulary of traditional expressive mark-making tools into the digital realm and putting them into the hands of artists. The initial vision of Painter may have been ours, but the users of Painter quickly became participants in the creation of new tools as we sought their input.

Jeremy was among the initial wave of Painter aficionados. I remember seeing him at the 1993 Digital Be-In one evening during Macworld in San Francisco, entertaining the crowds with his soon-to-be famous portraiture sessions. He was using Painter! I was intrigued and watched for several minutes until I got an opportunity to speak with him. His enthusiasm was immediately apparent. He was full of questions about various aspects of Painter's inner workings. It was obvious that he possessed an innate understanding of Painter's expressive tools.

In the past year or so, I have observed the focus of Painter users shifting from questions of technique to those of style. I believe this indicates a maturing of both the medium and its proponents. Painter has now been in the artists' hands long enough that they are finding their own unique expressive voices. Jeremy's passion and expertise continues to flow in this latest edition of *Painter Creativity*. As through dance, Jeremy utilizes Painter as an expressive medium through which he reveals his zest for life. He is an excellent guide to aid you in finding your unique creative voice in the form of style.

Over the years, Jeremy has been one of Painter's principal goodwill ambassadors. His good-natured enthusiasm has been responsible for launching many on their creative odysseys, with Painter acting as their compass. Jeremy has taken both his enthusiasm and teaching experience and poured it into these pages. And you, now holding this book, are about to be the beneficiary of his efforts. If you are considering starting, or are already on your own creative odyssey, you couldn't be in better hands.

Yes, each of us is on a personal creative odyssey. A bit of experienced guidance goes a long way towards helping us finding our own path. In this book, Jeremy graciously shares his journey with us. If Painter is a compass, this book is the map. Bon voyage!

John Derry
Overland Park, Kansas
April 2007

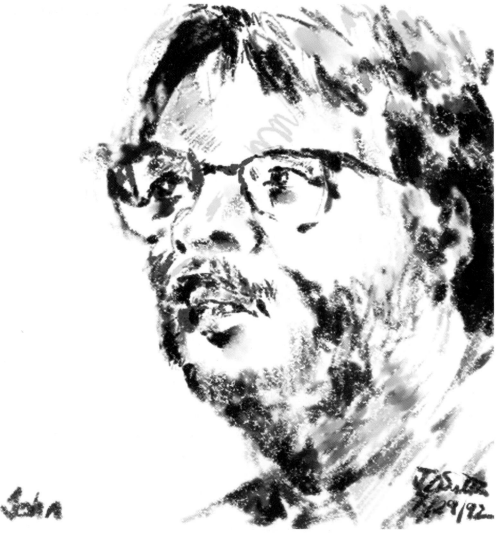

Portrait of John Derry created by Jeremy Sutton (using Fractal Design Painter 2) at the 1992 SIGGRAPH tradeshow in Chicago.

Introduction

Unparalleled Creative Freedom

Fasten your seat belt! You are entering a journey of unparalleled creative freedom. My goal is to excite, enthuse, inspire and encourage you on every level and to empower you to make beautiful expressive paintings using the powerful combination of Corel Painter X software and a Wacom tablet. You will experience the joy of creative improvization and expressing yourself on the digital canvas with boldness, passion and joie de vivre. If you are interested in getting your creative juices going, this book is for you.

In the following pages I share my personal perspective on the art of digital painting. The techniques described here can be applied to suit any artistic style and choice of subject. I encourage you to be true to yourself, to follow your heart and to use this book as a creative catalyst. I intend to empower and encourage your individual creativity, to help you on your own original voyage of discovery and to develop your unique voice as an artist.

My focus throughout this book is on developing your artistic skills, on being bold, on taking risks and on using your hand rather than applying effects, filters and automatic techniques. I focus on sharing what works for me and what I believe will make a practical difference to you. This is not intended to be a comprehensive user manual. There is already an excellent User Guide and an even more extensive Corel Painter X Help system built into Painter which I encourage you to make full use of. Use the Corel Painter X Help to look up any topics that I touch on in this book about which you wish to learn more.

What's New?

This edition of my book has been completely revised and rewritten. It includes a fresh structure and design for easier learning, inspiring artworks and effective new projects based on what has worked best in my recent seminars. We will explore the many exciting new features of Corel Painter X such as the RealBristle and Smart Stroke brushes, the enhanced Photo Painting and Mixer palettes, the Workspace Manager, and the Divine Proportion and Layout Grid tools.

I have included a folder of Jeremy Tutorial Images on the Painter X Creativity Resource Disc that accompanies this book (in future referred to as the PXC Resource Disc). The exercises are designed such that you can either use my images or your own.

One of the most valuable benefits of this book, besides what is contained on the printed pages, is the collection of Jeremy Extras on the PXC Resource Disc. This wonderful assortment of extra brushes, brand new custom palettes, papers, patterns, nozzles and powerful workspaces will transform your experience of Corel Painter X. You will enjoy the tutorial images and viewing lively QuickTime movies.

Each chapter methodically builds your foundation of technical setup, skills, knowledge and insights that will allow you to make the most of subsequent chapters. I strongly recommend you work through the chapters in the order they appear no matter what your skill and experience level.

Technology

This book describes the use of state of the art technology. I have made every effort to ensure all product names, model and version numbers and technical specifications are current at the time of writing. Given the rapid pace of change in digital technology I suggest you consult the appropriate company web sites to find accurate and current product information. Please also visit www.paintercreativity.com where you will find updates and Frequently Asked Questions regarding this book.

Terminology

For brevity the abbreviation "Mac" is used for reference to computers running the Macintosh Operating System, and the abbreviation "PC" for reference to computers running the Windows Operating System. Instructions are described with the Mac version first and PC version second. Sometimes keyboard shortcuts are separated by a forward slash, for instance: "Cmd-Shift-S/ Ctrl-Shift-S" (the shortcut for Save As). Most screen captures in this book show a Mac screen. Where appropriate I also include screen captures showing a PC screen. Generally, Painter looks and behaves similarly on both platforms. I have assumed the reader has basic computer skills including knowledge of how to open folders, copy files, locate applications and generally navigate within their operating system.

I use the symbol ">" to denote hierarchy, such as the folder hierarchy "Corel Painter X > Brushes > Painter Brushes" or the brush hierarchy "RealBristle Brushes > Real Fan Short". I also use ">" for describing multiple menu navigation, such as "Window > Custom Palette > Add Command".

This book uses standard American spelling (such as color instead of colour) and Imperial units of measurement (inches). All the techniques described will work on any localized version of Painter anywhere in the world.

Painter was originally designed to emulate traditional artist media ("natural media") and uses many traditional art terms in its menus and interface. This can sometimes be confusing to the traditionally trained fine artist since the terms do not always mean exactly the same in Painter as in the traditional art world. For instance the term "palette", which traditionally refers to the surface used for mixing color and to the range of colors selected in painting, in Painter refers to the various floating palettes from which you access your materials and tools. Another example is the term "paper texture" which traditionally refers to the rough texture of a paper surface. In Painter it is used interchangeably with the words paper and grain, and refers not to an actual quality of the surface on which you are painting but to a textural effect.

Further Training Resources

If you wish to enhance your learning experience with video training there are three options you may wish to consider. The first option, "Learning Corel Painter X with Jeremy Sutton", provides a complete interface tour and overview of Corel Painter X. If you already have this DVD I recommend you watch it before reading this book. You'll find that it introduces many of the features and concepts that are dealt within greater depth in the book.

Focusing on creative painting techniques working from photographs, the DVD set "How to Paint from Photographs using Corel Painter X: Creative Techniques with Jeremy Sutton" features a case study project taken from conception, through digital painting, to completion. This video comes with the most extensive set of my custom brushes and custom art materials available to date.

If you are interested in collage then you will enjoy "Expanding Your Creativity: The Art of Collage Portraiture" DVD set, an excellent complement to Chapter 7—Collage Portraiture. This video follows a collage case study in depth, detailing how I integrate a multitude of digital and traditional techniques in creating an artwork that reflects many aspects of the subject's life.

There is nothing that approaches the effectiveness, power, impact, inspiration and energy of participating in my hands-on seminars at Sutton Studios & Gallery in San Francisco. This book evolved out of the workbook I developed for my seminars. I offer workshops designed for all levels of experience (Painter Creativity Seminars for beginners through Painter Panache Master Classes for advanced students) and for specific themes (such as the Collage Workshop and the annual Great Gatsby Impressionist Workshop).

To order the DVDs and for class schedules, please visit www.jeremysutton.com. You'll find a Sutton Studios & Gallery order form at the back of the book.

Digital Painting in Perspective

The combination of the Wacom tablet and the Painter software is a revolutionary painting medium, which I expect will be seen as significant an advance in the history of painting as oil and acrylic paint were when they were first introduced. As powerful an art tool as the digital paint medium is, it is only one part of your creative process, a process that starts before you turn on your computer and continues after you close it down. As you follow the exercises in this book please keep a sense of perspective—the tools are only tools and you are in the driver's seat, not the computer.

Please use this book to create your own laboratory for experimentation.

Be bold! Have fun and enjoy,

Cheers,
Jeremy
San Francisco, 2007

Acknowledgments

I especially want to thank all my students over the years, who have been the inspiration and motivation behind this book, and from whom I have learnt so much. Thank you to everyone who contributed to this book, including my portrait subjects and those who generously allowed me to share their custom brushes and art materials. Contributors include Gisele Bonds, Scott Dupras, Peggy Gyulai, Denise Laurent, Paulo Roberto Purim and Sherron Sheppard.

Many thanks to Rick Champagne and Steve Szoczei and the rest of the Painter team at Corel, the publishers of Corel Painter, the paint program that changed my life and that of thousands of artists all over the world. Keep up the great work!

Thank you to Doug Little, Michael Marcum, Jim McCartney, Mark Mehall and everyone else at Wacom, the company whose excellent graphics tablets have helped transform the computer into a true art tool, and who have always been so supportive.

Thank you to Chris Siebert and Lavay Smith of Lavay Smith & Her Red Hot Skillet Lickers, to Adrian Jost of Trio Garufa, and to Andrew Galli of Studio Galli, who have generously permitted me to use their music on the movies that are included in the Painter X Creativity Resource Disc. See the Contributors List for contact details and web links.

Thank you to my wonderful Sutton Studios and Gallery team, Beth Waldman and Jennifer Gordon.

Thank you to my family for their support and encouragement. Thank you Peggy for your indefatigable support, for reading my drafts and keeping me caffeinated, not to mention sharing your great color palette.

Special thanks to John Derry for writing such an insightful foreword and for sharing your personal creative odyssey.

Many thanks to my editor, Valerie Geary and everyone else at Focal Press for doing such a great job designing, producing and publishing this book.

And thank you, the reader, for taking the time to follow my instructions, enjoy the artwork and be inspired on your own creative journey.

1

Preparing

The preparation described in this chapter is designed to free you up to perform at your best and to fully realize your creative potential on the digital canvas.

An athlete makes sure they have good shoes and they stretch before running a race. A musician makes sure their instrument is tuned and warms up their hands and their instrument before performing. A speaker does a sound check, drinks water and clears their throat before talking on the podium. All three may take some quiet moments to relax and enter the mental state that will allow them to perform at peak potential. Likewise an artist needs to prepare their tools, mind and body to perform at their best. In thinking through what has helped me perform as an artist I have identified seven basic principles.

Seven Principles

1. Perseverance

The most powerful principle is also the simplest: to persevere. Be committed to your individual brush strokes and to persevering with your artwork, even when you feel like giving up. Albert Einstein (Figure 1.1) was an example of perseverance. In his words: "I know quite certainly that I myself

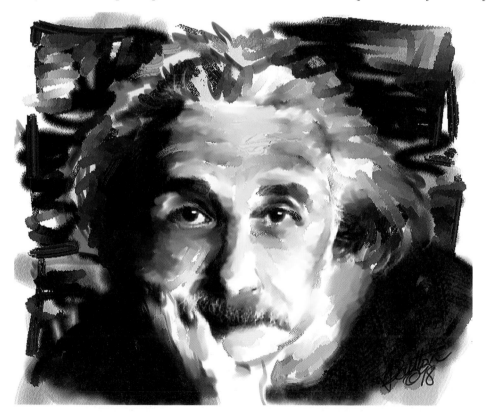

Figure 1.1 *"Contemplation—Portrait of Albert Einstein"*, 1998, 31 inches × 36 inches.

have no special talent; curiosity, obsession and dogged endurance, combined with self-criticism have brought me to my ideas".

My portrait of Ray Charles (Figure 1.2) went through several stages where it wasn't working and I felt like giving up. I kept going and was pleased with the end result.

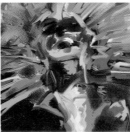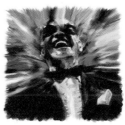

Figure 1.2 "*Brother Ray*", 2005, 40 inches × 40 inches, showing a sequence of stages including the "ugly" second stage when I felt like giving up … The final stage can be seen in more detail in Chapter 6, Figure 6.1.

2. Passion

Paint with passion! Be true to yourself and your intuition.

When you paint from your heart it shows in the work and moves others. One of my students Linda Huddle-Martin, a professional portrait photographer from Pennsylvania tried an experiment: every time she made a commissioned portrait, she first made a version that she thought her clients would like and then made one for herself, more expressive and daring. She then showed her clients both versions and in every case they purchased the livelier version she did for herself.

We can draw inspiration from the passionate intensity with which Pablo Picasso (Figure 1.3) made art.

3. Respect

Respect yourself and your art. Make yourself comfortable and set up a healthy working environment. When you enter your painting studio (Figure 1.4) pause for a moment and prepare yourself for making the most of your creative space.

4. Serendipity

Serendipity is the accidental discovery of things. Embrace happy accidents and be open to the unexpected. This principle is a powerful tool in pushing your artwork to new levels of power and beauty. Welcome the unpredictable and uncontrollable artifacts of the creative process.

When a brush does something you don't like or didn't expect, don't immediately dive for the Undo command, but see it instead as an opportunity to enrich your painting and explore directions

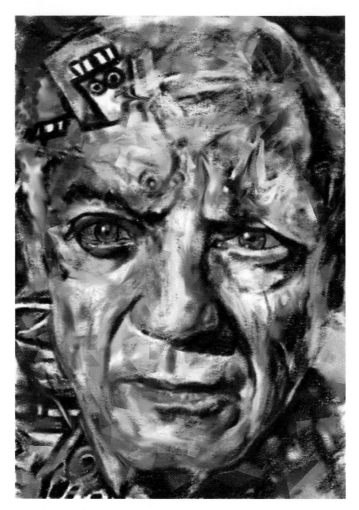

Figure 1.3 "Pain & Passion: Portrait of Pablo Picasso", 1993, 38 inches × 56 inches, an early digital painting inspired by the Picasso's passionate intensity.

you may not have previously considered. Improvize with whatever appears on your canvas. Each unexpected or unintended happening on your canvas is a little miracle that opens up new doors. With Painter's vast array of brushes there are always surprises in store, and thus you won't be short of little miracles in your paintings.

5. Imperfection

We are often tempted to correct, delete or hide imperfections. Consider the opposite approach, one in which you appreciate imperfections.

Take a look at the beautiful rough sketch marks or loose brush strokes or visible corrections showing through in some of the finest works of art throughout history. Examples include Leonardo

Figure 1.4 The view of my studio as I walk in.

da Vinci's unfinished masterpiece, the "Adoration of the Magi" (1481–1482, Uffizi Gallery, Florence, Italy), left in its yellow ocher and brown ink sketch phase, or Pablo Picasso's seminal and powerful masterpiece, "Guernica" (1936, Museo Reina Sofia, Madrid, Spain), in which you can see his half-erased sketch marks revealing his compositional changes. Paradoxically it is often the imperfections, the marks of trial and error left visible, that vitalize and energize these paintings.

Painting is problem solving. As you paint you continually resolve what is not working, trying out different solutions until the painting works. In non-digital painting every brush mark leaves its trace, even when you paint over or scrape off the paint. Every cycle of creation and destruction, of building up and breaking down, leaves its imprint and adds to the beauty of the end result. This applies whether you are using traditional or digital paint.

In the computer we are tempted by the instant Undo, which erases all traces of a brush stroke as if it had never existed. We tend to Undo anything we consider imperfect. I advise you to avoid the Undo command during your painting process. My painting, "Sisters" (Figure 1.5), is full of rough, imperfect brush strokes and has a sketchy background that I purposely left unfinished. The rough brush strokes serve as a counterbalance to the tender love between the two sisters.

Many cultures reflect this attitude of appreciating the imperfect. The renowned basket weavers of the Navajo Nation have a saying that "God is in the imperfections". They always specifically include a subtle imperfection in their designs. The Japanese esthetic of Wabi-sabi finds beauty in the patina of aging and in the small details of everyday life that we so often overlook. It accepts the transience and impermanence of the world—that all things are in flux and are imperfect.

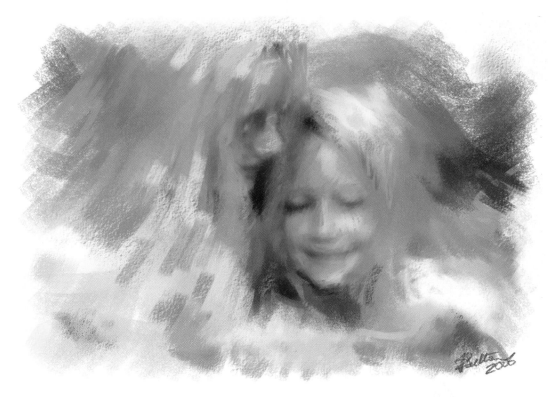

Figure 1.5 *"Sisters"*, 2006, 24 inches × 34 inches, showing imperfect brushwork and an unfinished background.

6. Improvization

Let go of the need to control and pre-determine every step of your journey. Allow yourself the freedom to improvize and respond spontaneously from moment to moment. Though you may start painting with a clear vision of starting from point A and ending up at point B, your path may take a turn you didn't expect and lead you to a different destination than the one you originally envisaged (Figure 1.6). Be prepared to let anything go, to allow it to be transformed. Let intuition, spontaneity, improvization, and serendipity guide you.

This approach to creating is beautifully summed up by musician Loreena McKinnett in her liner notes for the album the *Book of Secrets*.

"In casting your inspirational net as an artist, you become familiar with the humility that comes with watching your best-laid plans veer sideways. So, you set out to travel to Rome ... and end up in Istanbul. You set off for Japan ... and you end up on a train across Siberia. The journey, not the destination, becomes a source of wonder."

"In the end, I wonder if one of the most important steps on our journey is the one in which we throw away the map. In jettisoning the grids and brambles of our own preconceptions, perhaps we are better able to find the real secrets of each place."

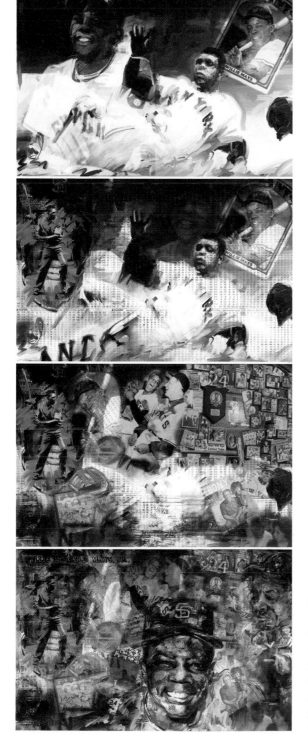

Figure 1.6 The development of "*Say Hey, a Portrait of Willie Mays*", 2005, from an early stage (top) showing what was originally intended as the main anchor image, through to the final stage at (bottom), which can be seen in more detail in Chapter 7, Figure 7.23. Notice how I experimented with ideas and changed the composition.

7

7. Detachment

Detachment is useful if you find yourself struggling with a painting—it allows you to step back from attachment to the end result and gain clarity in the present moment. Conversely if you create a masterpiece that is widely acclaimed, allow yourself well-deserved satisfaction and pleasure while recognizing there is always room to further develop your mastery. Always move forward and explore new directions.

Detachment is also a quality you can convey in portraiture by your choice of expression and pose. In my painting of Diane Wagner (Figure 1.7) I was inspired by her detached and serene poise as she looked out of a window.

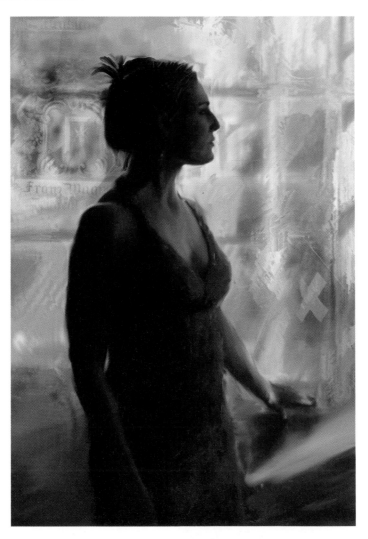

Figure 1.7 *"Diane Wagner"*, 2006, 38 inches × 55 inches, part of the San Francisco Bay Area Women of Style portrait series.

Materials List

In order to follow your heart and fully realize your creative potential on the computer, and to follow all the projects described in this book, you will need the right tools for the job: a digital camera, a Mac or PC computer, Corel Painter X software and a Wacom tablet. I recommend the latest version of Adobe Photoshop and a color inkjet printer that uses durable pigment inks and can print on fine art papers and canvas. These digital tools will get you going. I also suggest you gather a selection of non-digital drawing and painting tools such as soft pencils, oil pastels or crayons, sketch books and acrylic paints. These non-digital tools allow you to hone your artistic skills and can be used on your digital prints. The exercise in Chapter 4 requires non-digital drawing tools and I specify below what I recommend.

Minimum Computer System Requirements

Mac OS® version

www.apple.com

Mac OS X (version 10.3.9 or higher with latest revision applied)

Mac® computer with a 700 MHz or faster Power PC® G4, Power PC G5 or Intel® processor

256 MB of RAM (512 MB or more recommended)

24-bit color display

1024 × 768 screen resolution (or better)

1 GB free hard disc space (10 GB or more recommended)

DVD/CD-ROM drive

QuickTime 7 Player or later (see www.apple.com/quicktime/download/mac.html)

PC® version

www.microsoft.com

PC VistaTM, PC® XP or PC® 2000 (each with latest Service Pack applied)

Pentium® III, 700 MHz or greater

256 MB of RAM (512 MB or more recommended)

24-bit color display

1024 × 768 screen resolution (or better)

1 GB free hard disc space (10 GB or more recommended)

DVD/CD-ROM drive

QuickTime 7 Player or later (see www.apple.com/quicktime/download/win.html)

Corel Painter X Software

www.corel.com

Figure 1.8 The limited edition Corel Painter X can.

This book is based on using Corel Painter X. If you have an earlier version of Painter, or have Painter Essentials, I recommend upgrading to Corel Painter X (or the most up-to-date version of Painter available). You will need Corel Painter X to get the most out of this book.

Wacom Graphics Tablet with Pressure Sensitive Pen

www.wacom.com

There are three main families of Wacom tablets in the US: the Graphire (consumer), Intuos (professional) and Cintiq (professional). I recommend either an Intuos3 or Cintiq. Only these professional tablets have the programmable Express Keys and Touch Strips, and work with the 6D Art Pen, an additional item that I highly recommend. The 6D Art Pen allows you to make the most of rotational sensitivity of the RealBristle brushes in Corel Painter X.

The Intuos3 range goes from the 4 inches × 6 inches (A6 Wide—Europe) tablet at the smallest end through the 12 inches × 19 inches tablet at the largest end. I find the Intuos3 6 × 8 (A5—Europe) or Intuos3 6 × 11 (A5 Wide—Europe) excellent for traveling and laptop use, and the Intuos3 12 × 19 (A3 Wide—Europe) ideal for use with my desktop computer and Apple 30 inches Cinema HD Display (Figure 1.9).

The Cintiq range of tablets combine color LCD displays built into the tablets. They are the ultimate in intuitive display—you apply your pen directly onto the display (Figure 1.10).

10

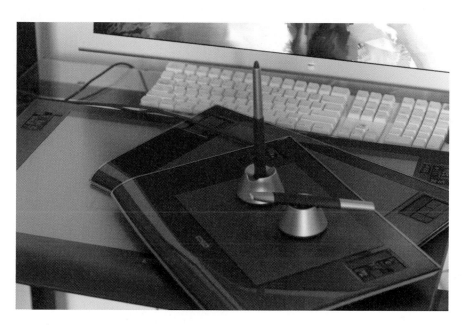

Figure 1.9 The Intuos3 6 × 8, 6 × 11 and 12 × 19 tablets, with the Grip Pen and 6D Art Pen.

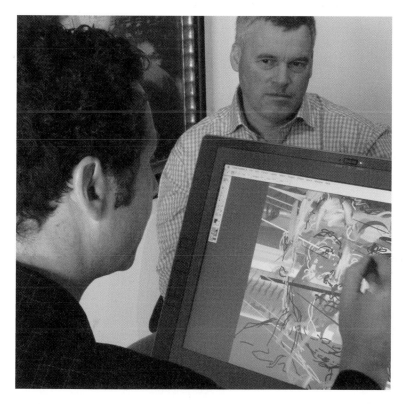

Figure 1.10 Jeremy painting a portrait of Doug Little on a Cintiq.

If you already have an Intuos3 or Cintiq tablet visit the www.wacom.com web site and download the latest driver. It is worthwhile updating your Wacom driver periodically.

Please take this opportunity to watch "4-Wacom Tablet Overview.mov" contained in the Jeremy Movies folder on the PXC Resource Disc that accompanies this book.

Sketching Materials

www.dickblick.com

I recommend complementing your computer art studio with a "wet" studio, that is non-digital art supplies. Here are a few basic materials to get you going.

Figure 1.11 Sample sketching materials.

Sketchbook

Cachet Classic Wirebound Black Cover Sketchbook, Blick Part No. 10328-1011, 80 Sheets 75 lb acid free drawing paper, 6 inches × 6 inches.

Colored Papers

Canson Mi-Teintes Muted Colors, Blick Part No. 10722-1050, Pkg of 10, 19 inches × 25 inches.

Crayons

Caran d'Ache Neocolor II Artists' Crayons, Blick Part No. 20042-1509, Set of 15.

Small mirror (approximately 5 inches × 7 inches) you can prop up near your computer screen. A small make-up mirror will suffice.

Set Up Your Wacom Tablet

Get Comfortable

Put on some music you like, get out of your chair and move. Stretch for the sky. Gently roll your shoulders, slowly turn your neck, shake your hands and feet, bend your wrists, move your fingers, rotate your ankles. I recommend you do this several times a day to keep your creative energy up.

Close your eyes, take a deep breath, hold it for a moment, and then expel your breath with a sigh. Clear your mind of the chatter of everyday life and give yourself permission and space to focus on being fully creative.

Open your eyes, sit down and make sure your chair is well adjusted and that the center of your screen is close to eye level. Place the tablet between you and your screen, not to one side like a mouse pad. Either rest your tablet on your lap or on the table, whatever is most comfortable. Place both your palms face down on the tablet surface and take a moment to relax.

Make sure the USB cable from your tablet is tucked out of the way and not laying across your keyboard. Sit squarely facing your computer screen without twisting your neck or torso. If using a laptop I recommend a support that lifts your laptop off the table and using a separate keyboard (Figure 1.12). This has the dual benefit of being more comfortable and opening up more space on your desk.

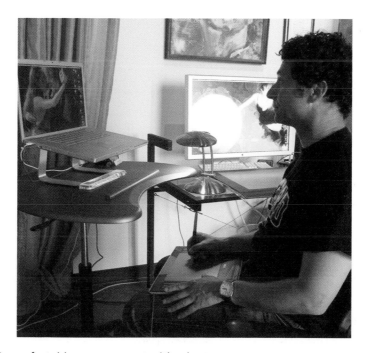

Figure 1.12 A comfortable arrangement with a laptop.

I recommend you read the article "Top Ten Tips for an Ergonomic Workstation" by Irene Diamond that appears in the Articles section of my web site *www.jeremysutton.com*. This explains the healthiest way to set up your chair, keyboard and screen.

Wacom Basics

A Wacom graphics tablet is your key to unlocking the computer as an art tool. It replaces all the functions of a mouse plus adds additional levels of control that a mouse can't provide. The active tablet surface represents your computer screen (or more than one screen if you wish). Every point on the tablet active surface corresponds to a unique point on the computer screen.

Hidden beneath the tablet surface is an electrified wire mesh grid that detects the change in a quality known as mutual inductance as the Wacom pen (which contains a small magnet) is brought close. The grid is extremely sensitive and can detect minute changes in the pen position and pressure, as well as tilt, bearing and, in the case of the 6D Art Pen, rotation. The tablet detects your pen tip when it is a small distance from the tablet surface. That enables you to move the cursor on the screen without accidentally clicking or dragging. A click is a light tap, a double click is two light taps. I recommend holding your Grip Pen close to the tip and slightly more upright than a regular pencil. Keep the side of your palm on the tablet (Figure 1.13) and use the angle of your hand to control the distance of the pen tip from the tablet.

Figure 1.13 Keep the side of your palm on the tablet when holding the Wacom Grip Pen.

Stroke Nib

The Wacom Inutos3 and Cintiq tablets are supplied with a Grip Pen with a standard stylus nib installed.

1 Locate the extra nibs that came with your Grip Pen. Pick out the one that has a small spring in it (Stroke Nib).

2 Remove the standard nib from the Grip Pen (you could use tweezers, pliers or your teeth).

3 Insert the Stroke Nib (Figure 1.14), spring end first, into the Grip Pen. This will give you a softer feel that I find better for painting.

Figure 1.14 The stroke nib adds a softer feel to the Grip Pen.

Grip Pen Button

1 Choose Apple Menu > System Preferences > Other > Wacom Tablet (Mac) or Start > Control Panels > Wacom Tablet Properties (PC).

2 You will see in the upper section of the Wacom Tablet control panel Window (Figure 1.15) three sections that specify the tablet model, the pen type and the application. Below that are, in the case of the Grip Pen, three tabs: Pen, Eraser and Mapping. With the Pen tab highlighted you can choose, via pop-up menus, the functions of the two-function button on the side of the Grip Pen. The Wacom tablet recognizes different pens so different users can set their individual pens to have different settings. For simplicity I set both functions of the two-function button to Disabled, though you may wish to set these to whatever functions you will find useful.

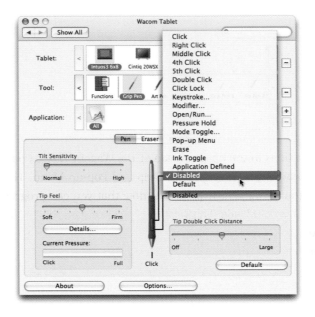

Figure 1.15 Adjusting the Grip Pen Two-Function Button in the Wacom Tablet Control Panel.

Mapping

1 Select the Mapping tab. You will see Screen Area: Full and Tablet Area: Full. Click on the Tablet Area pop-up menu and change Full to Portion.

2 You will now see a window (Figure 1.16) showing you three ways to select which portion of the tablet will be active. In the top option, titled "1. Drag Handles", drag the handles to bring in the

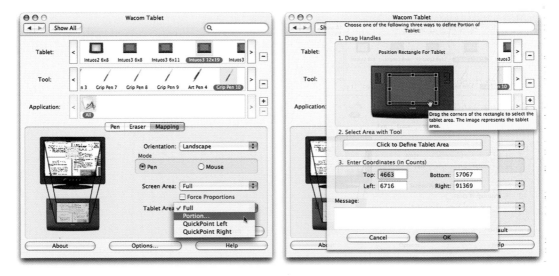

Figure 1.16 Adjusting the Mapping of the active surface area of the Wacom tablet.

active area from the corners. This will prevent your pen tip getting caught in the small gulley at the edge of the plastic flap when you are painting or selecting at the edge of your screen. In the case of my Intuos3 12 × 19, for maximum comfort I set the active area to be a smaller region in the center.

3 Click OK.

ExpressKeys

1 Select the Tool: Functions in the upper section of the Wacom Tablet Control Panel. You will see three new tabs appear: ExpressKeys, Touch Strip and Pop-up Menu. The ExpressKeys is high-lighted. Before programming your Expresskeys, note that you can program these to have differ-ent functions for different individual applications by clicking on the "+" icon on the right of the Application menu. You can select which application you are programming the ExpressKeys for. If you go between Painter and Photoshop frequently and like to use different keyboard short cuts in each program then this would be a useful functionality. In that case use the "+" icon to select Corel Painter X. I tend to work in Painter so much I just leave it with all applications selected and just program the Expresskeys once. That also means I only have to remember one set of shortcut functions.

2 Some of the settings I use require the selection of "Keystroke …" in the ExpressKey pop-up menu and others require the selection of "Modifier …" in the ExpressKey pop-up menu. Let's look at an example of each. Click on the top left ExpressKey in the left set of keys.

3 Choose Keystrokes.

4 Click once on the Tab key. Note that to clear what you've typed into the Keystrokes window, you have to click the Clear button, not click the delete key on your keyboard.

5 Click OK.

6 Name the shortcut (Figure 1.17).

7 Click on the top right ExpressKey in the left hand group of keys.

8 Choose Modifier.

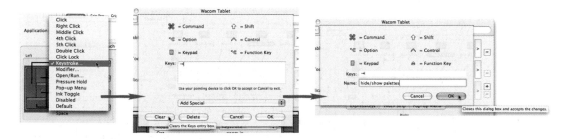

Figure 1.17 Setting the Wacom ExpressKeys using the Keystroke command.

9 Check the Option Key and Command Key check boxes if you are using a Mac, or the Alt and Ctrl check boxes if you are using a PC (Figure 1.18). This combination of keys is the shortcut in Painter for changing brush size while painting (hold down this shortcut ExpressKey and then click and drag on your canvas to dynamically resize the brush).

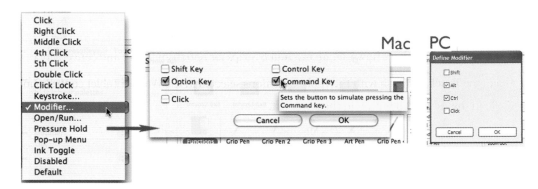

Figure 1.18 Setting the Wacom ExpressKeys using the Modifier command.

10 You will see below (Figure 1.19) my current ExpressKeys settings. I am right handed and my settings reflect, on the left, shortcuts I may wish to apply while painting (such as hiding palettes and changing brush size), and on the right shortcuts that effect my canvas display (such as zooming in and out and mounting in screen mode). If you are left-handed you may wish to reverse these settings. I write the shortcuts in silver pen on black electrical tape and tape these on my tablet to remind me. After using them a few times you'll find that you remember them without needing to refer to the labels.

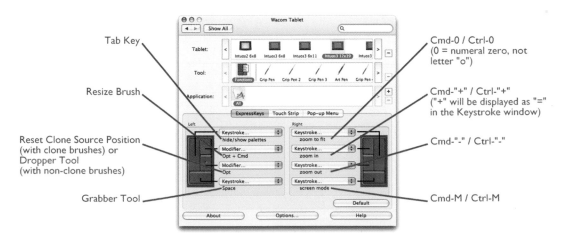

Figure 1.19 My ExpressKey settings.

Touch Strips

The Intuos3 and Cintiq series of tablets include Touch Strips, usually one on either side of the active surface area. The Intuos3 4 × 6 only has one Touch Strip. This section is based on setting up a tablet with two Touch Strips. The default setting for these Touch Strips is as Auto Scroll/Zoom shortcuts that accept input from being touched by skin, so you can use a fingertip going up or down on either Touch Strip to zoom in and out in Painter. Depending on the size of your tablet and the way you move your hands as you paint, you may find yourself accidentally zooming in or out when you don't wish to. I share with you here how I set up my Touch Strips for optimum utility and convenience.

1 Select the Touch Strip tab with the Tools: Functions selected in the Wacom Tablet control panel.

2 Click on the Advanced button in the lower left.

3 Check "Accept Touch Strip input from pen only" for the left and right Touch Strips (Figure 1.18). This avoids accidental activation of the Touch Strips when you run your hand or fingers across them.

4 Click OK.

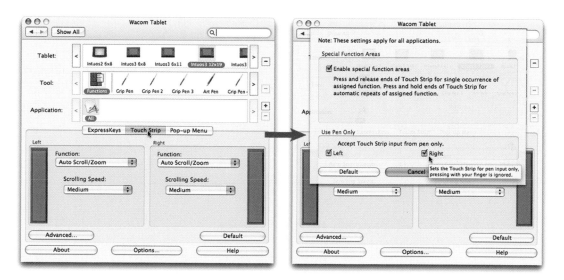

Figure 1.20 Advanced Touch Strip settings.

5 On the right Touch Strip select Function: Keystrokes.

6 Click on the downward arrow.

7 On your keyboard type in "Cmd-Shift-S/Ctrl-Shift-S", the short cut for Save As (Figure 1.19). Note that, as with programming the ExpressKeys, to clear what you've typed into the Keystrokes window, you have to click the Clear button, not click the delete key on your keyboard. On a PC your Shift key command is not displayed even though it is included in the shortcut.

8 Click OK.

9 Name the shortcut Save As.

10 Click OK. You can now activate this shortcut when in Painter by clicking once on the inner lower left side of the right Touch Strip. Touch Strips take advantage of the fact that the active surface area matrix of a Wacom tablet extends a little beyond the apparent active area and thus the sensitive portion of the Touch Strip is along the side closest to the main active area. If you make a downward stroke you'll be repeating the command many times and you'll see a Save As window with a message like "An item names 'untitled-1' already exists in this location. Do you want to replace it with the one you are saving?" If you see that message click cancel and rename your file for saving. Due to the sensitivity of the tablet you may see that message even when you think you just clicked once.

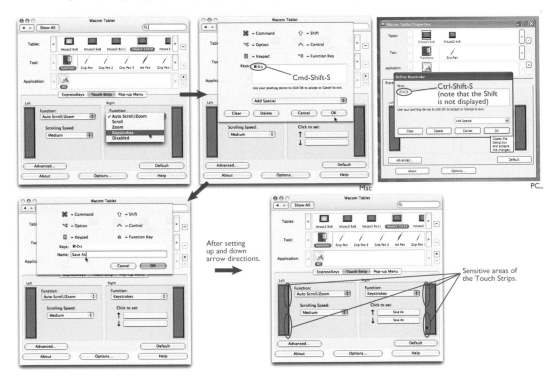

Figure 1.21 Program the right Touch Strip with Save As shortcut settings.

11 Repeat steps 6 through 10 for the upward arrow on the right Touch Strip. This will make the upper left hand side of the right Touch Strip act like a Save As button. Please make good use of this shortcut. Whenever you are working on a project, whether my instructions mention Save As or not, please make a habit of regularly doing a Save As and saving sequentially numbered versions of your images as they progress. This habit will empower you creatively and enable you to make use of the many phases your paintings go through.

If you wish you may continue programming further shortcuts in the left Touch Strip or leave it in the default Auto Scroll/Zoom. In Painter you can quickly zoom in and out using this setting. When

looking at web pages you can scroll up and down a page using the same setting. When finished close the Wacom Tablet Control Panel.

Prepare Your Computer

Optimize Your Computer System

It is your goal within Painter to flow freely with your creativity. To do this you need fast, responsive brushes that paint as you move your pen, and plenty of space to store the many versions of your images that you save as you work on a project. This requires a fast computer with plenty of memory and free hard drive space. For the best experience working in Painter I recommend you invest in as much memory as your computer can accommodate, free up as much hard drive space as possible and make sure your operating system is running smoothly and efficiently.

Single User License Agreement

By loading any of the materials from the Painter X Creativity Resource Disc onto your computer you are agreeing to the Single User License Agreement which is reproduced in this book. Please read over that agreement carefully before using any of the Jeremy Extras. The key element of the agreement is that you are only granted permission to use these materials for yourself for personal use and you are not permitted to share them with others, even in a classroom situation, or to rent, loan, sell or distribute any of the materials. Thank you for respecting my copyright and that of all the contributors and agreeing to the conditions of the Single User License Agreement.

Install Jeremy Extra Brushes

These instructions explain how to install the Jeremy Faves 2 brush category supplied with this book.

1 Place the PXC Resource Disc (that accompanies this book) in your computer.

2 Open PXC Resource Disc > Jeremy Extras (For Single User—Please Do Not Share) > Jeremy Extra Brushes (Mac and PC). In the Jeremy Extra Brushes folder you will see a brush category folder "Jeremy Faves 2" and an associated brush category icon image file "Jeremy Faves 2.jpg".

3 Select these two items (the "Jeremy Faves 2" folder and icon).

4 If you are using a Mac open a separate window in the Finder and drag the two items into Applications > Corel Painter X > Brushes > Painter Brushes (Figure 1.22). If you are using a PC choose "Copy the Selected Items" in My Computer and then copy the two items to Local Disc (C:) > Program Files > Corel > Corel Painter X > Brushes > Painter Brushes (Figure 1.23).

The exact positioning of the extra brush category and category icon in the folder hierarchy is critical to the brushes working in Painter. Be sure that you can see the "Jeremy Faves 2" folder and icon inside the Corel Painter X > Brushes > Painter Brushes folder.

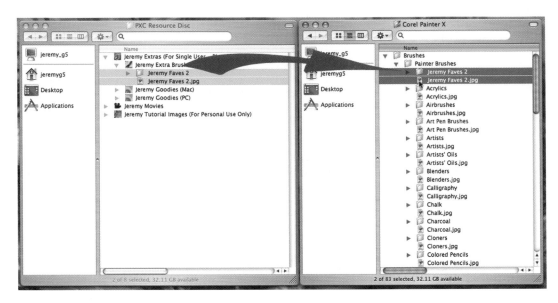

Figure 1.22 Installing Jeremy Faves 2 extra brush category on a Mac.

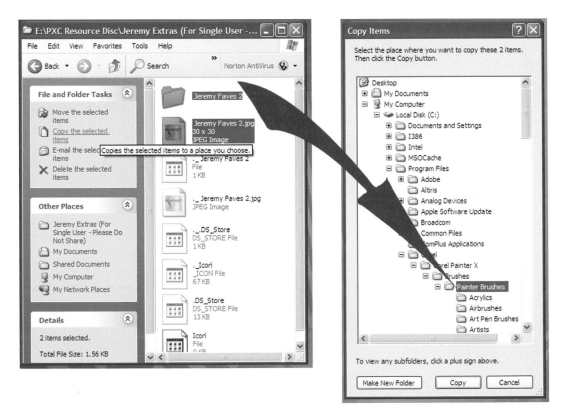

Figure 1.23 Installing Jeremy Faves 2 extra brush category on a PC.

Installing Other Jeremy Extra Brushes

If you have "Expanding Your Creativity: The Art of Collage Portraiture" DVD set then copy the JeremyOwnFaves3 and JeremyGuestFaves3 category folders and JPEGs, instead of the Jeremy Faves 2 category folder and JPEG, into the Painter Brushes folder. Likewise if you have the "How to Paint from Photographs using Corel Painter X: Creative Techniques with Jeremy Sutton" DVD set then copy the JeremyOwnFaves4 and JeremyGuestFaves4 category folders and JPEGs, instead of the JeremyOwnFaves3, JeremyGuestFaves3 or Jeremy Faves 2 category folders and JPEGs, into the Painter Brushes folder. Anytime the instructions in this book refer to a brush variant from Jeremy Faves 2 you will find the same brush variant in JeremyOwnFaves3 or JeremyGuestFaves3, and in JeremyOwnFaves4 or JeremyGuestFaves4.

Installing Brushes from the Corel Painter X CD

The Corel Painter X CD comes with a folder called Extras within which are eight folders each containing different types of extra materials. One of them is a folder called Brushes. Inside this folder you'll find twenty more folders, most with names that sound like a brush category (Calligraphic Brushes, Effects 1 and so on). These are brush library folders that contain category folders and category icon JPEG files. Often the category names are the same as the library folders they are contained in. You could copy the library folders into the Corel Painter X application folder > Brushes but you'd then need to use Load Library to access each of them. You could copy the category folders and category JPGs into the Corel Painter X application folder > Brushes > Painter Brushes if you wished to have them accessible from the current brushes library. One of the reasons I originally created my own Jeremy Faves category was specifically to save you diving into this virtual Russian nesting doll of folders within folders within folders. I looked through all the variants in these extra categories and picked out my favorites and put them conveniently in a single extra brush category which became Jeremy Faves. I then added custom brush variants that were created by myself and guest contributors who kindly let me share them with you.

Install Jeremy Goodies

1 Return to the PXC Resource Disc.

2 In your Finder (Mac) or My Computer (PC) open the folder titled either "Jeremy Goodies (Mac)" or "Jeremy Goodies (PC)", as appropriate.

3 Hold the Shift key down as you select the four folders: "Jeremy Color Sets", "Jeremy Custom Palettes", "Jeremy Fave Papers, Patterns and Nozzles" and "Jeremy Workspaces".

4 If you are using a Mac open a separate Window in the Finder and drag the four folders into Applications > Corel Painter X > Support Files (Figure 1.24). If you are using a PC choose "Copy the Selected Items" in My Computer and then copy the four folders to Local Disc (C:) > Program Files > Corel > Corel Painter X > Support Files (Figure 1.25).

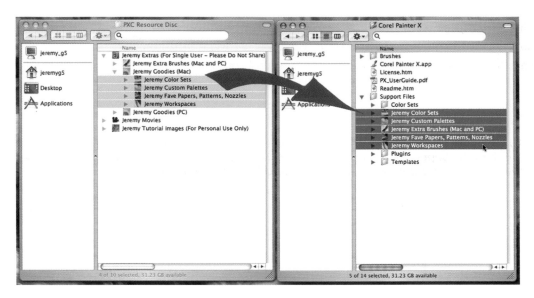

Figure 1.24 Installing Jeremy Goodies on a Mac.

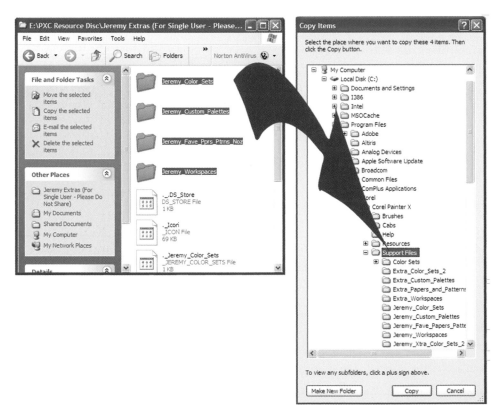

Figure 1.25 Installing Jeremy Goodies on a PC.

These items could be stored anywhere in your computer. Unlike with the brushes, their location is not critical to their functioning in Painter. However, you will be making regular use of these Goodies and I therefore suggest you keep them in the Support Files folder for easy access.

Making a Support Files Sidebar Shortcut (Mac)

If you are using a Mac, in the Finder browse window click on Applications > Corel Painter X and drag the Support Files folder into the Sidebar on the left of the window (Figure 1.26). You will find this a useful shortcut when searching for art material libraries.

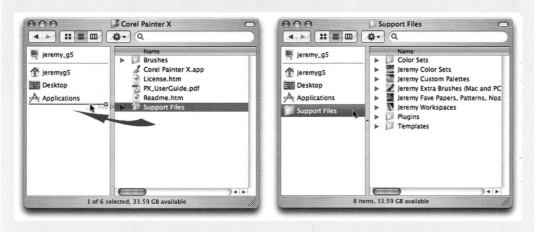

Figure 1.26 Mac users create a Support Files shortcut in the Finder browse window Sidebar.

Create a PXC Projects Folder

1 Create a new folder in your computer where you wish to save all the artwork you create as a result of following the exercises in this book. If in doubt choose your desktop—you can always move the project folder to another location later. Mac users can choose Shift-Cmd-N (File > New Folder) in the Finder desktop or browser to generate the new folder. PC users can right click on the desktop or in My Computer and choose New > Folder.

2 Click on the new untitled folder and title it "PXC Projects".

3 Copy the folders "Jeremy Movies" and "Jeremy Tutorial Images (For Personal Use Only)" into your PXC Projects folder.

4 Within your "PXC Projects" folder create a new folder. Mac users choose Shift-Cmd-N (File > New Folder). PC users right click and choose New > Folder.

5 Title the new folder "01 Abstract". This will be your folder for the first project you do. The PXC Projects folder should now contain three folders: "01 Abstract", "Jeremy Movies" and "Jeremy Tutorial Images (For Personal Use Only)".

Watch the Movie "1-Jeremy Studio Tour.mov"

Double click on the movie PXC Projects > Jeremy Movies > 1-Jeremy Studio Tour.mov. In this movie I give you a brief tour of my studio and share my approach to painting. Every artwork you see in this movie was created using Painter (and most have other media applied onto the print).

Establish a Back-up and Archive System

If you do not already have one, establish a system for backing up and archiving all your digital files. I recommend periodically backing up all new work onto external media (such as DVD) in duplicate, saving the two copies in two separate locations. Name each disc with a sequential number and date, and catalog what is on each disc so that you can easily and quickly locate files when you need them (Figure 1.27).

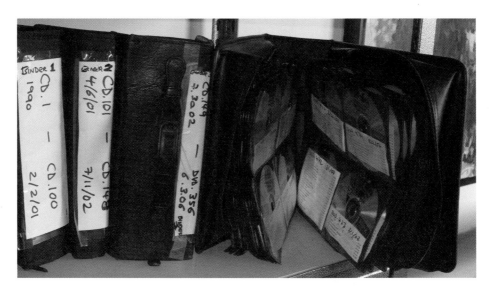

Figure 1.27 My entire digital archive, dating back to my first digital paintings in 1990. This archive is stored in duplicate in two locations.

At this juncture I suggest you make a back up of your Corel Painter X application folder (Mac: Applications > Corel Painter X; PC: Local Disc (C:) > Programs > Corel) and your Corel Painter X custom data folder (Mac: User Folder > Library > Application Support > Corel > Painter X; PC: Local Disc (C:) > Documents and Settings > User Directory > Application Data > Corel > Painter X) and save them onto DVD. Note that Painter X is designed for a multi-user environment and therefore stores all your custom data in your user folder, not in the application folder.

A Trouble Shooting Tip (… That I Hope You Don't Need!)

I expect everything will go smoothly. However in the unlikely event you run into any problems with Painter, first restart the program. Check that the extra brush category folder and JPG are in the precisely the right place (they must be in the Applications/Programs > Corel Painter X > Brushes > Painter Brushes folder). If you still have a problem, remove the extra brushes. If all else fails back up any custom Painter data you have from your user folder (Mac: Users > username > Library > Application Support > Corel Painter X; PC: Documents and Settings > username > Application Data > Corel Painter X). Then hold the Shift key down while opening Painter. You will be asked if you want to restore Painter to its factory-default settings and you will be warned that this will erase all your custom data including brushes, papers and textures. If you are sure you wish to go ahead you can choose to restore the current or all workspaces (I recommend all). Only do this as a last resort.

Optimize Painter X

Open a New Document

When you open Corel Painter X you will first see the Welcome book with five tabs arranged vertically down the right side of the book. Clicking on each tab opens one of the five pages of the book. The first page (top tab) gives you access to creating a new image file or canvas (referred to as a "document") and accessing existing and recently saved images (Figure 1.28). You can also access templates that you store in the Corel Painter X application folder > Support Files > Templates.

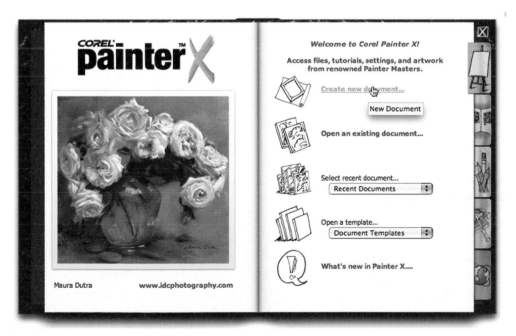

Figure 1.28 The first page of the Welcome book.

1. Click on "Create new document". You will see the new document Window appear. You can also access this by choosing Cmd-N/Ctrl-N or File > New.

2. Change the Width and Height units from pixels to inches.

3. Set the document dimensions to be Width: 10 inches and Height: 8 inches. Set the Resolution: 150 pixels per inch (Figure 1.29).

4. Click OK. This new document will serve as your initial scratch pad to practice on while setting up the Painter preferences and trying out brushes.

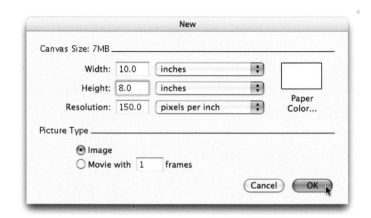

Figure 1.29 New document window.

Import Jeremy Workspaces

The workspace management system introduced in Corel Painter X is an immensely powerful tool for optimizing workflow. It allows you to completely customize almost all aspects of your Painter workspace, save your custom workspaces and export or import custom workspaces. This feature allows me to share with you my own custom settings without you having to import and set up every detail.

1 Choose Window > Workspace > Import Workspace.

2 If you are using a Mac locate Applications > Corel Painter X > Support Files > Jeremy Workspaces. If you are using a PC locate Local Disc (C:) > Programs > Corel > Corel Painter X > Support Files > Jeremy Workspaces. You will see a list of Jeremy workspaces optimized to suit different sets of Jeremy Faves custom brushes and different screen resolutions.

3 Choose the Jeremy workspace that has the appropriate custom brush set number and screen resolution (see the sidebar "Which Jeremy Workspace to Import?"). If your screen resolution is not amongst the four I have designed the workspaces for, choose a resolution bigger than your screen resolution.

4 Choose Open. You'll see your palettes rearrange themselves in a manner that I have predetermined, one of my JeremySupaDoopa custom palettes will appear, my custom patterns and nozzles will be the current active patterns and nozzles libraries, and all the preferences, settings and palette arrangements will be set as I have them set on my computer. In other words in one short, easy, fell swoop you've just accomplished in seconds what took me, and may otherwise have taken you, many hours to prepare and set up. This feature alone is a great reason to get Corel Painter X.

Which Jeremy Workspace to Import?

The Jeremy workspaces are subdivided by a number system (2,3,4): Basic2, Basic3 or Basic4. The numbers 2, 3 and 4 refer to the Jeremy Fave custom brush set you are using. If you have installed Jeremy Faves 2 from this book (or the earlier edition) you will use the workspace Basic2. If you have installed the JeremyOwnFaves3 and JeremyGuestFaves3 brushes from the "Expanding Your Creativity with Jeremy Sutton: The Art of Collage Portraiture" DVD set then you will use workspace Basic3. If you have installed the JeremyOwnFaves4 and JeremyGuestFaves4 brushes from my "How to Paint from Photographs using Corel Painter X: Creative Techniques with Jeremy Sutton" DVD set then you will use workspace Basic4.

To determine your screen resolution on a Mac locate the screen icon on the Finder top menu bar, or choose the blue apple menu > System Preferences > Displays (Figure 1.30). On a PC choose Start > Control Panel > Display > Display Properties > Settings (Figure 1.31).

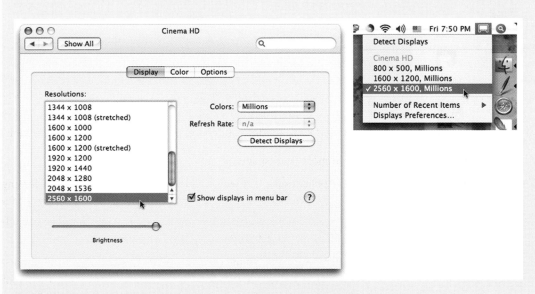

Figure 1.30 Determining your screen resolution on a Mac.

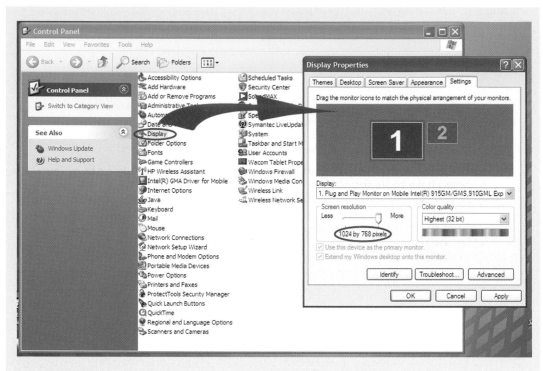

Figure 1.31 Determining your screen resolution on a PC.

Note that you can always return to the factory default workspace by selecting Window > Workspace > Default. You can also import other people's workspace. The Corel Painter X CD comes with a folder of Custom Workspaces containing workspaces made by Cher Threinen-Pendarvis, author of the Painter WOW series of books and creator of the many brushes in Painter, and John Derry, who joined Painter co-creators Mark Zimmer and Tom Hedges in the early days and helped make Painter what it is today and who kindly wrote the Foreword to this book.

Save Your Document

1 Choose File > Save As (Cmd-Shift-S/Ctrl-Shift-S). If you have programmed this command short-cut into your Wacom Tablet right hand Touch Strip you could try it out now, or you could choose the Save As button on the JeremySupaDoopa custom palette.

2 Name the file "abstract-01-blank". This P-V-N (Project-Version-Notes) file naming format, with a short, consistent project name immediately followed by a two digital version number followed by notes, is a useful way to organize your files (see sidebar "The Importance of the P-V-N File

Naming Convention"). They will line up in chronological order and you can immediately tell what brush you used, etc.

The Importance of the P-V-N File Naming Convention

The P-V-N (Project-Version-Notes) file naming convention is based on over 15 years experience of saving tens of thousands of image files. It may seem a trivial part of this book but it has a significant impact on your creative workflow. The key concepts are:

- *Compactness*: Keep your project name as short as possible, preferably eight or less characters, so you have room for notes.
- *Consistency*: Always make sure the project name is exactly the same at the beginning of the file name (get rid of "Clone of" and any spaces before the name) and make sure a sequential two digit version number (01, 02, 03 and so on) always follows immediately after the project name (separated by a hyphen for readability) before you add any notes.
- *Meaningfulness*: Add notes at the end of the file name that help you understand and recall your process. If making a note of the last brush variant you used, abbreviate the brush name, for example "dofc" to indicate JeremyFaves2 > Den's Oil Funky Chunky. Iterative Save automatically adds a sequential version number to the end of the file name and doesn't give you the opportunity to add notes. For that reason I generally recommend using Save As over Iterative Save.

In a reflection of how important I consider this, you will find reminders about regularly using Save As and sticking with the P-V-N naming convention sprinkled throughout the book.

1 Ensure the file format is RIFF, which stands for Raster Image File Format and is the native format of Painter and is the safest format since it preserves all edibility, including the Watercolor, Liquid Ink, Digital Water Color and Impasto brushes and the Dynamic Plug-In layers. A RIFF file can only be opened in Painter. I recommend you back up your files in TIFF format (for flat files) or Photoshop format (for layered files) before closing Painter.

2 Make sure Uncompressed is checked and File Extension is set to Append (this can be set automatically in the Preferences > Save and is the default in the Jeremy workspaces).

3 For "Where" select your PXC Projects folder (on the Mac, if you don't see the file browser window, click on the small downward facing triangle to the right of the file name) and generate a project folder titled "01 Abstract" within the Painter X Creativity Projects folder (Figure 1.32).

4 Click Save and save the file into the 01 Abstract folder.

5 Choose Window > Screen Mode Toggle (Cmd-M/Ctrl-M).

6 Hold the Space bar down (or press the Space bar shortcut on your Wacom Tablet ExpressKeys) while dragging with your cursor on the canvas to move it towards upper left of your screen.

7 Choose Window > Zoom In (Cmd+/Ctrl+) or Zoom Out (Cmd-/Ctrl-) if needed. Initially I like to see the edge of any canvas I am working on.

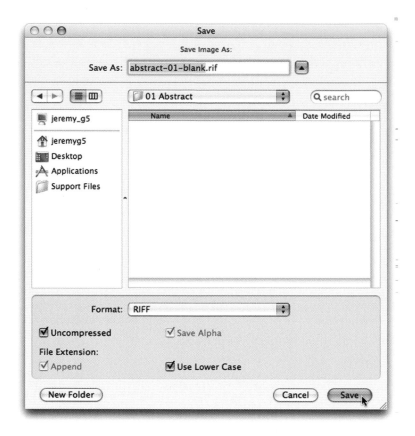

Figure 1.32 Save As dialog Window.

Use the same file saving protocol described here for all projects throughout the book.

Let's return to exploring the Welcome book. To bring the Welcome book back choose Help > Welcome. Click on the second tab down to access an art gallery showcasing Painter artwork. The artwork changes every time you click on the second tab. The third tab down gives you access a variety of online resources.

Color Management

Painter's Color Management controls can help you maximize the consistency and control of the colors you see on your screen when painting in Painter compared with the colors you see in the same image when displayed in Adobe Photoshop or when printed out. This is not an exact science and no matter what color management you use I recommend always making a proof print. The Welcome book's fourth tab provides links to setting up Color Management and to a Color Management tutorial. You can also access the Color Management Window through Canvas > Color Management.

The settings that work for me are to set the central Internal RGB icon (i.e., the Painter color space) to be Adobe RGB (1998), link it to the Monitor icon; set the Monitor to be consistent with the display I am using, activate the Import/Export links in the upper left of the Color Management Window and set these to recognize and assign preset ICC or other profiles and set the printer to have the profile of the canvas I use (Figure 1.33).

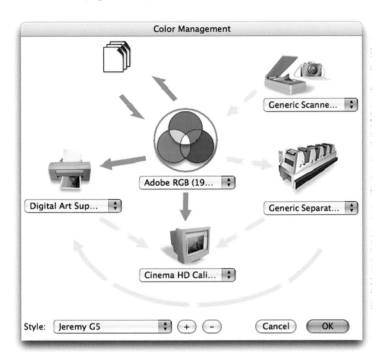

Figure 1.33 Color Management—example of my settings.

You can save your custom settings as a Style by clicking on the "+" symbol at the bottom of the Color Management Window.

In the remainder of the Welcome Book you will find a link for setting up Brush Tracking, which we will address shortly when going through the Preferences, an acknowledgments list, and links for updates and Quick Tips. If you don't wish to see the Welcome book every time you start Painter then uncheck the "Show this dialog at startup" check box at the bottom of page four. Close the Welcome book by clicking the close button in the top right corner of the book.

The Painter X Interface

Corel Painter X Help

Choose Help > Corel Painter X Help (Cmd-?/Ctrl-?). This accesses the Corel Painter X Help, an immensely valuable resource. It is a localized (i.e., not dependent on an Internet connection)

comprehensive user manual with advanced search features and containing the equivalent of over 700 pages of information (significantly more than the 331 pages of the paper User Guide). If you wish to have any feature or menu item in Painter explained look it up here first. Take some time to explore Corel Painter X Help. As a test type in "Toolbox" and select "The Toolbox" option. Scroll down and you'll see a complete summary of every tool in the Toolbox (Figure 1.34). In the future whenever you come across a technical issue in Painter look up the topic in the Corel Painter X Help.

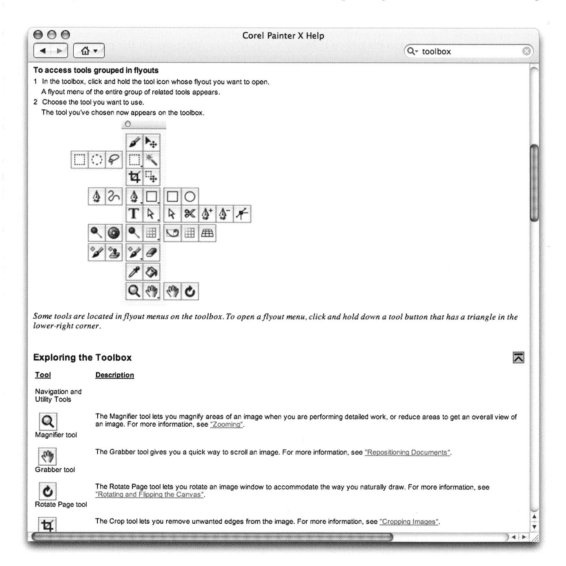

Figure 1.34 Corel Painter X Help.

Help > Tech Support refers you to your closest source of technical support. Help > Tutorials and The Corel Classroom both need an Internet connection to work.

Palette Overview

The arrangement of palettes (Figure 1.35) you now see on your Painter desktop will depend on what workspace you last imported and any changes you have subsequently made to that workspace. Generally, moving clockwise from left to right, you will see the Toolbox (which includes the tools, the color swatches and six selectors), the Property Bar (which changes to suit each tool or, in the case of the Brush Tool, each brush variant), the Brush Selector Palette, the Color Palette (with the Mixer and Color Sets palettes, and Color Variability palette in the Jeremy workspace palette arrangements) and the Layers Palette (with Channels palette). These palettes are a subset of all the palettes that exist in Painter. Look under the Window menu and wherever you see the word "Show ..." that indicates a palette that is available but not displayed on your Painter desktop. When a palette is already displayed you will see the word "Hide ...". To hide a palette click on the close box, a square with an "X" inside, located in the right of the palette bar (the dark gray title bar at the top of each palette).

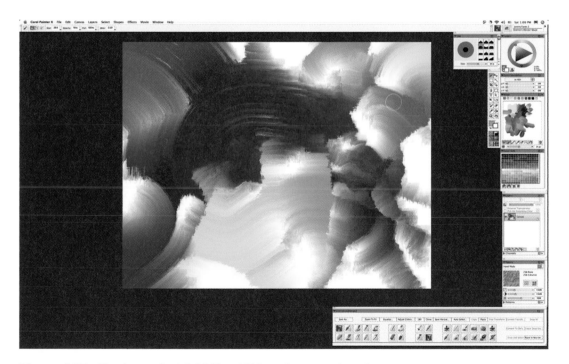

Figure 1.35 The JeremyBasic2-2560 × 1600 workspace palette layout.

There are small solid black triangles in the left and right most palette bars. The triangles on the left (palette arrows), and the palette titles themselves, toggle between expanding the palettes (palette arrow pointed down) and minimizing the palettes (palette arrow pointing to the right). The small triangles in the top right corners (palette menu arrows) give access to the palette menus (Figure 1.36). Click on different triangles and observe the results.

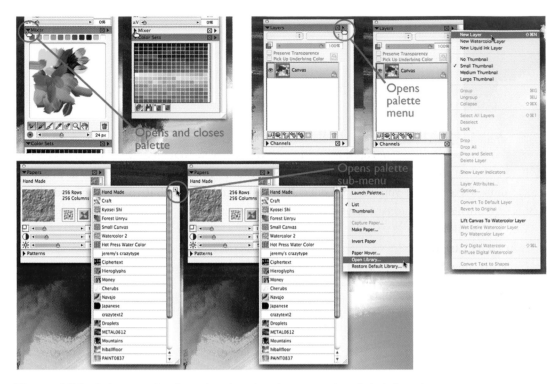

Figure 1.36 Palette navigation triangles, showing examples of their functions.

To move a whole set of palettes in unison, such as all the Color palettes, click and drag on the upper most light gray bar at the top of the set of palettes (above the top-most title bar). To move an individual palette up or down within a set of palettes, or to move an individual palette out of a set or into another set, click and drag on the middle section of the palette title bar (between the palette title and the close box).

Brushes—The Heart & Soul of Painter

In 1991 Mark Zimmer and Tom Hedges launched Fractal Design Painter. This revolutionary new art medium utilized proprietary Natural-Media technology, which enabled artists, animators and graphics professionals to closely simulate the techniques and look of traditional art media while offering innovative effects and productivity advantages made possible by digital media. Fifteen years later the core of Painter's strength is still its incredible brushes. The brushes are the heart and soul of the program. For convenience the multitude of wonderful brushes have been divided into groups, or categories, of related brushes. The categories are contained in a default brush library (the Painter Brushes library, contained in the Painter Brushes folder, located inside the Brushes folder in the Corel Painter X application folder). Within each category are the individual brushes, known as variants. Painter X comes installed with over 800 variants divided into 36 categories (before you add the extra brushes

that come with this book). Understanding the brush library > category > variant hierarchy allows you to easily find the brushes you are seeking (Figure 1.37). In the Brush Selector palette you will see two icons that access the category and variant lists.

1 Click on the left icon in the Brush Selector palette. The category pop-up menu will appear, listing all the categories in the brush library.

2 Check that the Jeremy Faves 2 category (or JeremyGuestfaves 3 and JeremyOwnFaves 3 categories if you installed them instead) appears in the category list. Note that all new brush categories will first appear at the bottom of the category list in Painter X (not in alphabetical order as in earlier versions of Painter). If you run into difficulties first double-check that you have copied all the appropriate files into the right locations. If Painter was open when you copied the categories into your application folder then select Load Brush Library from the Brush Selector palette pop-up menu (black triangle on upper right). You'll see the Painter Brushes library highlighted. Choose Load. Any new brush categories will now appear.

3 Choose the RealBristle category.

4 Click on the right icon and a variant pop-up menu will appear, listing all the brush variants in the category.

5 Select the Real Fan Soft variant. If you have the Wacom 6D Art Pen, note the way your brush stroke reacts to the pen pressure, rotation and tilt.

6 Click on the left icon in the Brush Selector palette and choose the Artists category.

7 Click on the right icon and choose the Sargent Brush variant. With either the Wacom 6D Art Pen or the Grip Pen make, on your out-breath, a large circular brush stroke on your canvas, starting with light pressure and progressively increasing pressure throughout the stroke. Notice how you can control the brush size through variation of pressure. The degree of control you have will depend on how sensitive Painter is to the pressure you apply. Initially you may find the stroke abruptly jumps from narrow to thick.

Brush Tracking

1 Choose Corel Painter X > Preferences > Brush Tracking (Mac) or Edit > Preferences > Brush Tracking (PC).

2 Make a single light stroke in the Brush Tracking scratch pad.

3 Click OK.

4 Try making another circular brush stroke with progressively increasing pressure and see if you now have more control, with a smoother transition from think to thick (Figure 1.38).

5 Repeat the Brush Tracking until you are satisfied.

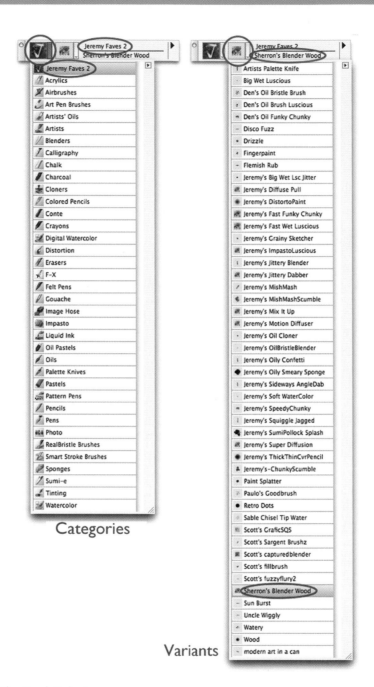

Categories

Variants

Figure 1.37 The Brush Selector.

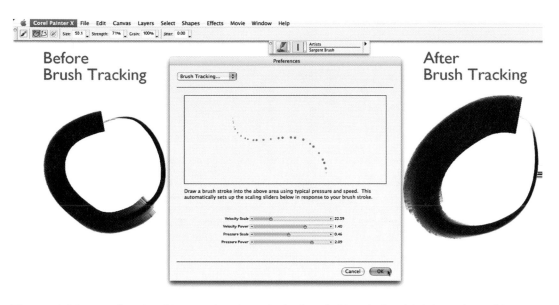

Figure 1.38 A soft to hard Sargent brush stroke before (left) and after (right) Brush Tracking.

Before we go further ...

The customized Jeremy workspaces automatically accomplish almost all the set up procedures that are outlined in the remaining section of this chapter. The beauty of the workspaces is that once you have imported them you are immediately ready for action! I include the detailed instructions (below) for the manual set up of the Painter preferences and the creation of custom palettes since you may wish to tweak the preferences (such as changing the brush ghost options) and alter the custom palettes (such as adding your own favorite brushes or commands) to suit your own workflow. These set up instructions are also outlined in my DVD "Learning Corel Painter X with Jeremy Sutton".

I recommend you skim through the rest of this chapter but not worry, at least on the first read through, about following all the steps.

Brush Size

You have experienced the control of brush size through pressure, which applies to many of the brushes. Another way to vary brush size is by adjusting the size slider in the Property Bar or the Size palette (already showing in the Jeremy workspaces). The Size palette Brush Dab Preview Window has two modes, one that shows you the maximum and minimum diameters (with gray and black circles) and one that shows the brush shape and scale (Figure 1.39).

Clicking on the preview toggles between these two modes. I keep my Size palette on the diameter preview mode. If the Size palette isn't showing on your Painter desktop here are the instructions for setting it up (together with moving the Color Variability palette to beneath the Colors palette, which is also included in all Jeremy workspaces).

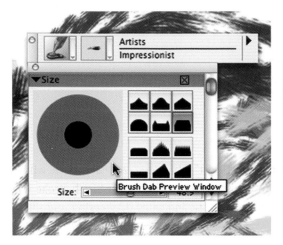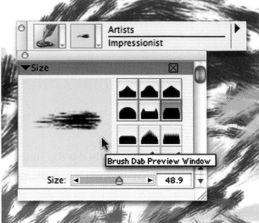

Figure 1.39 The Size palette Brush Dab Preview Window.

1 Choose Window > Brush Controls > Show Size. You will see an open Size palette amongst a long set of Brush Controls palettes. Don't be intimidated by the large number of palettes—we'll be hiding most of them out of sight.

2 Click and drag the Size palette title bar and place it just above the General title bar at the top of the Brush Controls palettes. If you inadvertently drag the Size palette out of the Brush Controls palettes you can just drag it back in again.

3 Locate the Color Variability palette (three from the bottom of the Brush Controls palettes of which the Size palette is part).

4 Click on middle of the Color Variability palette bar, to the right of where the title is written and to the left of the close box. Drag this palette between the Color and Mixer Pad palettes. This brings all the main Color palettes together.

5 If you minimized the brush Size palette click on the left palette arrow in the Size palette bar and open it again.

6 Drag the lower right corner of the Brush Controls palettes upwards until you just see the size slider and preview.

7 Grab the light gray title bar at the top of the Brush Controls palettes and drag the Brush Size palette into the lower right corner of your screen. This palette now gives you a convenient graphic indication of brush size at any time.

8 Change the brush size slider in the Brush Size palette and make a brush stroke.

9 Hold down the key combination Option-Cmd/Ctrl-Alt and click and drag in your canvas. As you drag your cursor you'll see a circle that represents your brush size. When you lift your pen from the tablet the brush size will be whatever the circle diameter was at that moment. This is the shortcut for changing brush size "on the fly" as you paint. If you programmed the shortcut into your Wacom Tablet ExpressKeys try it out at this time.

Brush Cursor Options

There are three ways that your brush cursor can be represented on your canvas (Figure 1.40). Choosing between these is a matter of personal preference. I recommend you initially try them all out. If you're not sure which to use, then stick with the default Enhanced Brush Ghost. I personally like to see exactly where my brush stroke is starting, so I use either the Enhanced Brush Ghost or the Drawing Cursor.

Enhanced Brush Ghost

The default representation method is the "Enhanced Brush Ghost" which depicts a faint circle whose diameter indicates the maximum brush diameter and whose center is where your brush stroke will begin. There is a "stick" that pivots in the center of the circle and indicates the bearing and tilt of your pen. If you are using the 6D Art Pen then you will also see a small dot on the diameter circle that indicates rotation.

Enable Brush Ghosting

1 Choose Corel Painter X (Mac) or Edit (PC) > Preferences > General (Cmd-K/Ctrl-K).

2 Uncheck the "Enhanced Brush Ghost" checkbox, leaving the "Enable Brush Ghosting" checkbox checked.

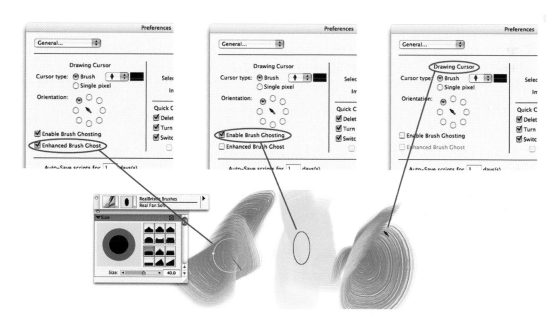

Figure 1.40 The three cursor options (left to right): Enhanced Brush Ghost, Enable Brush Ghosting, Drawing Cursor.

3 Click OK. Note that now when you paint with the Artists > Sargent Brush you'll see a vertical rectangle shape until you start your brush stroke at which time the brush tip position is represented by the Drawing Cursor.

4 Change the brush variant from Artists > Sargent Brush to Artists > Impressionist. Note the different shape of the brush ghost.

5 Change brush size (using the size slider or the shortcut) and observe how the brush ghost reflects the new size.

Drawing Cursor

1 Choose Corel Painter X (Mac) or Edit (PC) > Preferences > General (Cmd-K/Ctrl-K).

2 Uncheck the "Enable Brush Ghosting" checkbox. Set the Drawing Cursor (represented by a small brush symbol or by other options accessible in the cursor pop-up menu) direction to suit your handedness (towards upper left if you are right-handed and towards upper right if you are left-handed).

3 Click OK. This representation doesn't change with brush size or shape, and remains the same before, during and after the making of a brush stroke.

Other General Preferences Options

1 Choose Corel Painter X (Mac) or Edit (PC) > Preferences > General (Cmd-K/Ctrl-K).

2 Set Units to be inches if you prefer to define your new canvas sizes in inches and resolution rather than pixels.

3 Check "Draw Zoomed-out Views Using Area-Averaging" for faster screen draw.

4 Check "Display Warning When Drawing Outside Selection" since that it is a useful reminder on the occasions you overlook to deselect a selection.

Customize Keys Preferences

Corel Painter has pre-assigned keyboard shortcuts for most commands, tools, menu bar and palette menu items in the program. In the Customize Keys preference you can view the pre-assigned shortcuts and modify them if you wish, creating your own customized key sets. I recommend two modifications to the default shortcuts that avoid accidentally choosing the Brush Line command or Scissors tool when pasting or undoing.

1 If you are in the General Preferences Window choose Customize Keys from the Preferences pop-up menu. Otherwise choose Corel Painter X (Mac) or Edit (PC) > Preferences > Customize Keys.

2 Choose Shortcuts: Tools.

3 Click on the application command Brush Line which highlights the shortcut "V".

4 Choose Shift-V on your keyboard. This resets the default shortcut.

5 Scroll down to application command Scissors which highlights the shortcut "Z".

6 Choose Shift-Z on your keyboard. This resets the default shortcut.

Save Preferences

1 If you are in the Customize Keys Preferences Window choose Save from the Preferences pop-up menu. Otherwise choose Corel Painter X (Mac) or Edit (PC) > Preferences > Save.

2 Leave Create Backup on Save checked, which ensures that whenever you do a Save (Cmd-S/Ctrl-S), Painter will automatically save a backup file, with file name ending with_bak, of the last saved version of that file.

3 If you are on a Mac computer, under File Extension, choose from the Append drop down menu Append: Always.

4 On either Mac or PC change the Color Space preferences to RGB for both TFF and PSD (Figure 1.41).

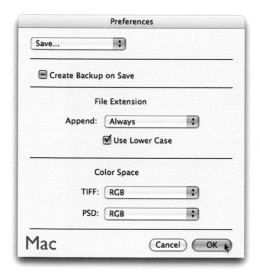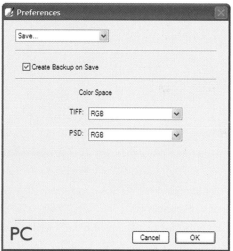

Figure 1.41 The Save Preference settings.

Window Background Color

1 If you are in the Save Preferences Window choose Palettes and UI from the Preferences pop-up menu. Otherwise choose Corel Painter X (Mac) or Edit (PC) > Preferences > Palettes and UI.

2 In your Color Palette select a color you'd like to use for your Window background color (i.e., the color which surrounds your canvas when you are in screen mode). The default is a neutral

mid-gray. For presenting work I often change this to a charcoal gray. If you wish to stay with the mid-gray just ignore the following step and choose OK.

3 In the Palettes and UI Window click on Window background: Use Current Color.

4 Choose OK.

Color Palettes

In the Jeremy workspaces I have grouped together the four palettes I find most useful for choosing and controlling paint color: Colors, Color Variability, Mixer and Color Sets.

In addition to these four palettes there are numerous effects within Painter that can be used to manipulate, transform and adjust colors in an image, for instance the many Effects palettes (Effects > Tonal Control and Effects > Surface Control menus) and the Underpainting palette (Window > Show Underpainting). We will look at some of those color manipulation effects in subsequent chapters. For now we will concentrate on the four palettes listed above and review how to use each one in turn to choose and control paint color.

Colors Palette

Color can be defined in a number of ways such as by combinations of three primary colors (which are red, green and blue when viewing an image within Painter) or by combinations of hue (the named color), saturation (the purity or intensity of color) and value (the lightness or darkness of color). The Colors palette is set up to allow you to easily choose the hue (moving the cursor on the Hue Ring), the saturation (varying the second cursor horizontally across the Saturation/Value Triangle) and the value (varying the second cursor vertically up and down the Saturation/Value Triangle). If your Saturation/Value Triangle cursor is in either the top left corner (pure white) or bottom left corner (pure black) then it doesn't make any difference what hue you pick. The combination of Hue Ring and Saturation/Value Triangle offers an intuitive way to pick color with a built in color wheel that is handy for applying color schemes such as juxtaposing complementary colors (colors from opposite sides of the color wheel that add vibrancy to a painting when placed next to each other).

The tricky part of the Colors palette (Figure 1.42) are the two overlapping Additional and Main Color squares. Though they resemble the Background and Foreground color swatches in Adobe Photoshop their functions are quite different. Most brushes that paint color (as opposed to those that blend, move or distort color already on the canvas) will paint with the currently selected Main Color unless they are cloning and are using a clone source as a means of determining color. The Cloners category of brushes are preset to use clone color. Any brush can be turned into a cloner brush by clicking on the Clone Color icon, the one that looks like a rubber stamp, or by using the keyboard shortcut "u". When the Clone Color icon is active the Hue Ring and Saturation/Value Triangle are inactive and usually grayed out.

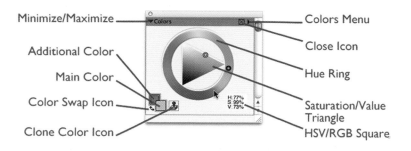

Figure 1.42 The Colors Palette.

I recommend that you always make sure the Main Color, the square that is in front, is the active square. Do this by clicking on the Main Color square. Nothing indicates that it is active except that you'll notice that it changes color as you change color in the Hue Ring and the Saturation/Value Triangle. The Additional Color square has a bold black outline when active.

The Additional Color square is useful when you wish to go between two colors, such as black and white when painting into a layer mask, or when using one of the few brushes that use both Additional and Main Color (such as F-X > Gradient Flat Brush 20 and Gradient String, Pens > Grad Pen and Grad Repeat Pen), when applying the Two-Tone Gradient and when painting with the Image Hose brushes with reduced Grain. I generally make use of the Color Swap Icon to swap the Main and Additional Colors (or use the keyboard shortcut Shift-X).

Color Variability Palette

This small but powerful palette includes three sliders that propel any brush from painting a uniform color within the brush stroke to painting a mixture of color that varies in hue, saturation and value as the brush stroke progresses, depending on the variability slider settings. Choose any brush that paints color. Adjust the HSV sliders in the Color Variability and observe their effect.

Mixer Palette

The Mixer palette offers the closest parallel to the traditional painter's palette. Using its own separate set of tools, you can paint any colors you wish onto the Mixer Pad, choosing colors from the Mixer Colors, a collection of color swatches across the top of the palette, or from the Colors or Color Sets palettes, or from using the Toolbox palette Dropper tool in the active image. You can use the Mixer Palette Knife tool to mix and blend colors in the Mixer Pad and then use the Mixer Palette Dropper tool to select the main Color from the Mixer Pad. One of the most astounding features of this Mixer Palette is when you use the Mixer Palette's Sample Multiple Colors Dropper Tool in combination with

certain brushes. For instance:

1 Choose the Gouache > Fine Bristle 30. Choose the Sample Multiple Colors Dropper Tool (the icon looks like a Dropper Tool with a circle at the bottom).

2 Set the Mixer Palette Brush Size slider to the right. This increases the area in the Mixer Pad from which multiple colors will be selected.

3 Click in the Mixer Pad in a region where you wish to select multiple colors.

4 Now paint on your canvas and you will see how multiple colors are distributed across the brush stroke (Figure 1.43), just as you would expect as if a brush was loaded with multiple colors.

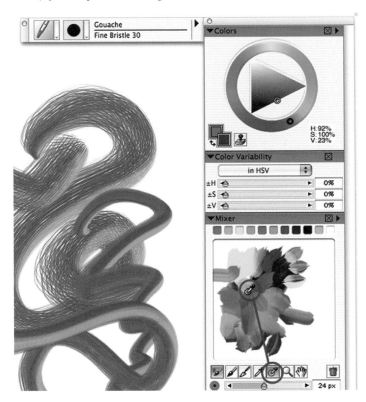

Figure 1.43 Apply the Sample Multiple Colors Dropper Tool.

The Sample Multiple Colors Dropper Tool only works with certain brushes. It does not affect the Main Color. Brushes that work with the Multiple Colors Dropper Tool include:

- Acrylics > Thick Acrylic Bristles, Flats and Rounds.
- Art Pen Brushes > Soft Flat Oils, Tapered Camel and Gouache.
- Artists' Oils > almost all.
- Gouache > Detail and Flat Opaques, Fine Bristles and Rounds, Thick and Wet Gouaches.
- Impasto > Opaque Bristle Spray, Opaque Flat and Opaque Round, and all the Smeary brushes.

- Oils > Bristle Oils, Fine Camel, Flat Oil, Glazing Flat, Round Camel Hair, Smearys and Thick Oils.

- RealBristle Brushes > almost all except blenders.

- Smart Stroke brushes > Gouaches when not cloning.

Once you have created a mix of colors you like in the Mixer Pad you can save the Mixer Pad by choosing Save Mixer Pad in the Mixer pop-up menu. You clear your Mixer Pad by choosing Clear Mixer Pad from the same menu.

Color Sets Palette

Color sets allow you to conveniently access a particular range of colors and easily pick those colors just by clicking on the color squares. They are ideal for keeping consistency of colors throughout a project or expanding your use of colors to include those you may not otherwise choose. They are intuitive and simple to use since you see a small swatch of the color you are picking and you don't need to mix or create the colors. There are many different color sets supplied with Painter (and on the PXC Resource Disc at the back of this book). It is easy to create your own custom color sets from existing imagery or the Mixer Pad.

The factory default color set is the Artists Oils Colors which you will find in the Corel Painter X > Support Files > Color Sets. It is based on traditional oil paint colors. In the default workspace you'll see the name of each color listed beside each color swatch. You can turn off the name display by opening the Color Sets pop-up menu (click on small solid black triangle in upper right of palette) and unchecking Display Names. You can also customize the color swatch size by choosing Swatch Size > Customize from the Color Sets pop-up menu and adjusted the swatch height and width for optimum viewing. In the Jeremy workspaces I have set up a custom color set Jeremy Color Sets > Peggy's Color Palette (Figure 1.44). This color set is based on the traditional color palette of artist Peggy Gyulai.

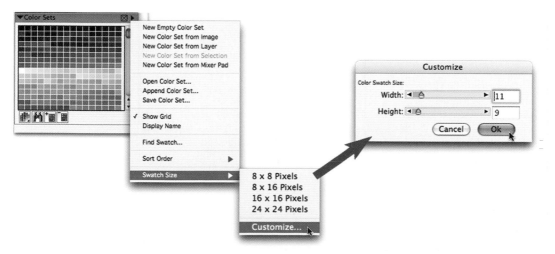

Figure 1.44 The Color Sets palette, with Peggy's Color Palette open, and showing the pop-up menu and the customize color swatch size window.

To access other color sets:

1 Choose Open Color Set from the pop-up menu.

2 Locate the Color Sets folder in the Corel Painter X > Support Files > Color Sets (where you'll find the default Artists Oils Colors color set if you wish to return to it later) or Jeremy Color Sets (where you'll find color sets I have made from historic master paintings).

3 Select a color set from those listed within the folder.

4 Choose Open. The selected color set now appears in the Color Sets palette.

You can edit any color set, adding or taking away colors, at any time from within the Color Sets palette. Adding colors to a color set as you work can be useful in building up a color set of your favorite colors over time.

It can be valuable to emulate, or limit yourself to, the color palette of an artist. Color sets make it easy to do this.

1 Open an image whose colors you wish to capture in a custom color set.

2 Select "New Color Set from Image" (Figure 1.45) from the lower left hand icon pop-up menu in the Color Sets palette. This will automatically generate a custom color set based on the colors in the current active image.

3 Choose Save Color Set (Figure 1.46) from the same pop up menu.

I have captured color sets from a number of Master paintings and have included these in the PXC Resource Disc > Jeremy Extras > Jeremy Goodies > Jeremy Color Sets.

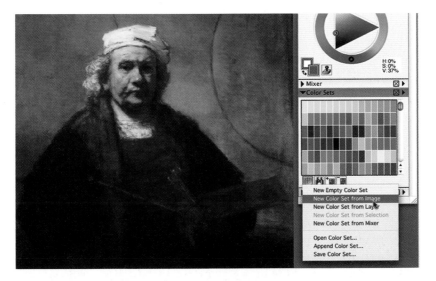

Figure 1.45 Generating a color set from a 1661 Self-Portrait by Rembrandt van Rijn.

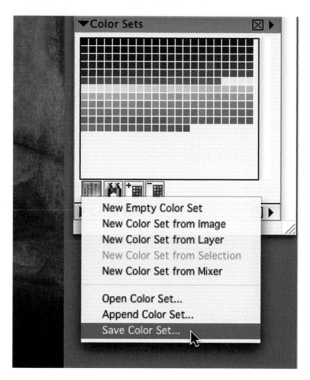

Figure 1.46 Saving the Rembrandt color set.

You can also generate a color set from your current Mixer Pad by choosing New Color Set from Mixer Pad. After creating a custom color set choose Save Color set, give it a suitable name and save it in the Color Sets folder (or any other location).

Challenge yourself by working with colors that you may not usually choose. For instance I chose a subdued browns and yellows color set whereas I typically work with intense bright blues, purples, yellows, teals and reds.

Custom Palettes

Custom palettes are a great aid to efficient workflow. Painter offers you the ability to easily create, edit, export and import custom palettes containing convenient shortcuts for menu commands and brush variants. Besides being more efficient than navigating through drop-down menus, custom palettes are also a great way to optimize your workflow by grouping frequently used sequences of command and brush shortcuts next to one another. I have found that my JeremySupaDoopa custom palettes (Figure 1.47), that contain shortcuts for many of my most frequently used commands and brushes, have significantly enhanced my Painter workflow, providing much of what I need at my

fingertips without cluttering my desktop. The JeremySupaDoopa custom palettes are included as part of the Jeremy workspaces and are automatically imported when you import the workspaces.

Within my JeremySupaDoopa custom palettes, I have grouped the commands into, on the left, those most related to photo transformation and painting and, on the right, those most related to collage and layers. I have grouped the brush variant shortcuts into (from left to right):

1 Big bold brushes (great for "muck up" underpainting).

2 Fine bristly brushes (great for finer details and softer effects).

3 Chalky brushes (great for bringing out paper texture and for pastel effects).

4 Sketching brushes (great for finer line work and contour drawing).

5 Modifying brushes (great for distorting, diffusing, lightening and adding washes).

6 Other brushes (an impasto bristly brush, the image hose, soft cloner for photo painting and an airbrush for working into the layer mask).

Figure 1.47 The Jeremy SupaDoopa2 custom palette.

As with the Jeremy workspaces, I have made three versions of my custom palette: JeremySupaDoopa2, JeremySupaDoopa3 and JeremySupaDoopa4. If you have installed Jeremy Faves 2 from this book (or the earlier edition) you will use JeremySupaDoopa2. If you have installed the JeremyOwnFaves3 and JeremyGuestFaves3 brushes from the "Expanding Your Creativity with Jeremy Sutton: The Art of Collage Portraiture" DVD set then you will use JeremySupaDoopa3. If you have installed the JeremyOwnFaves4 and JeremyGuestFaves4 brushes from the "How to Paint from Photographs using Corel Painter X: Creative Techniques with Jeremy Sutton" DVD set then you will use JeremySupaDoopa4.

I explain here (i) how to manually import the JeremySupaDoopa custom palette separately from importing a workspace and (ii) how to make your own shortcuts custom palette or edit an existing one.

1 Choose Window > Custom Palette > Organize.

2 Choose Import.

3 Locate the appropriate custom palette. As per the instructions earlier, you should find this in (Mac) Applications > Corel Painter X > Support Files > Jeremy Custom Palettes, or (PC) Local Disc C > Program Files > Corel > Corel Painter X > Support Files > Jeremy Custom Palettes.

4 Click on the appropriate JeremySupaDoopa palette.

5 Choose Open. You should now see the custom palette appear on your Painter desktop. You will probably need to drag the bottom right corner out to see all the shortcuts in the custom palette. When fully extended with all the shortcuts showing the JeremySupaDoopa2 and JeremySupaDoopa3 custom palettes are approximately 1024 pixels wide.

6 Position the JeremySupaDoopa custom palette along the bottom of your desktop, hiding some of it out of sight if you find it is taking up too much room.

7 To activate any command shortcut in the custom palette just click once on the button. Try clicking on the Save As button. Save your current file with the next version number (e.g., abstract-02.rif).

8 To choose any brush variant from the shortcut icons in the custom palette just click on the icon and the variant it is a shortcut for will become the current variant. Try a few of the brush variant shortcuts.

Make Your Own Custom Palette

1 Choose Window > Custom Palette > Add Command (Figure 1.48).

2 Choose File > Save As.

3 Choose OK. You will see a new custom palette appear containing just a Save As button. The custom palette title will be something generic like Custom 1.

4 Choose Window > Custom Palette > Organizer.

5 Click on the name of the custom palette corresponding to the one you have just created.

6 Choose Rename.

7 Rename the custom palette with a meaningful name such as "basic Shortcuts" (you can always rename it again later).

8 If you see other custom palettes that you wish to delete select them all (if there are more than one custom palettes you wish to delete, hold down the Cmd/Ctrl key as you click on each custom palette name in the list to select them individually, or click on one and hold the Shift key down as you click on another to select a block of names). Then choose Delete.

9 Choose Done.

10 Choose Window > Custom Palette > Add Command.

11 Choose your custom palette name from the Add To: pop-up menu.

12 Choose File > Clone.

13 Choose OK. You'll now see a Clone button added to your custom palette.

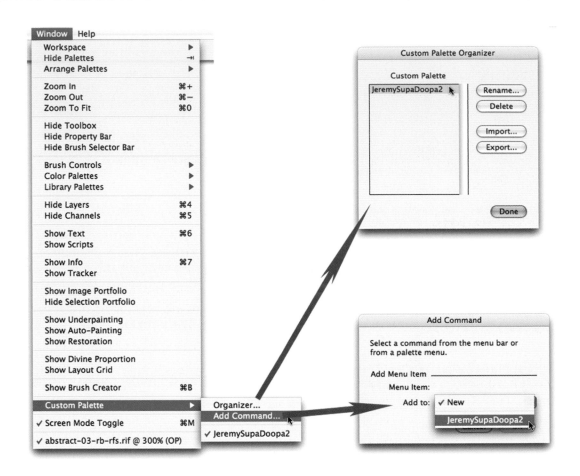

Figure 1.48 The basic steps of making and organizing your custom palettes.

14 Repeat steps 10 through 13 for all the other menu command shortcuts you wish to add to your custom palette. You can make shortcuts for almost any menu command anywhere in Painter.

15 Choose a favorite brush in the Brush Selector palette, such as Artists > Sargent.

16 Drag either the category or variant icon from the Brush Selector palette into your custom palette. You will see the category icon appear in the custom palette as a shortcut to the particular variant.

17 You can repeat this for any other variants you like. However if you pick more than one variant from the same category the shortcut icon will look the same and there is no way to tell which shortcut is which other than memorizing the position or trying each one out. That is why I have generally included one variant shortcut per category, or separated variants from the same category, in my JeremySupaDoopa custom palettes.

18 To export your custom palette choose Window > Custom Palette > Organizer.

19 Select the custom palette you wish to export (click on its name in the custom palette list so it is highlighted).

20 Choose Export.

21 Choose where you will save the custom palette.

22 Name the export file (I suggest using the same name as the custom palette).

23 Choose Save. Your export is now complete. If you are on a Mac and you wish to share the custom palette with a PC machine you will need to find the file on your hard drive and add the file tag ".pal".

Tracker Palette

Choose Window > Show Tracker. You'll see a list of brush stroke dabs you have used in Painter. Resize the palette by dragging in the bottom right corner. Choose List from the Tracker pop-up menu (top right corner of the Tracker palette) so you see the names of the variants listed. Each time you use a new brush, the variant is saved on the Tracker palette, up to a maximum of 25 variants. You can return to a brush variant you like by choosing it from the Tracker palette. You can lock your favorite variants so that they are always at the top of the Tracker palette by selecting the variant in the Tracker and then clicking on the lock icon (lower left). Clicking again on the lock icon will unlock the variant. To clear selected (or all) unlocked brush variants choose Clear Selected (or Clear All) from the Tracker pop-up menu. Brush variants are stored in the Tracker after the document you were working on has been closed and between Corel Painter sessions.

The Tracker is a handy way to keep a temporary record of the variants you use in a session. It is also an alternative way to store and access your favorite brushes. The down side is that it takes up a lot of space in your precious Painter desktop real estate. It can also be slow to load when full of variants. For these reasons I prefer to use the variant shortcuts in my JeremySupaDoopa custom palette. Try it out and decide for yourself if it works for you.

Saving Your Palette Layout

Once you have settled on a palette layout you can save it:

1 Choose Window > Arrange Palettes > Save Layout.

2 Name your layout.

3 Click OK. You will now see your saved layout listed under the Window > Arrange Palettes menu (Figure 1.49), unless there are already 16 palette layouts which is the maximum. If you reach the maximum you will need to choose Window > Arrange Palettes > Delete Layout and delete some of the layouts.

You can save numerous different layouts for different tasks. I have included some layouts that I use in the Jeremy workspaces, some specifically designed for different screen resolutions. Palette layouts

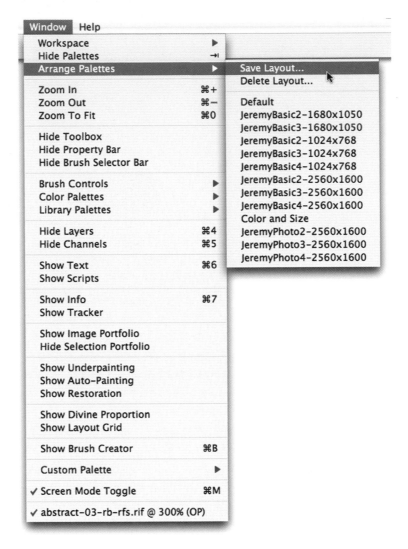

Figure 1.49 Saving the current palette layout.

are a powerful tool for efficient workflow. One of the benefits of saving palette layouts is that they always remain exactly as you saved them.

The palette layout associated with the current workspace changes as you move palettes around. To return to the original layout associated with a workspace you will need to re-import it (Window > Workspace > Import Workspace).

Choose Shift-Cmd-S/Shift-Ctrl-S (File > Save As) and save this image into the 01 Abstract project folder, with the name abstract-xx-chpt1end.rif where xx is the next sequential version number in your on-going Abstract project series. You're going to continue working on it in Chapter 2.

Congratulations! Take a deep breath. You've now got through the set up and preparation and I am sure you're itching to get painting. Well that's exactly what's coming up next ...

2

Exploring Brushes

Figure 2.1 Try out of the brushes included on the JeremySupaDoopa2 custom palette.

Understanding and controlling brushes is fundamental to anything you do in Painter. In this chapter we explore the breadth and variety of brushes, their looks and their behaviors. We review how to control, customize, save, edit and organize brushes.

Visual Glossary

To give you a taste of the amazing diversity of Painter's brushes I have made a series of small paintings, each created using just the variants from one brush category. The pictures are displayed in alphabetical order by category except with Jeremy Faves 2 at the top (as you'll find in the Jeremy workspace brush selector category list). They are a convenient guide to the types of brush strokes you can expect from each category. They are not a substitute for exploring and experimenting with the brushes on your own. You'll be amazed at what gems you discover when you do!

Figure 2.2 Jeremy Faves 2.

Jeremy Faves 2

Some brushes, like the Blenders and Distortion, do not add color to the canvas but move paint already on the canvas. The images for these brushes were created by painting over other paintings.

This is an extra brush category contained on the companion PXC Resource CD at the back of this book (loading instructions in Chapter 1). The brushes in this category are all favorites of mine. They include my pick of the best brushes from earlier versions of Painter (such as the classic Big Wet Luscious) and some custom brushes made by me and by others who have kindly given their permission for me to share their wonderful creations with you (such as the all-time super favorite Den's Oil Funky Chunky, made by Denise Laurent of London, UK).

Figure 2.3 Acrylics.

Acrylics

Brushes with a fine bristle structure. My favorite variants in this category are the Captured Bristle for a tight oil paint look, Glazing Acrylic for subtle colorizing, and Wet Acrylic and Wet Soft Acrylic for a rich bristly oily look.

Figure 2.4 Airbrushes.

Airbrushes

There is a lot of variety within the Airbrushes. I like the Digital Airbrush variant for straightforward soft airbrushing and the Graffiti variant for its tilt-sensitive spray of paint.

Figure 2.5 Art Pen Brushes.

Art Pen Brushes

These brushes are designed to take advantage of the rotational sensitivity of the Wacom 6D Art Pen. There are some wonderful chalky brushes in this category. Try out the Square Grainy Pastel and the Worn Oil Pastel.

Figure 2.6 Artists' Oils.

Artists' Oils

Great brushes that mix in streams of color, pulling from color already on the canvas. My favorite variants are the Oil Palette Knife, Blender Palette Knife and Wet Oily Brush.

Figure 2.7 Artists.

Artists

The Impressionist and Sargent Brush variants are "must try" brushes. The Sargent Brush is one of my all-time favorites.

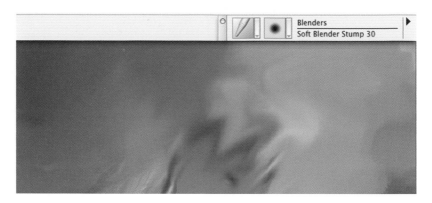

Figure 2.8 Blenders (applied to the Artists painting).

Blenders (applied to the Artists painting)

Great brushes for blending color already on your canvas. My favorite Blenders include Grainy Water and Just Add Water with very low opacity and soft pressure, and Runny and Smear for Luscious oily edges.

Figure 2.9 Calligraphy.

Calligraphy

As the name suggests, some good variants for calligraphic handwriting. Dry Ink is good for a spontaneous Sumi-e style of gesture painting.

Figure 2.10 Chalk.

Chalk

Large Chalk (soft edged) and Square Chalk (harder edged) are my favorite variants. Both good for showing paper texture.

Figure 2.11 Charcoal.

Charcoal

Similar to the Chalks, the Charcoal variant has nice grainy edges.

Figure 2.12 Cloners.

Cloners

All these variants take color from the clone source, which by default is the current pattern (Window < Library Palettes < Show Patterns), or which can be your own photograph. An incredible range of variants from the funky Fiber Cloner and Furry Cloner to the wet Watercolor Run Cloner (watch out—this one creates a watercolor layer) and subtle Soft Cloner.

Figure 2.13 Colored Pencils.

Colored Pencils

Good for simple line work. Most variants are build-up method (except the Cover Color Pencil) meaning they are translucent brushes that show through what's underneath (therefore light colors don't show up on top of dark colors) and they build-up to black, not to a pure saturated color.

Figure 2.14 Conte.

Conte

The Square Conte and Tapered Conte offer very nice grainy effects. Some overlap with Chalks and Charcoals.

Figure 2.15 Crayons.

Crayons

Grainy brushes with heavy build-up to black. My favorite is the Grainy Hard Crayon variant which creates a thick dramatic textured brush stroke.

Figure 2.16 Digital Watercolor.

Digital Watercolor

This is one of those categories you just have to explore. All the variants in this category can produce wonderful effects either on your background canvas or on a regular image layer. Though they do not create a special layer like the Watercolor or Liquid Ink brushes, some Digital Watercolor brushes only effect other Digital Watercolor brushstrokes (for instance, with Salt).

Figure 2.17 Distortion (applied to the Crayons abstract).

Distortion (applied to the Crayons abstract)

Great brushes for distorting, blending and bending what is already on the canvas. My favorites include the classic Distorto (add a little opacity for an interesting oily brush stroke) and Confusion for a watercolor fringing effect. Just experiment with these and have fun!

Figure 2.18 Erasers (applied to the Distortion painting).

Erasers (applied to the Distortion painting)

This category is a mix of various shaped erasers, bleaches and darkeners. I tend to simply paint with white when I need white, rather than use erasers.

Figure 2.19 F-X.

F-X

A bunch of bizarre and wild effects are worth exploring. Where the word Gradient is mentioned in a variant title, such as Gradient Flat Brush, the brush uses two colors (from the regular and additional color swatches of the Colors palette) and alternates between the two dependent on pressure.

Figure 2.20 Felt Pens.

Felt Pens

Bold, dramatic, translucent brushes. Design marker is good for the big lines and Thick and Thin Marker (particularly the largest) better for filling in color.

Figure 2.21 Gouache.

Gouache

Luscious bristly brushes. My favorite variants in this category are the Fine Round Gouache and Wet Gouache Round.

Figure 2.22 Image Hose.

Image Hose

The Image Hose is unlike any other brush. Instead of adding, moving or removing paint from your canvas, the Image Hose is a device for delivering a stream of images. These images are organized in sets called nozzles. The library of nozzles is accessed through the Nozzle Selector in the lower right corner of the Tools palette. The Image Hose variant choices determine the way the images emerge as you paint (size, orientation and placement on the canvas).

Figure 2.23 Impasto.

Impasto

Impasto is a traditional art technique meaning thick paint. The Impasto brushes endeavor to overcome the inherent flatness of a two-dimensional digital image by creating an illusion of depth. The result can sometimes be pleasing, sometimes distracting. Impasto depth, which acts as if it is a separate layer, can be turned on and off via a small purple star "bubble gum" icon on the upper right of the canvas window.

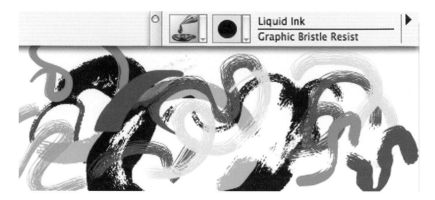

Figure 2.24 Liquid Ink.

Liquid Ink

Liquid Ink brushes paint into a special Liquid Ink layer which is generated automatically when you use one of these brushes (and which you can see in the Layers palette). To use a brush from another category after using a Liquid Ink brush you need to either drop the Liquid Ink layer (flatten your image) or select the Canvas in the Layers palette. These brushes have a nice graphic feel, especially when you apply any of the resists, which give a similar effect to the way waxy crayon resists water-based paints. I like the Smooth Thick Bristle, Graphic Bristle Resist and Soften Edges and Color variants.

Figure 2.25 Oil Pastels.

Oil Pastels

These are wonderful grainy brushes that have a nice way of mixing and blending colors as they paint. My favorite variant in this category is the Variable Oil Pastel.

Figure 2.26 Oils.

Oils

These brushes are close to the Acrylics in look and feel, though I find the Oils somewhat softer. I like the Thick Wet Oils variant for its smoothness and subtle blending and the Glazing Round for its gentle coloring effect.

Figure 2.27 Palette Knives (applies to the Oils painting).

Palette Knives (applies to the Oils painting)

Some different ways to move paint around. The Sharp Triple Knife gives an interesting decorative way to embellish an image.

69

Figure 2.28 Pastels.

Pastels

Very similar to the Chalk, Charcoal and Conte, the Pastels offer some nice variations of grainy brushes such as the Square Hard Pastel and Square X-Soft Pastel.

Figure 2.29 Pattern Pens.

Pattern Pens

Pattern Pens are brushes whose behavior is filtered by the current pattern, some of which spew the pattern out in a continuous stream for the duration of the brush stroke. With the right pattern, or combination of patterns, you can get some great results. My favorite variants in this category are the Pattern Chalk, Pattern Pen Soft Edge and Pattern Pen Transparent.

Figure 2.30 Pencils.

Pencils

Pencils behave rather like thin charcoals or chalks, except that they are build-up method brushes which build up to black rather than cover up with pure saturated color. A couple of Pencil variants I particularly like are the Grainy Variable Pencil and the Greasy Pencil.

Figure 2.31 Pens.

Pens

A wide variety of pen-like mark-making implements. Two of my picks are the Nervous Pen and the Leaky Pen, both aptly named.

Figure 2.32 Photo (applied to the Pens abstract).

Photo (applied to the Pens abstract)

Named because of their application of photographs, the Photo brushes include many variants you may wish to apply to painterly images. I often end a portrait with a little Dodge (lightens highlights) and Burn (darkens shadows). The Diffuse Blur gives a nice oily blending effect.

Figure 2.33 Real Bristle Brushes.

Real Bristle Brushes

These fast responsive brushes make the most of both the Wacom 6D Art Pen rotation and the Mixer Palette Sample Multiple Color Dropper. They incorporate an enhanced brush engine that gives a visceral sense of the bristles as you paint. Real Round and Real Flat Opaque are two of my favorite variants from this category.

Figure 2.34 Smart Stroke Brushes.

Smart Stroke Brushes

These brushes are designed to work as clone brushes on a clone copy of a photograph using Auto-Painting with Smart Stroke Painting and Smart Settings checked. I like combining them in sequence, for instance Acrylics Dry Brush followed by Gouache Thick Flat followed by Pastel Tapered. As the Auto-Painting progresses, the brush strokes get smaller and follow the forms in the image.

Figure 2.35 Sponges.

Sponges

The Sponges, as the name suggests, act like absorbent sponges loaded with paint that you dab on or drag over your canvas. I like the way you can build up overlapping organic structures with varied colors and create an almost Impressionistic visual mixing of color. The variant I use the most is the Sponge variant, though I also like the Glazing Sponge.

Figure 2.36 Sumi-e.

Sumi-e

I have to make an in-book confession here ... I have really neglected these wonderful Sumi-e brushes and now that I've made the effort to explore them, I find I love them! There's something fresh and spontaneous about the way they respond and the brush strokes they make. It's difficult to single any out because they work so well in combination. The Coarse Bristle Sumi-e is good for building up background, Digital Sumi-e adds a thin rake effect and the Thin Bristle Sumi-e adds an interesting flower-like artifact at the ends of each brush stroke.

Figure 2.37 Tinting.

Tinting

A useful collection of brushes for both painting and blending. The Blending Bristle and Bristle Brush are good for brush work, while the Diffuser2 is unbeatable for a rich diffusion of paint into the canvas.

Figure 2.38 Watercolor.

Watercolor

My innate desire to paint portraits finally came through! These Watercolor brushes are designed by artist Cher Threinen-Pendarvis to emulate many characteristics of "real-world" watercolor in the way the paint runs, drips, fringes and diffuses into the paper. Whilst I can't highlight specific favorites, I like the way they work in combination. Like the Liquid Ink brushes, Watercolor brushes paint into a special Watercolor layer which is generated automatically when you use one of these brushes (and which you can see in the Layers palette). To use a brush from another category after using a Watercolor brush you need to either drop the Watercolor layer (flatten your image) or select the Canvas in the Layers palette.

Fearless Exploration!

Having wet your appetite with the visual overview of the diverse range of marks you can make, now is the time for you to get your fingers wet and explore the behavior of all these great brushes. Open the last saved version, abstract-xx-chpt1end.rif, of the canvas that you started painting on in Chapter 1. Start trying out different brush variants on the image, using any colors you wish. Do not use the Undo command. Try out all the brush shortcuts on the JeremySupaDoopa custom palette. Then work your way through all the categories, exploring the variants within each category. For each variant you use, vary the way you apply your brush strokes—soft versus hard pen pressure, slow versus fast brush movement and short dabs versus long strokes. Be fearless and push the limits of each brush. See how each change affects the quality of your marks. Fill your canvas with brush strokes. Once your canvas is full, continue covering brush strokes with other brush strokes. Use this as an opportunity to try out different ways of choosing color: using the Colors palette, the Mixer and Color Sets. You will come across brushes that don't behave as you expect, and you may run into error messages. Please read ahead. The section "Expect to Scratch Your Head" will explain most of what you encounter.

Remember to do a Save As

Periodically use the Save As command and save the file as the next version number into your 01 Abstract folder, making an abbreviated note at the end of the file name of what brushes you were using.

Take Your Time …

Take the time to do this brush research exercise thoroughly, even if you are already an experienced Painter user. There are around 800 default variants in Painter, plus you have the extra variants in Jeremy Faves 2, so there's a lot to explore! I've been using Painter for over fifteen years and I still discover wonderful new things every time I research brushes. The goal of this exercise is to get a good sense of what different brush looks and behaviors there are at your fingertips.

Brushes I Really Like!

Unless you write them down it is easy to forget which variants you really like. Use the space below to note brush variants you really like as you come across them.

Category	Variant	Comments

Custom Variants

Play with the Brush Properties

See what happens when you adjust the sliders in the Property Bar. Adjust the Color Variability sliders and see their effect. This simple brush customization can result in some fabulous custom brushes.

One powerful pair of properties that work well in opposition are a pair I call the Dynamic Duo: the brush size and opacity. Try large brush size and low opacity (and low pressure) versus small brush size and high opacity (and high pressure) using the same brush. See the difference in the quality of your marks (Figure 2.39).

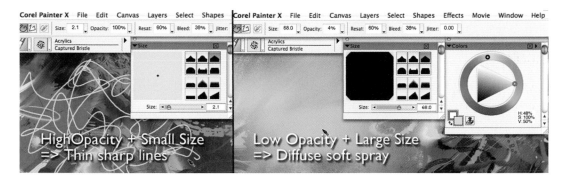

Figure 2.39 An example of the Dynamic Duo (of opposing opacity and size values) in action!

Brush Controls

The properties that appear in the Property Bar for each brush variant are a small subset of the vast array of customizable settings contained in the Brush Controls palettes (Window > Brush Controls > ...). The Brush Controls contain all the settings that determine the behavior of each variant in Painter. They can be a little intimidating at first sight but are fascinating to explore. In the Jeremy workspaces you'll find the Brush Controls palettes beneath the Size palette (which is one of the Brush Controls). Minimize the Size palette (click on arrow in top left) or drag down the bottom right corner of the Size palette window to view the full set of Brush Controls palettes (Figure 2.40).

I have moved one Brush Controls palette, the Color Variability palette, to be just below the Colors palette which is where I find it more useful. If you wish to delve deeper into brush customization than the Property Bar, then choose a brush variant you like and start experimenting with the Brush Controls, testing their effect (Figure 2.41). You'll find that not all controls are applicable to all brushes and they will be grayed out when not applicable. You will find a graphic demonstration of the RealBristle Brush Controls sliders in "Learning Corel Painter X with Jeremy Sutton" DVD.

Figure 2.40 The Brush Controls palettes.

One further level of brush experimentation that the brave-hearted may venture into is the use of the Randomizer and the Transposer in the Brush Creator (Cmd-B/Ctrl-B or Window > Show Brush Creator). Look up the article "Getting Started with the Brush Creator" in the Help > Corel Painter X Help (Cmd-?/Ctrl-?) for a detailed explanation of how to use the Brush Creator.

Save, Move, Edit and Organize Your Custom Variants

As you experiment with the brush properties you will create custom brushes you want to save for the future. Here is how to save and organize a custom variant.

1 Select Save Variant from the Brush Selector pop-up menu (Figure 2.42) or click on the Save Variant shortcut button in the JeremySupaDoopa custom palette.

2 Name the new variant something appropriately descriptive with 23 characters or less (with more than 23 characters the OK button will be grayed out). Adopt an organized custom variant

Figure 2.41 Try out the Brush Controls and see their effect.

Figure 2.42 Saving a custom variant.

naming system. For instance begin each new custom variant with your initials, so you can easily identify and differentiate your custom variants from the default variants. Alter the variant name to indicate what it looks like.

3 Click OK. The new variant appears in the current variant list. It can be conveniently accessed at any time in the future.

4 If you wish to move any variant (custom or default) from one category to another (for instance to group your favorite variants together in one category) then first choose the variant you wish to move (note that new custom variants are not automatically selected when they are saved).

5 Choose Copy Variant from the Brush Selector pop-up menu.

6 Choose the category into which you wish to copy the variant from the Copy variant to: pop-up menu in the Copy Variant window (Figure 2.43).

Figure 2.43 Copying a custom variant.

7 Click OK.

8 If you now wish to delete up the copied variant from the original category (it'll still be the active variant) choose Delete Variant from the Brush Selector pop-up menu. Be careful that you don't accidentally delete default variants.

9 If you wish to return any variant to its original factory default settings, select that variant in the Brush Selector.

10 Click on the Reset Tool, which looks like a brush icon and is located on the far left of the Property Bar. This resets the current variant to its factory default settings.

Create Your Own Brush Categories and Libraries

You can create your own custom brush categories and brush libraries. To learn about this choose Cmd-?/Ctrl-? (Help > Corel Painter X Help). Search for "Managing Custom Brushes" and click on "Managing Custom Brushes" for information on making your own brush categories, and click on "Brush Libraries" for information on making your own libraries.

Variant and Category List Order and Visibility

1 Select the category into which you copied your custom variant. Note that the custom variant appears at the bottom of the variant list.

2 To change the order in which variants are displayed within a category variant list, choose Window > Workspace > Customize Workspace.

3 In the Media list on the left of the Customize Workspace window select Brushes > Painter Brushes > the category within which you wish to reorder variants.

4 In the central part of the Customize Workspace window you can click and drag on variants to change their ordering (Figure 2.44).

Figure 2.44 Adjust the variant order position using the Customize Workspace window.

5 You can also click on the eye icons to toggle their visibility on and off.

6 The same can be done at the category level by selecting Painter Brushes in the Media list on the left and moving the categories around or toggling their visibility on or off by clicking on the eye icons (Figure 2.45).

Figure 2.45 Moving a category in the category list order (on PC).

Export Your Custom Variants to Other Computers

To export your custom variants you need to know where the custom files are stored in your computer and which files to copy. This is also important information for backing up your custom data.

1 Before searching on your computer hard drive for your custom data, first, within Painter, look under Window < Workspace and note which workspace is checked. If you haven't imported a workspace the current workspace may be the one named "default". Your current workspace includes not only your current palette layout but also every library, custom palette, custom brush variant, preference setting and so on. Knowing the name of your current workspace will allow you to find where the custom variant data is stored.

2 The next step on a Mac is to open the Finder browser window. Open the user folder (user name) > Library > Application Support > Corel > Painter X > (current workspace name) > Brushes > Painter Brushes > (category containing the custom variant). PC users choose in the My Computer window Local Disc (C:) > Documents and Settings > user directory (user name) > Application Data > Corel > Painter X > (current workspace name) > Brushes > Painter Brushes > (category containing the custom variant). This is where all the custom data associated with any custom variant is saved.

3 Hold down the Cmd/Ctrl key while you select all the files with the custom variant name contained within the folder identified in step 2 above. You may find files ending in .xml, .nib, .stk and .jpg (Figure 2.46). Watch out because the .xml file may be listed lower in the folder contents list than the other files and it is easy to accidentally overlook selecting the .xml file.

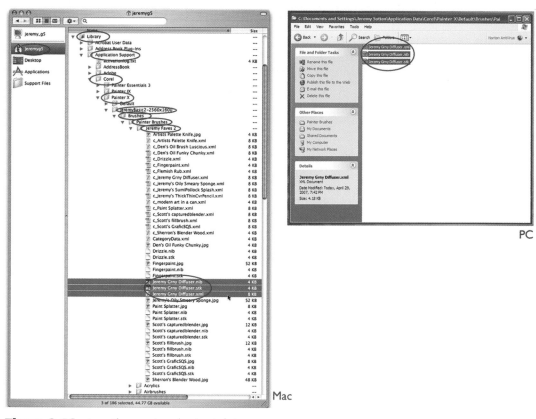

Figure 2.46 Locating custom variant data.

4 Copy these selected files onto a portable device (such as a thumb drive). Take your portable device to your other computer (or share over the web or email the files or however you wish to transport them between computers).

5 On the other computer copy these .nib, .stk and .xml files into, for Mac users, Applications > Corel Painter X > Brushes > Painter Brushes > category folder, or for PC users: Local Disc (C:) > Programs > Corel > Corel Painter X > Brushes > Painter Brushes > category folder. The category folder corresponds to the category you wish to see the custom variant appear in. It will appear at the bottom of the variant list in that category.

Export Your Customized Workspaces

After using Painter X for a while you will customize your Painter workspace in a way that best suits your personal creative workflow. The workspace in Painter includes your palette layouts, your custom palettes, your preferences, your custom variants, the ordering and visibility of the contents of all libraries (Brushes and Art Materials) and the choice of current libraries. As you make changes to any of these, those changes are applied automatically to

your current workspace (which you can see checked in the Window > Workspace menu). When you reach a stage where you wish to save your current workspace settings for future use or for sharing with other computers, go to Window > Export Workspace. Give it a meaningful name (I recommend including the screen resolution in the workspace name since the resolution may affect where palettes appear) and save it somewhere logical, such as in the Support Files folder in the Corel Painter X application folder. You will then always be able to return to that workspace by Window > Workspace > Import Workspace and selecting it. If you wish to save your current palette layout for future use, then choose Window > Arrange Palettes > Save Layout. Note that reselecting your current workspace in the Window > Workspace menu will not return you to your original workspace palette layout. You would have to re-import the workspace to achieve that.

If you need to clean up your current list of workspaces choose Window < Workspace < Customize Workspace, select a workspace (from the "Workspace:" pop-up menu) you wish to delete and click on the "−" symbol (to the right of the "+" symbol). You will be asked if you are sure you wish to delete the workspace. Click Yes.

To learn more about Workspace Management choose Cmd-?/Ctrl-? (Help < Corel Painter X Help). Search for "workspace" and click on "Brush Libraries" followed by "Customizing the workspace".

Expect to Scratch Your Head

There are many brushes that may initially cause you to scratch your head. Here is an overview of such brushes with explanations to help you understand their behaviors.

- *Liquid Ink* and *Watercolor* brushes generate layers that you can see listed in the Layers palette and that don't allow other brushes to be used on those layers. You will see an error message (Figure 2.47) when you try to paint on these layers with a different type of brush.

Figure 2.47 Error message seen when trying to paint on a Watercolor layer with a non-Watercolor brush (similar to message you will see when trying to paint on a Liquid Ink layer with a non-Liquid Ink brush).

To flatten these layers and continue painting over them choose the Drop All command in the Layers pop-up menu or the Drop All shortcut on the JeremySupaDoopa custom palette (Figure 2.48).

Figure 2.48 Use the Drop All command to flatten your image and paint over Liquid Ink or Watercolor layers.

• *Digital Watercolor* and *Impasto* brushes generate layers that you can't see listed in the Layers palette but that seem to remain above any other brush marks. Use Cmd-Shift-L/Ctrl-Shift-L to dry the Digital Watercolor (Figure 2.49). This is the equivalent to dropping the layer into the background canvas.

Figure 2.49 Dry the Digital Watercolor.

- To toggle the Impasto effect on and off, click on the Toggle Impasto Effect icon, which looks like a piece of bubblegum or small purple starfish when activated, in the upper right of the canvas window (Figure 2.50). The canvas window is visible only when not in screen mode. You can clear the entire Impasto layer through Canvas > Clear Impasto. If you wish to keep your Impasto effects but be able to paint on top of them, save your file as a TIFF file. Close it. Then reopen it. Because the TIFF format doesn't support Impasto layers, it has the effect of dropping the Impasto layer into the background canvas. The reopened TIFF file will show the Impasto illusion of depth but allow you to paint over it.

Figure 2.50 Toggle the Impasto effect on and off with the Impasto Effect icon.

- *Blenders* and *Distortion* brushes don't add color, they only affect color already there.
- Brushes that use the Build-up Method seem to be translucent, unable to paint over dark colors and build up to black if an unsaturated color is selected. Examples are the *Crayons* and *Colored Pencils* brushes. To see what method a brush uses, expand the Size palette window and you'll find the Brush Controls General palette (or choose Window > Brush Controls > Show General).
- The *Image Hose* sprays imagery and can be loaded with different sets of images, known as nozzles. The Image Hose variants determine the size, distribution and ordering of the nozzle elements as they emerge from the hose. The nozzles can be selected from the Nozzle Selector in the bottom right corner of the Toolbox. Check out the JeremyFavesNozzles1, which is loaded as the default nozzle library in the Jeremy workspaces (Figure 2.51).
- Some brushes use paint color from the current clone source. These brushes include those from the *Cloners* category. You can also transform any brush that adds color into a cloner brush by activating the Clone Color icon in the Colors palette. Choose File > Clone Source to see what the current clone source is and thus identify where the clone color is coming from. The default clone source is the current pattern.
- Dry media grainy brushes, such as the *Chalks* and *Charcoals*, show paper grain as they paint. These brushes all have a Method Subcategory (see Window > Brush Controls > General > Method >

Figure 2.51 Select Image Hose nozzles from the Nozzle Selector.

Subcategory) that contains the word "Grainy". Use the Paper selector in the Toolbox or the Papers palette to explore papers. Click on the Paper selector to choose papers in the current library. Choose Open Library from the Papers pop-up menu to explore other Paper libraries. There are many paper libraries in the Corel Painter X application CD. Explore JeremyFavePapers2 which is set to be the default paper library in most of the Jeremy workspaces. To load the factory default paper library click on the Paper Selector at the lower left of the Toolbox (top left of the six selector icons) and then select Restore Default Library from the pop-up menu (small triangle in top right corner of selector).

- Some seem to have a time lag and build up after the brush stroke has been completed. An example is Jeremy Faves 2 < *modern art in a can*—this builds after the stroke is complete and has an unpredictability to its structure. You will also find that many of the *Watercolor* brushes continue to diffuse or run for a short time after the brush stroke has been completed.

And so on ... The bottom line in experimenting is to expect the unexpected and not to panic. Explore all the brush categories mentioned in the notes above. Keep building up your abstract image, continuously transforming it.

When you've explored most of the brushes choose Shift-Cmd-S/Shift-Ctrl-S (File > Save As) and save your abstract image into the 01 Abstract project folder, with the name abstract-xx-brushplay.rif where xx is the next sequential version number in your on-going Abstract project series.

Painting Projects

Scratchboard Variation

1 Make sure you have saved your last version of your abstract (following the protocol of using Save As and giving the file name a sequential version number).

2 Choose Cmd-Shift-N/Ctrl-Shift-N (Layer > New Layer). This generates a new transparent layer which you can see listed in the Layers palette.

3 Make sure that Preserve Transparency is unchecked in the Layers palette.

4 Choose the Pens > Scratchboard Tool in the Brush Selector.

5 Choose black as the Main Color in the Colors palette.

6 With the new layer selected (highlighted in the Layers palette), choose Cmd-F/Ctrl-F (Effects > Fill).

7 Choose Shift-X to swap the Main and Additional colors. Black is now the Additional color.

8 Choose white as the Main Color in the Colors palette.

9 Change the Composite Method pop-up menu from Default to Gel in the Layers palette.

10 Now start painting (Figure 2.52). You'll see that you have created the equivalent of a scratch-board where you scratch away the black to reveal the colorful design underneath. To bring black

Figure 2.52 Apply the scratchboard technique.

back you just choose Shift-X to swap the Main and Additional colors. Shift-X toggles between black and white.

11 Choose Save As. Save your scratchboard image, with the appropriate sequential version number, as a RIFF file in your 01 Abstract project folder, adding "scrtchbrd" to the end of the file name to remind you that this is the scratchboard variation.

12 This is such a fun exercise you may wish to do more than one scratchboard design. To start a fresh design you can either fill your current scratchboard layer with black (swap colors and the choose Cmd-F/Ctrl-F). Alternatively you could turn off the visibility of the current scratchboard layer (click on the eye icon) and create a new layer, following steps 2 through 10 above.

Abstract to Self-Portrait Transformation

1 After saving your file as a RIFF with the consistent P-V-N (Project-Version-Notes) naming convention, make sure the scratchboard layer is highlighted in the Layers palette.

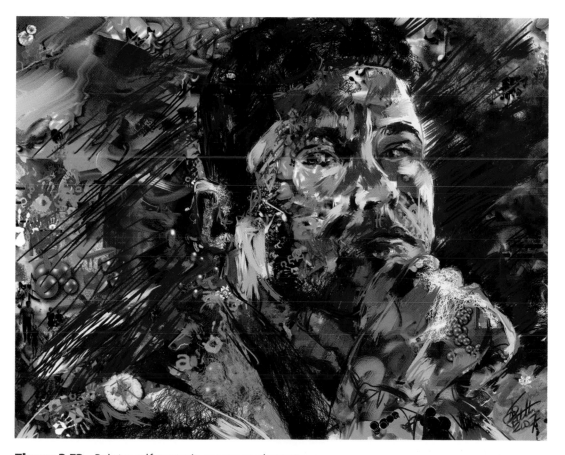

Figure 2.53 Paint a self-portrait over your abstract.

2 Press the trashcan delete icon in the Layers list. This deletes the scratchboard layer.

3 Position a small mirror next to your computer screen angled so that you can see yourself.

4 Looking back and forth between the mirror and your screen, and without undoing or erasing anything, paint a self-portrait on top of your abstract (Figure 2.53). See if you can incorporate parts of the abstract. Try using some Distortion brushes to move paint around as well as brushes that simply cover up what is there. Have fun with this! The goal here is not to create a masterpiece or even a close likeness, but simply to express yourself on the canvas, basing your brush marks on what you see in the mirror.

5 Remember to Save As regularly as you build up the self-portrait, continuing to save version, continuing the same sequence of version numbers you started in Chapter 1 and continuing to use the project name "abstract" and save the versions in the 01 Abstract folder. Add "selfp" as a note after the version number to remind yourself that this is where you transformed the image into a self-portrait.

6 When you feel you have reached a point of completion choose Save As, add the next version number, and after the version number add the note "selfpFINAL", for example: "abstract-23-selfpFINAL.rif", and save in your 01 Abstract project folder.

Hidden Gem: Liquid Metal

1 Click on the second icon from the left at the bottom of the Layers palette, the Dynamic Plugins icon, and choose Liquid Metal (or Layer > Dynamic Plugins > Liquid Metal). You will see a Liquid Metal Dynamic Plugin layer called "Liquid Metal Floater 1" with a small plugin icon on the right appear in the Layers palette and a Liquid Metal dialog window will also appear. While this window is open you will only have access to limited functions in the Painter interface.

2 Make a brush stroke in your image. Try changing pressure. Note the sensitivity of the metal diameter to pressure (Figure 2.54).

3 Click on the circle icon in the top left of the Liquid Metal window.

4 Drag in your image and see how you can now create droplets of metal.

5 Click on the arrow icon (second down) on the left of the Liquid Metal window.

6 Click and drag in the droplets and move one through another. Note the way they exhibit surface tension like liquid mercury.

7 Click on the paintbrush icon (third down) on the left of the Liquid Metal window.

8 In the Patterns selector (second Selector up on the bottom left of the Toolbox or accessible through the Patterns palette, Window > Library Palettes > Show Patterns) select the Honey pattern in the JeremyFavePtrns2 patterns library. JeremyFavePtrns2 is the default pattern library in the Jeremy workspaces. If that patterns library is not the current library choose Open Library from the Patterns selector pop-up menu and choose JeremyFavePtrns2.

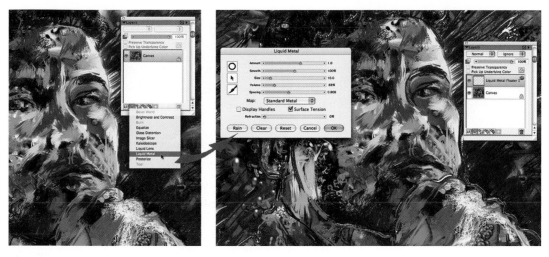

Figure 2.54 The Liquid Metal Dynamic Plugin layer.

9 *Now select Map*: Clone Source in the Liquid Metal window. You'll immediately see all the metal you have painted this far turn from silver to gold. To return to silver you would simply choose Map: S tandard Metal; Stay with the Map: Clone Source setting.

10 Paint in your image and you'll see a beautiful gold metal flow out of your brush.

11 For fun click on the Rain button in the Liquid Metal window. You'll see metal rain droplets appear.

12 Click in the image to stop the rain.

13 Take the Refraction slider in the Liquid Metal window all the way to the right (100%) and see how the metal becomes water.

14 Continue painting in the image and you'll see yourself painting with water.

15 Bring the Refraction back to the left (0%) and, as in alchemy, see the water become gold.

16 Click Clear in the Liquid Metal window to clear all the metal and start a fresh.

17 Click OK in the Liquid Metal window to close the window and return to full functionality of the Painter interface. To return to work in the same Liquid metal layer double click on the Liquid Metal layer in the Layers palette.

18 Using a combination of Liquid Metal and other brushes, work on your self-portrait and transform it into a love card (Figure 2.55) for someone special in your life. You may create a love heart or add a message (in Liquid Metal or paint). It doesn't matter whether the self-portrait shows through or not. Just continue the process of transformation.

19 Choose Save As. Add the next version number, and after the version number add the note "liquidmtl" for example: "abstract-3 5-liquidmtl.rif", and save as a RIFF file in your 01 Abstract

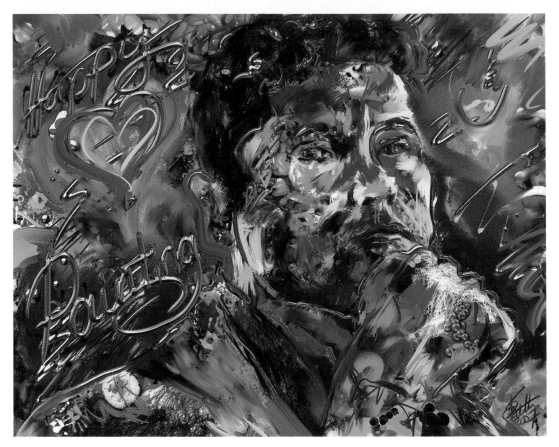

Figure 2.55 Happy Painting!

project folder. Note that RIFF is the only file format that will preserve the edibility of the Liquid Metal layer (or any other dynamic plugin layers).

20 Print out your love card on a nice card stock.

21 Sign it by hand.

22 Give it to someone you love ...

3

Texture and Pattern

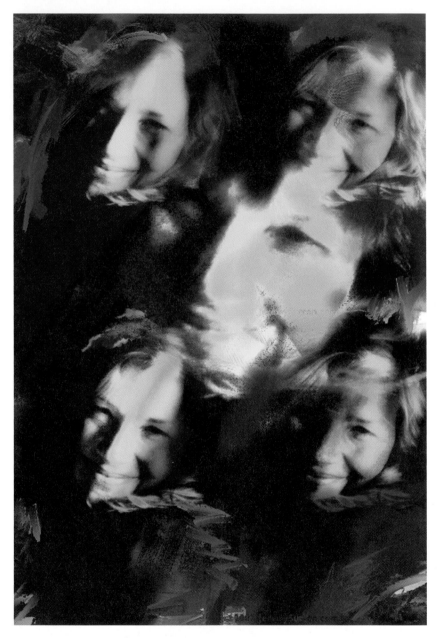

Figure 3.1 *Peggy Multiplied*, 2007, 14 inches × 20 inches.

Texture and pattern are closely related. When light falls on a textured physical surface the physical relief of the texture creates a pattern of light and shadow. When a dry chalky medium, such as a stick of chalk, is dragged across a rough textured surface the chalk particles are deposited on the raised parts of the textured surface (the "mountains"). We are then left with a pattern of color where

94

we see the surface color showing through in some areas (the "valleys") and the chalk color showing through in other areas (the "mountains"). The harder you press with your chalk the deeper the chalk color penetrates down the mountains into the valleys and the less of the underlying surface color shows through.

Painter accurately emulates some of these traditional properties of physical color, texture and pattern and also goes beyond those, offering unique effects only possible in a digital environment. In this chapter we examine the fundamentals of working in Painter with color, texture and pattern, and the relationships between them. Since the words color, texture and pattern mean different things in the physical world and within Painter we will start with some simple Painter-centric definitions.

Painter-centric Definitions

Texture

The word texture in Painter is used interchangeably with paper, paper texture and grain. A paper texture in Painter is a repeating grayscale tile that acts as a filter for grainy brushes and for effects where the Using menu is set to Paper (Figure 3.2).

Figure 3.2 Mix of textures from the default and the JeremyFavePapers2 paper libraries, applied with the Chalk > Square Chalk 35, and with the Apply Surface Texture effect using the JeremyFavePapers2 > Kyosei Shi paper.

Pattern

A pattern in Painter is a repeating color tile that can be applied into an image using the Effects > Fill command (Pattern selected), using any of the Pattern Pens brushes, or, when the pattern is set as clone source (which it is by default), any clone brush and any Effect where the Using menu is set to Original Luminance, in which case the luminance or value in the pattern will be used to filter the effect (Figure 3.3).

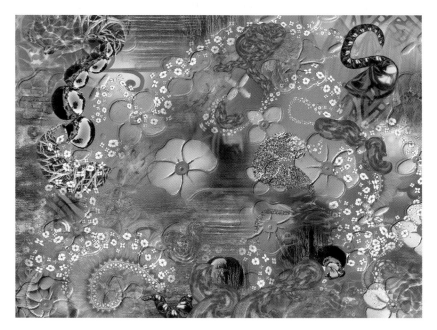

Figure 3.3 Mix of patterns from the default Painter and the JeremyFavePatterns2 pattern libraries, applied with the Cloners > Soft Cloner, Patterns Pens > Pattern Pen and Pattern Pen Masked, and with the Apply Surface Texture effect using the Floral Fabric pattern from the default pattern library.

Paper Textures in Painter

Understanding Paper Textures

Whereas in the traditional non-digital world paper texture is an intrinsic property of a substrate relating to the roughness of the substrate surface, in Painter "paper texture" is not an intrinsic property of your canvas. You can change the paper texture at any time and it has no retroactive effect on the image but will influence grainy brushes and effects set to Using: Paper when you apply them.

Examples of grainy brushes, which are all sensitive to paper texture, include Chalks, Charcoals, Conte, Crayons, Oil Pastels, Pastels and Pencils. There are many other grainy brush variants distributed throughout other categories, often with the word "grainy" in the variant name. If the Grain

slider is featured in the Property Bar you then know the current variant is grainy. Grainy brushes have the word "grainy" in their Method Subcategory which you can see in the Brush Controls > General palette (Figure 3.4).

The Grain slider controls how deeply pigment penetrates into the grain. A low grain value means that the pigment penetrates very little until at 0% grain, the brush will not leave any mark at all. Conversely large grain means the pigment penetrates deep into the valleys until at 100% you get a solid brush stroke that shows no grain at all (Figure 3.5).

You can see a small thumbnail of the current paper in the Toolbox Paper Selector (the third icon from the bottom on the left side of the Toolbox) or you can see a larger image of the paper in the Papers palette Paper Preview Window (Figure 3.6). If you don't see the Papers palette choose Window > Library Palettes > Papers. You can move both the thumbnail and preview view by clicking and dragging in the preview images. You'll see that the papers are grayscale images only. The dark regions of the paper texture tile act like the mountains, and the light regions act like the valleys. You can invert the paper texture by clicking on the Invert Paper icon in the Papers palette, making the light parts (valleys) of the paper texture tile dark (mountains) and vice versa.

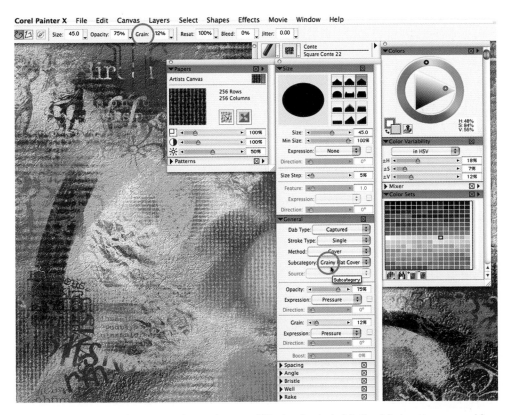

Figure 3.4 Grainy brush variants have the word Grainy in their Method Subcategory and have the Grain slider in the Property bar.

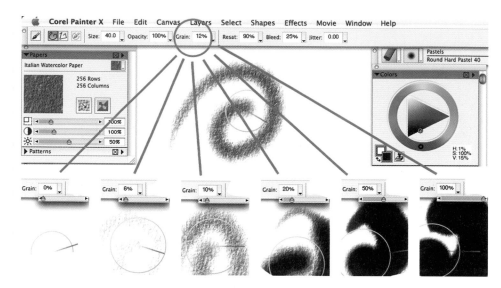

Figure 3.5 A comparison of the effect of different Grain settings. Note how quickly the texture gets filled in—the brush stroke is almost solid color when the Grain setting is 20%. Typically 9–12% seems to work best.

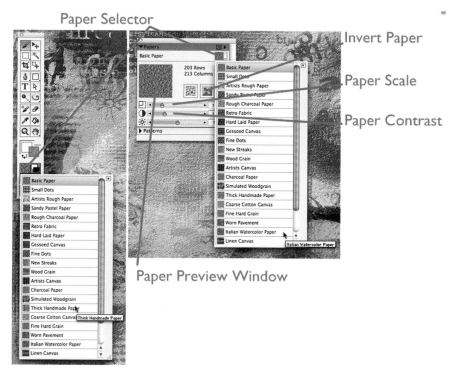

Figure 3.6 The Paper Selector in the Toolbox and the Papers palette.

Apply Existing Paper Textures

1 Choose a photograph to work on. You can either pick one of the photos included in the PXC Projects > Jeremy Tutorial Images or you can choose one of your own images. We will be working with this image for most of this chapter.

2 Open your chosen image in Painter.

3 Choose Canvas > Resize. Have a look at the size of the image in inches. All the tutorial images are sized at 4.5 inches in the maximum dimension at a resolution of 180 pixels per inch. If you use your own image it can be larger than this.

4 Choose Cmd-E/Ctrl-E (Effects > Tonal Control > Equalize). This effect increases the contrast in the image, making it better suited to make a strong paper texture.

5 Choose Save As.

6 Name the file TxtrPtrnExpt-01-origphoto.rif. I suggest RIFF just as a good habit. In fact you could save this file as a TIFF and it would be fine since there are no special layers, etc.

7 Create a new project folder within the PXC Projects folder.

8 Name the new project folder 02-TxtrPtrnExpt.

9 Save the file.

10 Choose File > Quick Clone. QuickClone does a number of operations in one fell swoop. You can set up the operations in the Preferences > General. By default the QuickClone will duplicate the photograph (creating a Clone Copy), set the original photograph to be Clone Source (see File > Clone Source), clear the duplicate, turn on Tracing Paper (which allows you to see the clone source superimposed over the canvas) and select the last used Cloner brush.

11 Choose Cmd-T/Ctrl-T (Canvas > Tracing Paper) to toggle the Tracing Paper off. You now see a plain white canvas.

12 Choose Cmd-M/Ctrl-M (Window > Screen Mode Toggle). You could also use the appropriate pre-programmed Wacom ExpressKey. Please note in some of the figures that illustrate this chapter, screen mode is turned off in order to give you a better idea of what is open in Painter. Generally, for visual simplicity, I recommend using screen mode whenever possible.

13 Hold down the Space bar while clicking and dragging in the image to move it to a convenient location on your screen. Use your Zoom In and Zoom Out ExpressKeys if needed. Make sure you can see the edge of the white canvas.

14 Make sure you can see the Papers palette. If not choose Window > Library Palettes > Show Papers.

15 Choose the Chalk > Square Chalk 35 in the Brush Selector.

16 Choose a dark color.

17 Paint in the canvas.

18 Experiment with different Grain slider values. I find that a smaller Grain, around 10%, often works best.

19 Change the current paper in the Paper Selector menu (which you can access through the Toolbox or the Papers palette).

20 Change color and make more brush strokes. Experiment with different papers and different grainy brushes.

21 Choose Shift-Cmd-S/Shift-Ctrl-S (File > Save As). Save the file as TxtrPtrnExpt-02-chalky.rif.

Explore Other Paper Libraries

The default paper library in the Jeremy workspaces is JeremyFavesPapers2. You can identify if you have this library because the papers in it include Mountains, Craft, Kyosei Shi and Jeremy's crazytype. You can access the default library through the Paper Selector pop-up menu > Restore Default Library (Figure 3.7). You can access the Paper Selector pop-up menu through either the Toolbox or the Papers palette. The default library contains Basic Paper, Small Dots, Artists Rough Paper and so on. To select a different paper library choose Open Library in the Papers palette pop-up library (Figure 3.8). You will be warned that you will lose any changes you have made. Unless you have made custom papers that have not yet been saved into a custom library, then it is OK to go ahead and click Load. Locate the papers library you are interested in and click Open. There are a wealth of paper libraries included in the Painter X application CD (under Extras > Paper Textures). If you have that CD explore those extra papers.

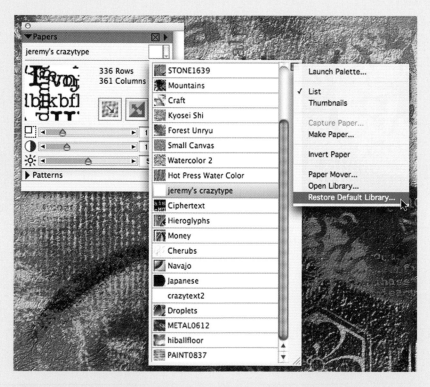

Figure 3.7 Choose the Restore Default Library command.

Figure 3.8 Choose the Open Library command.

Capture a Sketch as Paper Texture

1 Choose black as the Main color in the Colors palette.

2 Choose Jeremy Faves 2 > Jeremy's Sumi Pollock Splash (also accessible from JeremySupaDoopa custom palette).

3 Choose Cmd-A/Ctrl-A (Select > All).

4 Choose delete/backspace.

5 Make an interesting shaped brushstroke on a small section of your canvas.

6 Choose the Rectangular Selection Tool in the Toolbox (second down on top left).

7 Drag the Rectangular Selection Tool over your brushstroke.

8 Choose Capture Paper, the first menu item in the Papers palette pop-up menu (Figure 3.9). Access the Papers palette pop-up menu by clicking on small solid arrow in top right of the Papers palette. Don't get confused by the second menu item, Make Paper, which sounds similar to Capture Paper but is completely different.

9 Name your paper "squiggle1", or whatever you wish, in the Save Paper window.

10 Set the Crossfade slider to zero (Figure 3.10).

11 Click OK.

12 You have now captured a custom paper. You should see it in the Papers palette preview (Figure 3.11). You may only see a small segment of the texture. Click and drag your cursor in the preview to move the texture around.

13 Choose Cmd-D/Ctrl-D (Select > None).

14 Choose Art Pen Brushes > Square Grainy Pastel in the Brush Selector.

Figure 3.9 Choose Capture Paper from the Papers palette pop-up menu.

Figure 3.10 Set Crossfade to zero in the Save Paper dialog window.

Figure 3.11 After saving the paper you will see the paper appear in the Papers palette preview window.

15 Choose a deep dark color (not black).

16 Paint in the canvas and you should see your paper texture appear.

17 Test out different grainy brushes, paper scale and colors.

18 Click on the Invert Paper icon in the Papers palette. Notice how the preview window shows a negative image—what was white is now black and vice versa.

19 Choose contrasting colors to those used thus far and paint in the image. With Invert Paper you paint everything but the design. You can think of this as painting in the "negative space" of the texture design (Figure 3.12).

Figure 3.12 Try out the custom texture with different grainy brushes, different paper scale, different colors and using the Invert Paper button.

20 Click the Invert Paper icon again.

21 Experiment with the paper texture scale slider, the top slider in the Papers palette.

22 Note the extremes of scale: 25% to 400%. Try them both out.

23 Choose Shift-Cmd-S/Shift-Ctrl-S (File > Save As). Save the file as TxtrPtrnExpt-03-cstmpaper.rif.

24 Try capturing and applying other papers.

Random Brush Stroke Grain

In the Window > Brush Controls > Random palette (which may be accessible under the brush controls Size palette) is a Random Brush Stroke Grain checkbox. When this function is checked you will find the grain is randomized. In the case of the Sponges > Smeary Wet Sponge 60 the random effect looked better with the grain inverted (Figure 3.13).

Figure 3.13 Two examples of the Random Brush Stroke Grain. In each example the brush strokes on the left were created with the Random Brush Stroke Grain unchecked and those on the right with it checked.

Save and Organize Your Paper Textures

Before changing paper libraries or closing Painter it is a good idea to save and organize all your custom paper textures. If you do not do this you stand the risk of inadvertently losing your custom papers. All art material libraries and their contents are edited and organized using Movers.

1 Choose Paper Mover from the Papers palette pop-up menu (Figure 3.14). You will see the Paper Mover window appear. On the left side you see the contents of the current library.

Figure 3.14 Select Paper Mover in the Papers palette pop-up menu.

2 Click on New on the right side of the Paper Mover window. This allows you to create a new paper library into which you can move all your custom papers.

3 Name your paper library "PXC-custompapers1" and save it in your PXC Projects folder. I find it useful to save custom papers associated with a particular project in that project folder. You will see that the new library is now open on the right side of the Mover.

4 Identify your custom papers in the current library on the left side of the paper Mover. You will need to click on the individual papers to see the name of each one. The custom papers are likely to be at the bottom of the library and may be represented in the Mover by white squares.

5 Drag the custom papers from the left to the right (Figure 3.15), from the current library to the new one you just created.

6 Repeat this for all the custom papers.

7 Select each custom paper on the left and choose Delete. Paper libraries have a limited capacity and once you fill them up you will not be able to capture any more new papers until you have deleted some from the library.

Figure 3.15 Drag a custom paper from the current paper library to the PXC-custompapers1 paper library.

Capture a Photograph as a Paper Texture

In the technique described here you will capture your entire photograph as a paper texture and initially use a chalky brush in a canvas exactly the same size as your photo. Subsequently you will bring back a little of the original photo with cloning brushes and add accent brush strokes with non-cloning, non-grainy brushes. The goal here is not only to learn a very versatile paper texture technique you can apply to your photographs, but also to let go of attachment to one technique or another and play with your imagery, trying out many ideas and techniques, generating many variations in the process. My paintings evolve through continual experimentation. I hardly ever follow the same series of techniques on any two paintings. I am not intending to give you recipes to follow, just to stimulate you to experiment. I encourage you to play with many ideas and mix up your techniques. Have fun!

1 Make the original photo your active image in Painter.

2 Choose File > Clone (or use the clone button in the JeremySupaDoopa custom palette).

3 An optional step here is to choose Effects > Surface Control > Express Texture. This effect creates a stark, high contrast black and white version of your photograph.

4 Choose Cmd-A/Ctrl-A (Select > All).

5 Choose Capture Paper from the Papers pop-up menu (Figure 3.16).

Figure 3.16 Choose Capture Paper from the Papers palette pop-up window.

6 Name the paper texture in the Save Paper window, so that you will recognize what it is from the name.

7 Set Crossfade to zero (Figure 3.17).

Figure 3.17 Set Crossfade to zero in the Save Paper window.

8 Click OK. You will see the captured paper appear in the Paper Preview Window.

9 Press the Delete/Backspace key. This clears your clone copy canvas.

10 Choose Shift-Cmd-N/Shift-Ctrl-N (Layers > New Layer). This generates a new layer that you can see listed in the Layers palette. Make sure that Preserve Transparency in the Layers palette is unchecked.

11 Choose dark colors and, with a grainy brush, start painting on your new layer.

12 Click on the Invert Paper icon and start painting in the negative space with contrasting lighter colors (Figure 3.18).

Figure 3.18 Paint with the Invert Paper icon active.

13 Choose Save As and save this file as TxtrPtrnExpt-xx-phototxtr.rif where xx is the next version number (keep the sequence going from earlier). Save the file in the 02 TxtrPtrnExpt project folder.

14 Choose Shift-Cmd-N/Shift-Ctrl-N (Layers > New Layer).

15 Choose Smart Stroke brushes > Acrylic Dry Brush. Make sure Clone Color is active (Hue Ring and Saturation-Value Triangle are grayed out).

16 Look at File > Clone Source and make sure your original image is checked as clone source.

17 Lightly paint in, on the newest layer, the original photograph. Be selective as to what you bring back. Use the bristle structure of the brush strokes to follow the forms in your image.

18 Experimenting with making the clone layer more subtle by reducing the Opacity slider on the Layers palette (Figure 3.19). (You can also selectively reduce opacity within a layer using Layer Masks, a technique described in detail in Chapter 7 Collage Portraiture.)

Figure 3.19 Lower the opacity of the clone layer.

19 Click on the eye (layer visibility) icons for each layer in the Layers palette. These icons toggle the layer visibility on and off. Set them so that the layers are no longer visible.

20 Select the Canvas in the Layers palette.

21 Work with a variety of non-clone, non-grainy brushes on the background canvas (Figure 3.20).

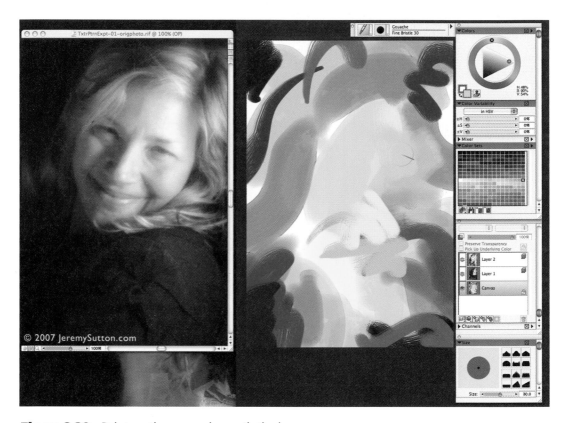

Figure 3.20 Paint on the canvas beneath the layers.

22 Click the eye icons again so the layers are once again visible.

23 Experiment with changing the layer Composite Methods (equivalent to Blending Modes in Photoshop), opacities and ordering (Figure 3.21).

24 Choose Shift-Cmd-S/Shift-Ctrl-S (File > Save As). Save this as the next sequential version.

25 Choose Layers > Drop All (also a button on JeremySupaDoopa).

26 Choose different brushes and add accent strokes.

27 Choose Shift-Cmd-S/Shift-Ctrl-S (File > Save As). Save this as the next sequential version.

110

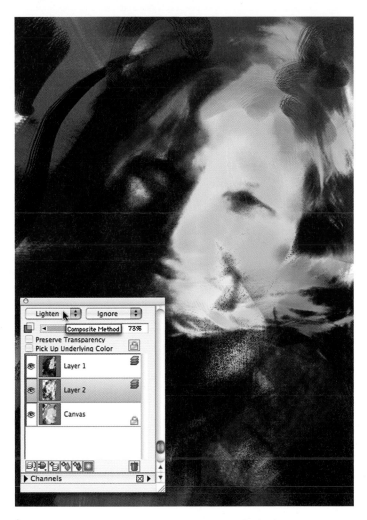

Figure 3.21 Turn on the layer visibility and experiment with the layer Composite Methods, opacities and ordering.

Make Pop Art Multiples a la Warhol

The paper texture photo technique lends itself to creating paintings that mix photographic screen-print effects with painterly effects. You can get ideas and inspiration for this genre of artwork from looking at the art of Andy Warhol. He made many works where he added paint on top of photographic screen prints. Look at the way he played with color combinations, accent brush strokes and contrasting textures.

1 Keep working on the same file.

2 Click and drag over the numerals in the box that says "100%" to the right of the Scale slider in the Papers palette. The 100% should be highlighted.

3 Type in 50. This should replace the number 100. The 50% scale will result in a multiple of four images, two up and two across. You can adjust the paper scale percentage to create any number of multiples, for instance a 33.33% scale will result in a three by three multiple. In this case we will stick with a multiple of four images.

4 Choose Shift-Cmd-N/Shift-Ctrl-N (Layers > New Layer).

5 Use a grainy brush to paint on the new layer. Periodically click the Invert Paper toggle icon so you paint in the positive and negative spaces of photo texture. Don't worry that parts of your earlier painting are showing through. That's an intentional part of this exercise, to give you the opportunity to experience the building up of multiple images over each other (Figure 3.22).

6 Use Save As to save versions your image as you progress. After you have saved your multiples versions with layers as a RIFF, choose Layers > Drop All. This flattens your image.

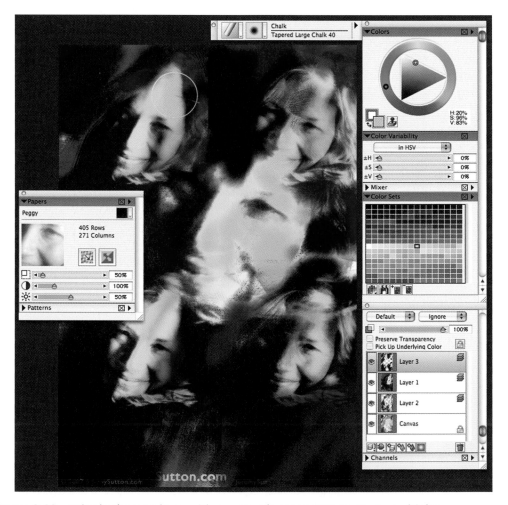

Figure 3.22 Paint in the new layer with paper scale set to 50% to create multiples.

7 Save this file as the next version with title TxtrPtrnExpt-yy-multiple.rif where yy is the next version number.

8 Choose different non-clone brushes and add some final accent brush strokes. You can see the result on my demonstration image at the beginning of this chapter (Figure 3.1).

Pattern Pizzazz!

The Difference Between Papers and Patterns

Confusion sometimes arises as to the difference between textures and patterns in Painter. In a nutshell, textures are grayscale repeating tiles whereas patterns are color repeating tiles. Both can be applied using brushes and effects. Both can be captured from existing imagery.

Apply Existing Patterns

1 Make the original photo your active image in Painter.

2 Choose File > Quick Clone.

3 Choose Cmd-T/Ctrl-T (Canvas > Tracing Paper) to turn off Tracing Paper.

4 Choose Cmd-M/Ctrl-M (Window > Screen Mode Toggle). Hold down the Space bar while dragging in the canvas to reposition the canvas if needed.

5 Expand the window around the Papers palette by dragging down in the bottom right corner. This should reveal the Patterns palette. Open the Patterns palette by clicking the open arrow (on left of palette title bar). If you don't see the Patterns palette choose Window > Library Palettes > Show Patterns.

6 Choose the Patterns Pen > Pattern Pen Masked in the Brush Selector.

7 Make short dabs on your blank white canvas. You will see your original photo reproduced in the brush strokes. This is because the Quick Clone operation made your original photo clone source and the Pattern Pens paint with the current clone source (which happens to be the current pattern until you assign another image to be clone source). You can verify your clone source by looking at File > Clone Source (Figure 3.23).

8 Try out other brushes from the Pattern Pens category.

9 Choose Shift-Cmd-S/Shift-Ctrl-S (File > Save As) and save this image as another sequential version in your on-going TxtrPtrnExpt project series.

10 Now select a pattern from the Pattern Selector (either in the Patterns palette or two up from the bottom left of the Toolbox). To choose the current pattern you will still need to open the Pattern Selector menu (the one that has the thumbnails of each pattern) and reselect the current pattern. By selecting a pattern you automatically reset the current pattern to be clone source.

11 Apply the Pattern Pen Masked on your canvas.

113

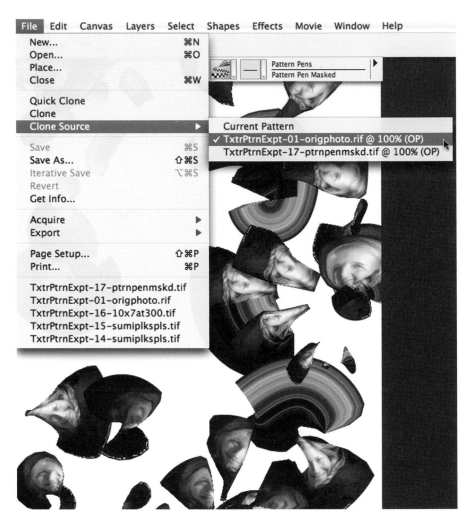

Figure 3.23 Short dabs of Pattern Pen Masked create distorted versions of the current clone source.

12 Now try applying brush strokes with variants from the Cloners brush category and with any brush with the Clone Color icon selected in the Colors palette.

13 Choose Cmd-F/Ctrl-F (Effects > Fill). The Fill window will automatically be set to "Fill with: Pattern" since you just selected a pattern.

14 Click OK. The canvas fills with the current pattern.

15 Choose Cmd-Z/Cntrl-Z (Edit > Undo) and continue adding to the image as it was at step number 12.

16 Explore other patterns in the current patterns library.

17 Choose Open Library in the Patterns palette or Pattern Selector pop-up menu.

The Jeremy workspaces have JeremyFavePtrns2 set as the default patterns library. You can recognize this library since it contains patterns such as PAINT1010, WOOD0923, Chocolate Chips and Honey. The factory default patterns library contains patterns such as Hens & Chicks (which leads to the gray color that many users first see coming out of clone brushes), Lame Ducks and Lotus Petals. You can always load this default library by choosing Open Default Library in the Pattern Selector pop-up menu.

18 Search for other pattern libraries. The Painter X CD comes with a selection of different pattern libraries. Check them out (Figure 3.24). If you haven't explored JeremyFavePtrns2 open

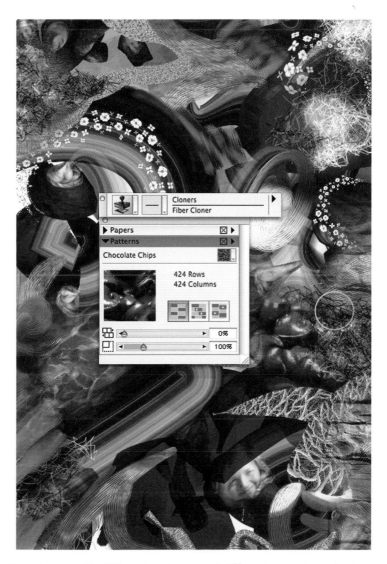

Figure 3.24 Experiment with different patterns and different ways to apply them.

that library (Corel painter X application folder > Support Files > Jeremy Fave Papers, Patterns, Nozzles). Try out all these patterns on your canvas without any Undo. Keep building pattern on top of pattern, brush strokes over brush strokes.

19 Choose Shift-Cmd-S/Shift-Ctrl-S (File > Save As). Save the file in your TxtrPtrnExpt folder as TxtrPtrnExpt-yy-patternplay.rif where yy is the appropriate sequential version number.

Make Your Own Patterns

1 Choose Cmd-N/Ctrl-N (File New).

2 Specify a new canvas that is 2 inches by 2 inches at 180 pixels per inch. Click OK.

3 Choose Cmd-M/Ctrl-M (Window > Screen Mode Toggle). Hold down the Space bar while dragging in the canvas to reposition the canvas if needed.

4 Choose Calligraphy > Dry Ink. Create a few brush strokes of different colors that go off the edge of the canvas.

5 Choose Define Pattern from the Patterns palette pop-up menu. Nothing visible will change and no check mark will appear next to Define Pattern when you look at it again in the pop-up menu. However the nature of the current canvas has significantly changed as you are about to see.

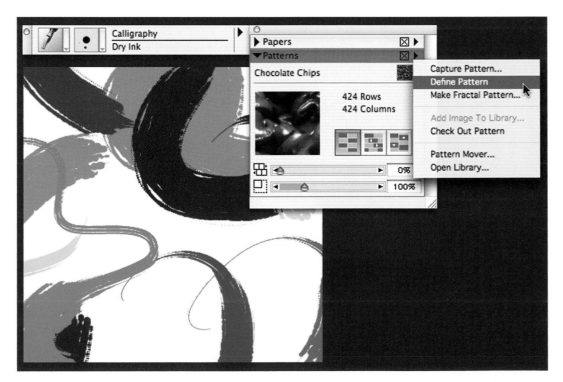

Figure 3.25 Choose Define Pattern.

6 Make more brush strokes that go off the side of the canvas. Note that now, as you paint off one side of the square, the brush stroke continues on the other side (Figure 3.26). This seamless painting allows you to avoid harsh edges to repeating tiles. Try other brushes. Most will work. The Acrylics > Captured Bristle and most Artists Oils are exceptions that don't work with seamless painting.

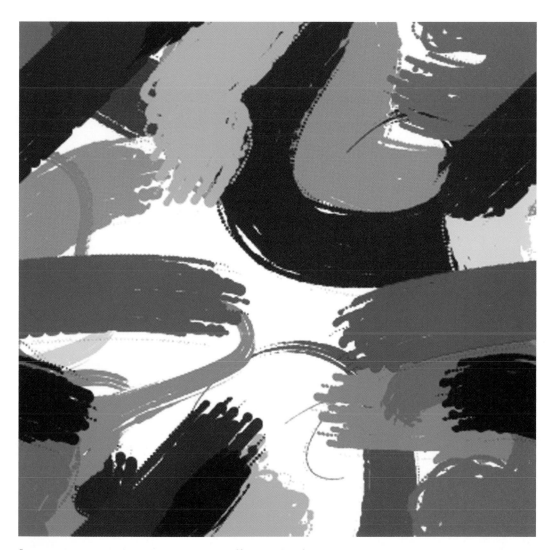

Figure 3.26 Seamless painting: paint off one side of canvas on to the other.

7 Hold the Shift key and Space bar down at the same time while you click and drag in the image. Note that the canvas scrolls seamless so you can see if there is an obvious edge showing. If there

are hard edges use brushes to cover them up or blend them in. Seamless scrolling, alongside seamless painting, is another property of images that have been defined as patterns.

8 Choose Capture Pattern from the Patterns palette pop-up menu (Figure 3.27). This command will capture as a pattern tile with color information (unlike capturing paper textures which are grayscale), the whole of the active image in Painter (no selection needed, unlike capturing papers when a selection is required) or, if you make a selection, a rectangle of the image.

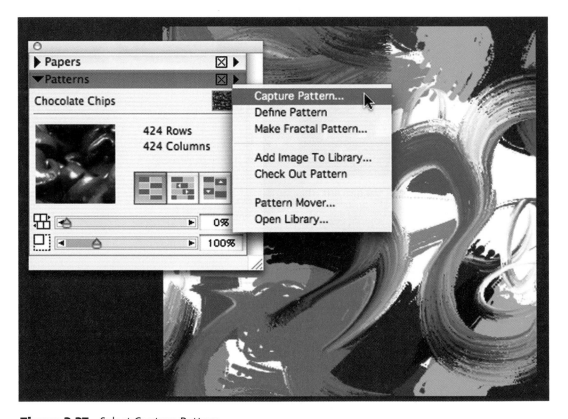

Figure 3.27 Select Capture Pattern.

9 Name your pattern in the Capture Pattern window (Figure 3.28). You can see a preview of how your pattern tiles will repeat and choose whether they tessellate with rectangular repetition or with horizontal or vertical offset (adjusted with the Bias slider, and which you can also adjust in the Patterns palette).

Figure 3.28 Name your custom pattern in the Capture Pattern window.

10 Click OK. You will now see your pattern listed in the Pattern Selector (Figure 3.29).

Figure 3.29 Your custom pattern will be listed in the Pattern Selector.

11 Experiment with applying the pattern using Pattern Pens brushes or the Fill effect.

Save and Organize Your Patterns

Just as with paper textures, before changing pattern libraries or closing Painter it is a good idea to save and organize all your custom patterns. If you do not do this, you stand the risk of inadvertently losing your custom patterns.

1 Choose Pattern Mover from the Patterns palette pop-up menu. You will see the Pattern Mover window appear. On the left side you see the contents of the current library.

2 Click on New on the right side of the Pattern Mover window. This allows you to create a new pattern library into which you can move all your custom patterns.

3 Name your paper library "PXC-custompatterns1" and save it in your PXC Projects folder. You will see that the new library is now open on the right side of the Mover.

4 Click on each of your custom patterns in the current library on the left side of the paper Mover and drag them from the left to the right, from the current library to the new one you just created (Figure 3.30). This is how you save your custom patterns.

Figure 3.30 Drag your custom pattern into a custom library in the Pattern Mover.

5 Repeat this for all the custom patterns.

6 Select each custom paper on the left and choose Delete. Pattern libraries, like paper libraries, have a limited capacity and once you fill them up you will not be able to capture any more new patterns.

Apply Patterns

1 Select your original photo, TxtrPtrnExpt-01-origphoto.rif, so it is the active image in Painter (you can verify which is your active image by which image has a check mark by at the bottom of the Window menu).

2 Choose Capture Pattern from the Patterns palette pop-up menu.

3 Name your pattern. Leave it in rectangular tessellation mode.

4 Click OK.

5 In the Patterns palette change the scale slider setting from 100% to 50%. The scale slider is the second slider down, unlike in the Papers palette.

6 Open the file you saved after generating a four-up multiple (TxtrPtrnExpt-yy-multiple.rif).

7 Choose Shift-Cmd-N/Shift-Ctrl-N (Layers > New Layer).

8 Choose the Cloners > Soft Cloner.

9 Gently clone in some of your photo (Figure 3.31). Note that since you have matched up the paper and pattern scales (both 50%) they both register over one another.

Figure 3.31 Clone in pattern into a layer.

10 Continue mixing textures and patterns until you are satisfied.

11 Choose Shift-Cmd-S/Shift-Ctrl-S (File > Save As). Save the file into your 02 TxtrPtrnExpt project folder as TxtrPtrnExpt-qq-txtrmix.rif.

Hidden Gem: Kaleidoscope Craziness

1 Continue working on the image you just created in the previous project.

2 Choose Layers > Drop All.

3 Click on the second icon from the left on the row of icons at the bottom of the Layers palette. This icon, which looks like an electric plug, is the Dynamic Plugins icon. A menu will pop-up.

4 Choose Kaleidoscope from the Dynamic Plugins pop-up menu (Figure 3.32) or through Layers > Dynamic Plugins > Kaleidoscope. This generates a special Kaleidoscope Dynamic Plugin layer (signified by a plug layer icon) and automatically changes the current tool from the Brush tool to the Layer Adjuster tool.

Figure 3.32 Choose Kaleidoscope from the Dynamic Plugins pop-up menu.

5 In the Kaleidoscope window set the size to be 500×500 pixels.

6 Move the kaleidoscope square around over your abstract by clicking and dragging with the Layer Adjuster tool.

7 When you find a pattern you like, choose Drop and Select from the layers pop-up menu (Figure 3.33) or click the Drop and Select shortcut button in the JeremySupaDoopa custom palette.

Figure 3.33 Choose Drop and Select from the Layers pop-up menu.

8 Choose Cmd-C/Ctrl-C (Edit > Copy).

9 Choose Edit > Paste into New Image (Figure 3.34) or click the Paste into New Image shortcut button in the JeremySupaDoopa custom palette. This makes the kaleidoscope pattern a new image.

Figure 3.34 Choose Edit > Paste into New Image.

10 Save the kaleidoscope pattern image. You could use this as a stand alone artwork or capture it as a pattern and apply it as a repeating tile.

11 Return to the abstract canvas where you generated the kaleidoscope pattern.

12 Choose Cmd-Z/Ctrl-Z (Edit > Undo). This reverses the Drop and Select command and returns the Kaleidoscope to being a separate Dynamic Plugin layer.

13 You can now continue generating patterns or just choose Shift-Cmd-S/Shift-Ctrl-S (File > Save As). Save the file in your 01 Abstract project folder as TxtrPtrnExpt-zz-kaleidoscope.rif where zz is the appropriate sequential version number.

4

Design and Composition

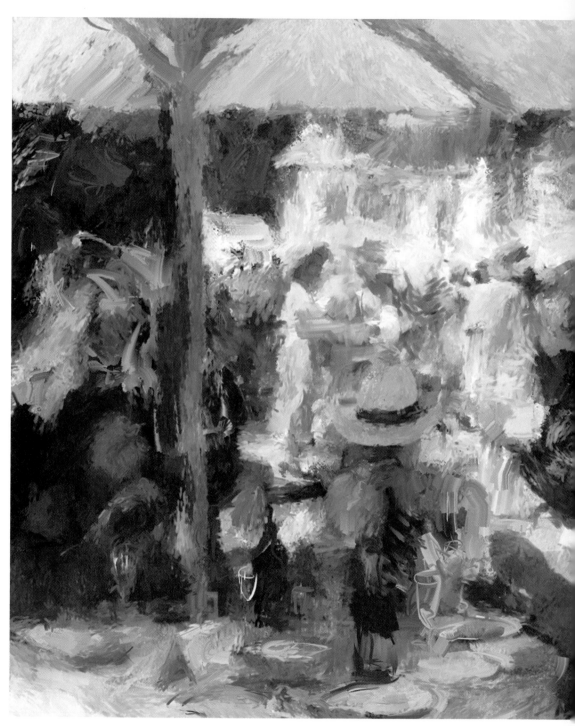

Figure 4.1 *Summer Afternoon*, 2005, 38 × 63 inches. Note the variety of colors in the highlights and shadows. These colors help bring the artwork to life and evoke the Great Gatsby atmosphere.

You have familiarized yourself with the tools, got to know the brushes and loosened up on the digital canvas. Before we dive deeper into Painter it is valuable to balance your technical skills training with basic design and composition training, which together empower you to reach your full creative potential. The information in this chapter will make more difference to your art than any step-by-step Painter techniques I can share with you.

Design is the act of working out, conceiving, planning and inventing the form of something. Composition is the act of composing a single cohesive harmonious structure by bringing together individual elements and arranging them in relation to each other and the whole. Design creates the intention and the vision and composition manifests the design in an effective way. Another way to look at it is design sets a destination and composition provides a road map to get there.

The beauty, impact and integrity of whatever you create in Painter, or in any other art medium, will be significantly amplified by your understanding and application of design and composition. This chapter is designed to help you to:

1 visualize your paintings' design before you begin;

2 recognize what is working and not working in your composition;

3 boldly take action in your art to resolve compositional problems.

Observation and Decisions

Design and composition involves continuous careful observation of your subject and your artwork, whether you are working from nature or from photographic reference, and a series of decisions, informed by your observation, which start even before you put your brush to canvas and which continue with every brush stroke you make. The strength of your artwork will be helped enormously by taking the time to observe carefully and make clear compositional decisions.

Here are a series of practical suggestions and ideas of ways to approach art making that have worked for me and helped me make design and composition decisions. Experiment, try out these ideas, and see for yourself if they work for you. I use the term "subject" in two contexts: (1) to refer to the individual or object that is the main subject of a painting and (2) to refer to the source visual image on which you are basing a painting, whether it be a digital photograph or direct observation from nature of a still life, landscape, cityscape or live model.

Design

Step Away From Your Subject

Before you begin any painting get out of your chair and step away from your subject. If you are working from a photograph on the computer mount your source image centrally in your screen

(Cmd-0/Ctrl-0 or Window > Zoom to Fit) and hide your palettes (Tab or Window > Hide Palettes). Walk out of the room where your subject is, then walk back in slowly and observe your subject from a distance. Stop periodically and half close your eyes. See your subject in terms of lights and darks only. Look for the "postage stamp size" jigsaw of abstract shapes that make up your subject. Make this stepping away a regular habit throughout your creative process. It is an excellent way to observe and compare the relative tones in your subject and your painting. Stepping away helps you assess where you are and make mid-course adjustments as necessary. It also serves the added benefit of keeping you fresh and comfortable.

Look at the painting *Impassioned* (Figure 4.2) from a distance. Half close you eyes.

Now do the same with the source photo (Figure 4.3)—look from a distance and half close your eyes. Note the various smaller versions of that same source photograph. I have used scale (pasted in the images as layers and then used Effects > Orientation > Free Transform), desaturation (Underpainting palette), Smart Blur (Underpainting palette), equalization (Effects > Tonal Control > Equalize) and posterization (Effects > Tonal Control > Posterize) to create all these variations. You can do the same for your own imagery. It's a useful exercise to create a series of variations like this of both your source image and your painting. It makes seeing blocks of light and dark easy. The set of images on the lower right shows just the brightest highlights against black. This is useful for making sure you painting captures the lightest highlight areas.

Choose a Point of Interest

As you approach your subject ask yourself what your source image says to you. I often find that a source image calls out to be depicted in a certain way, or with a certain emphasis. Decide what point of interest you wish to draw the viewers' attention to in your painting. What story do you wish to convey? What emotion do you wish to evoke? What single visual element is most important? What relationship within your composition is most important?

The center of interest in *Impassioned* is the intense connection between the dancers. I see a dynamic triangle of important connection points (Figure 4.4) in the composition: where their foreheads touch, their hands meet and Jaimes' right hand cradles Mariana's back.

Choose a Point of View

Decide what technical and artistic approach you wish to take. Does the mood of your subject suggest certain choices of brush strokes, media or color palette? Decide what vantage point you wish to place the viewer in. What perspective do you wish to give your painting? How deep or narrow do you wish your depth of field to be (determining what you depict in focus and what out of focus)? How dramatic do you want your composition to be? Visualize your completed painting. How big do you see making your painting? Consider the impact of scale on the power of the finished artwork.

129

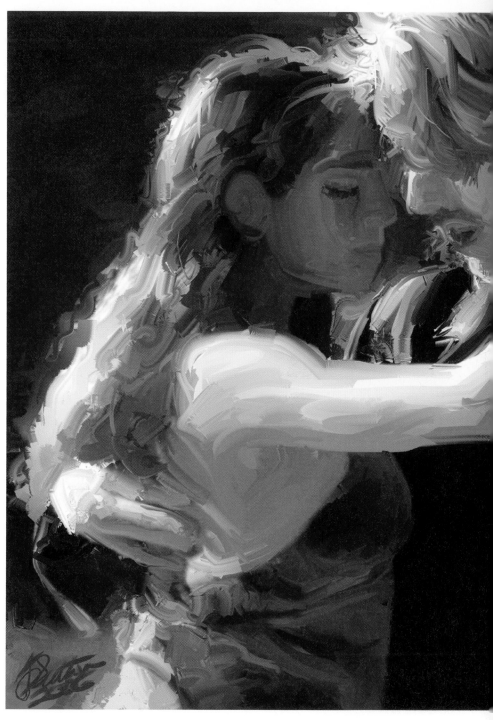

Figure 4.2 *Impassioned*, 2006, 28 × 38 inches. Portrait of professional Argentine Tango dancers Mariana Dragone and Jaimes Friedgen.

Figure 4.3 The source photo for *Impassioned* and various interpretations of how the image looks as you walk away and half close your eyes.

These design choices are informed by more than just what your subject looks like. They are influenced by the complete context of who you are, your experience and your goals. Every artist will interpret a subject differently. Part of the beauty of Painter is that it allows for so much individual freedom of expression and interpretation. From the choices you make to the questions outlined here, all your compositional decisions will follow.

As soon as I saw the photograph I captured of Mariana and Jaimes I pictured a powerful painting with thick bold brushwork and strong tonal contrasts. I knew I wanted to focus on the deep

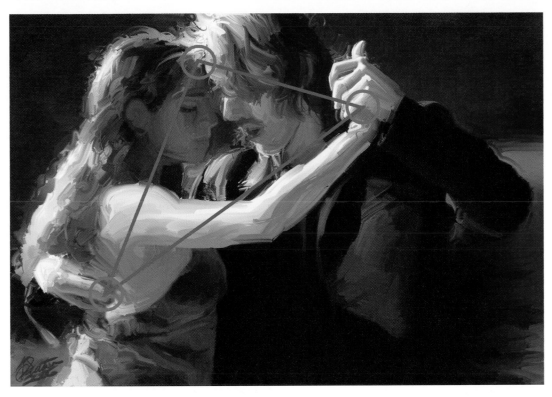

Figure 4.4 The triangle of connection between the dancers. The corners of the triangle are the main points of interest.

emotion and passion of the dancers, not on the surface details of how they looked. This point of view guided the way I approached the painting. My initial muck up was raw and wild. I used the Jeremy's MishMash Scumble brush. After that energetic start I struggled with this painting, taking it in several directions (Figure 4.5) until I settled on the simple rawness of the Sargent Brush with a limited color palette.

Composition

Boundary

A critical part of composing your painting is your choice of where you set the boundary of the canvas with respect to your subject. Think in terms of the whole composition, including the edge of the canvas, not just in terms of an individual isolated subject within a background. Try out different possibilities and see what works best. With digital photography you can conveniently try out

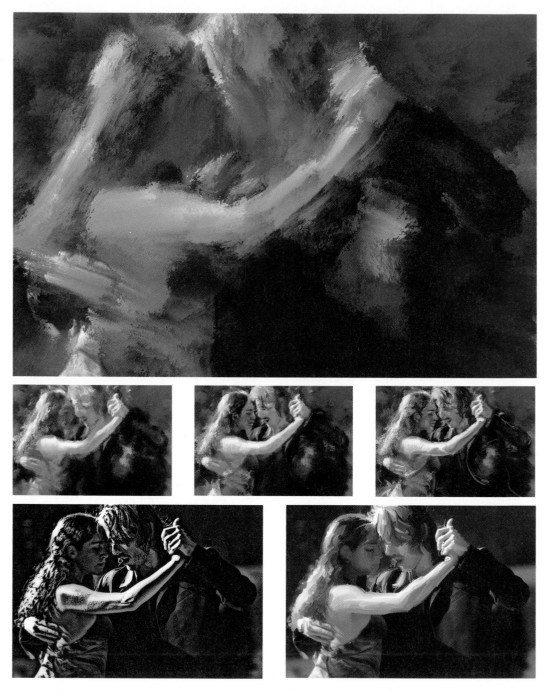

Figure 4.5 Various stages that *Impassioned* went through including the Jeremy MishMash Scumble muck up (top), bright and colorful versions that ended up too tight and precise (middle row), a woodcut version (bottom left) and the Sargent Brush painting (bottom right) that led to the final painting.

alternative crops (see Chapter 5—Painting from a Photograph). When painting from direct observation of nature you can use your hands or a rectangle cut out in a piece of card to experiment. When painting digitally you can use crop or selection tools to experiment.

As you try out alternatives half close your eyes and look at the interlocking shapes of subjects against background (contour shapes) and blocks of light and dark (tonal shapes) that are created by the choice of boundary. You can look at your subjects as positive space and your background as negative space. Both contour shapes and tonal shapes are visual elements that are affected by our choice of boundary. Answer the following questions:

- What are the shape, scale and relative positions of these main blocks of positive and negative space and of lights and darks?

- What are the rhythms, patterns and repetitions in the way different elements relate to each other?

- Do you see strong shapes like dynamic triangles and strong lines like diagonals?

- How does energy flow in the composition?

- What are the directions of movement?

- Are there visual coincidences that distract the eye, such as the edge of an arm coinciding exactly with the edge of the canvas? If so try another framing option that either creates space between the arm and the edge of the canvas, or clearly crops into the arm.

- What are the positive and negative shapes carved out by the outside contours of your subject and the outside boundary of your composition? Notice how some sets of shapes work better together than others. Varied, interesting, moderately proportioned, non-symmetrical and contrasting shapes work well.

Not only do the internal shapes within your canvas edge count, but also the canvas aspect ratio (height to width), symmetry (rectangle or square) and orientation (portrait or landscape).

The example shown here is a photograph I took of Joan and Mitch Bostian on Bolinas beach, California, at the same location where they were married. Joan was wearing her original marriage veil. The photograph captured their love and laughter. In preparing to create a painting, which I titled *Love Laugh*, based on this photograph I first experimented with different crops. I tried a couple of square crops (images 1 and 2 in Figure 4.6) since a square, through its symmetry, seemed to echo the spirit of two people coming together as a whole. I tried one portrait crop (image 3 in Figure 4.6) and one landscape crop (image 4 in Figure 4.6).

To better assess these choices of crop (or not to crop) I looked at the compositions in terms of contour shapes (positive and negative space, shown in Figure 4.7) and in terms of tonal shapes (lights and darks, shown in Figure 4.8).

Look at all these representations of the crop options and decide for yourself which you would choose or what different crop you would make. Which set of interlocking shapes works best?

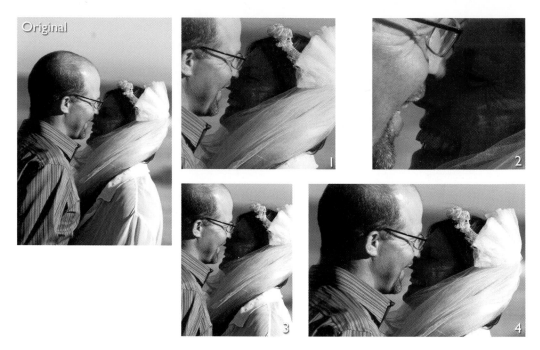

Figure 4.6 Crop experiments.

Figure 4.7 Positive (red) and negative (blue) contour shapes.

136

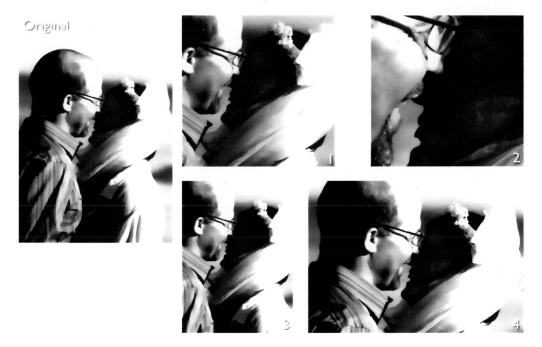

Figure 4.8 Light and dark tonal shapes.

You can see which I chose by seeing the final painting I created (Figure 4.9). Notice that I decided to crop in a little on the right hand side compared to the original crop (image 4). This was because I didn't like the visual coincidence of having Joan's veil almost, but not quite, touching the right edge of the canvas. Overall I liked the balance of positive to negative shapes, and lights to darks, in image 4. The image 4 crop seemed to focus attention more on the relationship between Joan and Mitch compared to the original photograph where there was more of their shoulders an arms showing.

Making Contour and Tonal Shape Comparisons

Making your own contour and tonal comparisons, as you see illustrated here in Figures 4.7 and 4.8, is a handy way to assess crop choices. In "Crops and Composition" in *Chapter 5—Painting from Photographs* you will learn the Paste into New Image Crop system. Once you have a series of crops you can do the following treatments for each crop image as well as for the original uncropped source image.

1 Choose File > Clone.

2 Take the Saturation slider to minimum in the Underpainting palette.

137

3 With the clone copy active, choose Shift-Cmd-N/Shift-Ctrl-N (Layer > New Layer).

4 Make sure Preserve Transparency in the Layers palette is unchecked.

5 In the Brush Selector choose the Pens > Scratchboard Tool.

6 Make sure brush opacity is 100%.

7 Choose red as the main color.

8 Start painting (on the new layer) closed shapes, that is, lines that join up so they completely enclose an area of the image, with the red Scratchboard Tool. These lines should follow the contours of the subjects and the canvas edge. They don't have to be precise but they must end up closing in a shape.

9 Choose Shift-X. This swaps the main and Additional colors and thus puts the red color in the Additional Color square.

10 Choose blue.

11 Now make closed shapes that follow the boundaries of the background and canvas edge.

12 Choose the Paint Bucket Tool (keyboard shortcut "K").

13 With the blue still chosen click in all the closed blue shapes. This will fill in the blue shapes with solid blue. If the blue leaks out that means your lines weren't closed. In that case undo the Paint Bucket fill and close the line and try again.

14 Choose Shift-X. This brings red back to be Main Color.

15 Click with the Paint Bucket in the red shapes.

16 Set the layer Composite Method to be Gel.

17 You now have your contour shape layer.

18 To get the tonal shapes return to the image.

19 Choose File > Clone.

20 Take the Saturation slider to minimum in the Underpainting palette.

21 Take the Smart blur slider to about 50% in the Underpainting palette.

22 Choose Cmd-E/Ctrl-E (Effects > Tonal Control > Equalize).

23 In the Equalize window pull the black and white points in towards the center of the histogram. This exaggerates the contrast and reduces the image to the main blocks of light and shadow, giving you the tonal shapes.

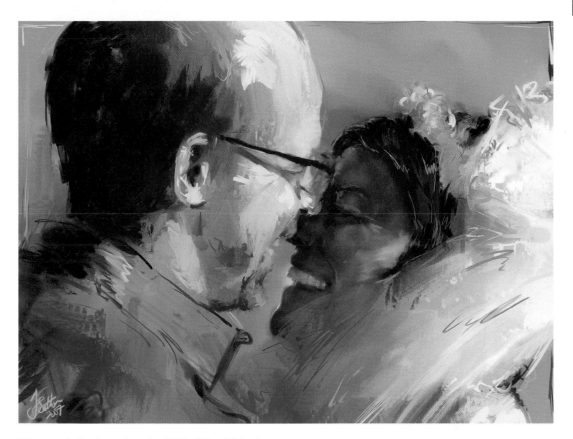

Figure 4.9 *Love Laugh*, 2007, 26 × 34 inches.

Key Contrasts

Observing key contrasts is essential for being able to successfully depict, and even exaggerate, them in a painting. I use the word "key" here to mean important, as opposed to referring to key in the context of images being "high key" (predominantly dark) and low key (predominantly dark).

1 Through careful observation identify where the lightest lights (key highlights) and darkest darks (key shadows) are in your subject.

2 Observe where the greatest tonal contrast is between adjacent light and dark areas (key contrasts). Besides the difference in tone between the lights and darks, this is also influenced by how sharp, smooth and straight the border is between the light and the dark regions.

3 Observe where the straightest contours are. All these points will draw the viewer's attention if depicted accurately as you observe them in your subject.

Consciously choose where you wish the most powerful contrasts to be in your composition. These may not correspond exactly to your subject. All contrast effects are relative so every part of your

composition plays a role in supporting the key contrasts. The energy and dynamism of a painting derives from the tension between opposites. Make a concerted effort to strongly and boldly depict your lightest lights (key highlights) and darkest darks (key shadows), and the places of greatest contrast between light and dark (key contrasts). Don't be timid about making use of the full tonal range.

In Painter you can get an idea of the tonal strength of your painting by seeing it as a grayscale image. You can do this by choosing Window > Underpainting and taking the Saturation slider all the way to the left (−139%). This is the computer equivalent of half closing your eyes and seeing just tonal relationships. Clicking on the Reset button in the Underpainting palette returns your painting to full color. It is useful to make a habit of checking this from time to time and evaluating how effective your use of tonal contrast is.

My painting Moment in Time (Figure 4.10) has a key contrast edge where Darren's head contrasts against the dark background. The key highlight is the upper right of his forehead. I bought out the key highlight by using a touch of light teal, a complementary color (from the opposite side of the color wheel) to the warm skin color around it.

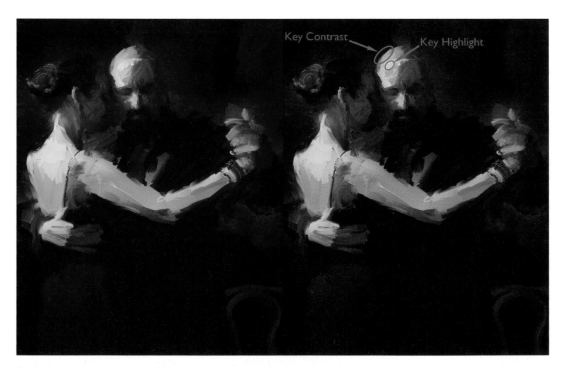

Figure 4.10 *Moment in Time*, 2004, 38 × 48 inches. Portrait of professional Argentine Tango dancers Christy Coté (www.christycote.com) and Darren Lees shown in full color and desaturated. Note the key contrast and highlight.

If the grayscale version of your picture looks flat and mostly mid-tone gray then you know that you need more tonal contrast. You can easily enhance your contrasts and ensure your lights are

really light and your darks are really dark by using the Equalize command (Cmd-E/Ctrl-E or Effects > Tonal Control > Equalize). Equalize applies an automatic adjustment to the black and white points of your image histogram which ensures your image has light lights and dark darks. If the Equalize effect is too strong choose Edit > Fade immediately after applying Equalize to fade back the effect. Take some finished images of yours and experiment with applying Equalize. You may be pleasantly surprised at the difference it makes.

Why Tonal Contrast and Edges are so Important

There are many different types of contrasts that you work with in a painting. These include:

- Lights and darks.
- Complementary colors.
- Saturated and unsaturated colors.
- Warm and cold colors.
- Sharp and soft edges.
- Straight and curved contours.
- Thick and thin lines.
- Regular and irregular rhythms, patterns and repetitions.
- Detail and lack of detail.
- Coincidence and lack of coincidence.
- Decline and incline diagonals.
- Horizontal and vertical forms.
- Symmetry and asymmetry.

Thus far we have focused on tonal (also known as value or luminescent) contrast—the contrast between perceived lights and darks. The reason for this is that tonal contrast underlies all others. To understand why this is it is instructive to understand how we see. Our visual perception system comprises of a colorblind Where system sensitive to luminescent contrast (this identifies where something is, what three-dimensional form it has and how it is moving), and a What system sensitive to color contrast (this identifies and recognizes what it is we are seeing and what color an object is). The colorblind Where system has a higher sensitivity to small differences in brightness, and is faster, than the What system. Thus biologically we are programmed to be visually more sensitive to tonal contrast than other types of contrast. Once you have your tonal contrasts working in a painting, you can use almost any colors compatible with that tonal contrast (just look at the work of Fauvists such as Henri Mattisse). Both the Where and the What systems respond to edges more than diffuse light and that is why the quality of edges (sharpness, direction, straightness and so on) and the contrasts between each side of an edge are so important in painting.

(See "Vision and Art: The Biology of Seeing" by Margaret Livingston to learn about this in more detail.)

Having said this, every type of contrast mentioned above plays a role in the strength and effectiveness of your painting. Besides sculpting with tonal contrast, see if you can include the full range of the other contrasts in your work wherever possible.

Use the Full Range of Your Tools

Push your brushes to their full range of expressive mark making. Challenge yourself to see how much variety of marks you can make with every brush you use. In *Love Laughter* I used a wide variety of types of brush marks, some short dabs and some long strokes (Figure 4.11).

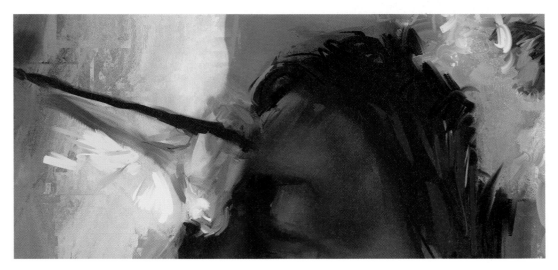

Figure 4.11 A detail of *Love Laughter* showing the range of brush marks.

Start General

Start with big, bold, rough marks on your canvas (Figure 4.12). Paint with gusto and vigor! Quickly map out the major blocks of light and dark tones.

Work Towards Selective Detail

Gradually work in selective detail, continually checking the tonal contrasts and relationships and making adjustments as needed. Err on the side of less detail than more. Engage the viewer as an active participant by leaving some things to their imagination.

Paint Color in the Lights and Darks

Paint a rich diversity of color into your lights and darks while keeping the perceived tone of those areas light and dark. Avoid pure white or pure black. This is particularly a challenge when working from photographs since photographs often have areas of flat light or shadow and do not have the richness of color in those regions that a painting has. Compare my original photograph (Figure 4.13) on which my impressionist painting *Summer Afternoon* was based with the final painting (Figure 4.1). Note how

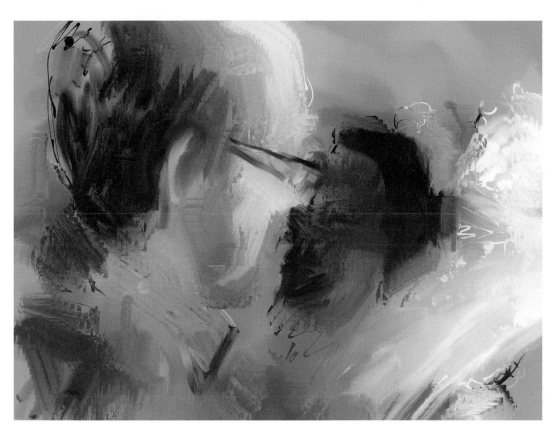

Figure 4.12 An early muck up underpainting stage of *Love Laughter* showing energetic bold brush work.

Figure 4.13 Source photo for *Summer Afternoon* compared with the final painting. Note how much more color is brought out in the highlights and shadows of the painting versus the photograph.

I worked in so many colors into both the light areas (Figure 4.14) as well as the shadows (Figure 4.15). These colors help bring the artwork to life and evoke the Great Gatsby atmosphere.

Figure 4.14 Detail of *Summer Afternoon* note the variety of colors in the light areas.

Figure 4.15 Detail of *Summer Afternoon* note the variety of colors in the shadows.

Make Every Mark Meaningful, Intentional and Varied

Make every mark count. Make every brush stroke intentionally contribute to your design goal. Vary something with every brush stroke, whether it be the shape, direction, thickness, settings tone or color. Use your brush directions to sculpt your forms (Figure 4.16). Avoid repetitive brush strokes of similar color, tone, orientation and structure—they will make an area look dull and flat. Variety of line quality and brush marks will liven up your painting.

Break Up Regularity

Avoid rhythmic regularity of visual elements that form a repeating pattern in the painting. Such regular repetition distracts the eye and reduces the dynamic movement in the composition. Use your paint to offset, alter and disrupt such regularity (Figure 4.17).

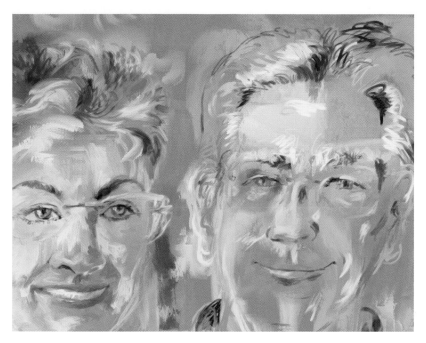

Figure 4.16 Detail from portrait of John and Linda Miller that shows how the direction, thickness, color and tone of each brush stroke contributes to sculpting the three-dimensional forms.

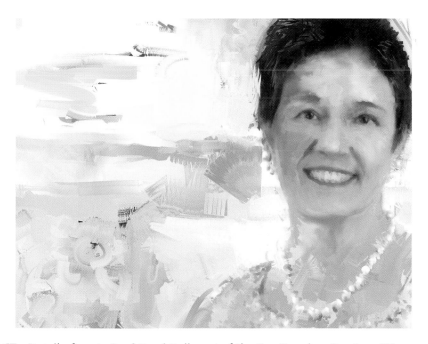

Figure 4.17 Detail of portrait of Carol Doll, part of the San Francisco Bay Area Women of Style series. Shows use of varied brush strokes to break up horizontal line.

145

Conclude with a Dash of Spice!

Just as in cooking a great dish, a painting can often benefit from a little dash of spice added as a final touch. Use a few select brush strokes to add final accents (Figure 4.18) and ensure you are using your full tonal range. These concluding dashes of panache can energize an already dynamic composition.

See how many of these suggestions you can incorporate into the next two exercises.

Figure 4.18 Detail from portrait of Anna Freiman, another in the series San Francisco Bay Area Women of Style. Notice the dashes of acrylic paint in the hair to add that finishing touch. You can see the full portrait in Chapter 5 (Figure 5.10).

Draw a Still Life

1 Get out the Cachet 6×6 inches sketchbook and Caran d'Ache crayons recommended in Chapter 1. If you have other drawing materials and tools that is fine.

2 Open the sketchbook on a free page.

3 Open the crayons and pick a dark color.

4 Take a line for a walk, as Paul Klee would say. Move the crayon on the paper and vary the quality of the line as you do so. Try varying the angle and pressure of the crayon as you move it.

5 Press hard and make the densest, heaviest mark you can.

6 Try again and press even harder! Don't be afraid of breaking the crayon.

7 Tear out a plain sheet from your sketchbook. This will be a 6×6 inches white square piece of paper. If you are using another dimension of paper just cut it down to be a square sheet.

8 Fold together two opposite corners of your torn sheet so it forms an isosceles triangle with two short equal sides and one longer side.

9 Fold together the corners at the ends of the longer side to create a new smaller isosceles triangle.

10 Starting half way along one of the short sides, use a pair of scissors to cut straight across to the point half way along the other short side. This cut will chop off the top of the triangle.

11 Open up the remaining triangle base of the folder paper and you will find you have created a small square paper frame with a 3×3 inches square window cut out of the center. I call this a composing window.

12 Set up a simple still life object (which could be a sculpture, vase of flowers, etc) on a small table.

13 Set up a lamp close to the still life to illuminate it softly from one side. If there are other light sources around that is fine.

14 Sit yourself close enough to the still life so that if you lean forward you can touch it comfortably.

15 Hold the composing window in your non-favored hand (if you draw with your right hand hold the frame in your left hand) between your eyes and the still life.

16 Move the composing window back and forth between your eyes and the still life. Half close your eyes. Note the shapes of light and dark and how those shapes intersect the edge of the composing window frame. Don't worry about what your subject is. Just observe lights and darks and how they relate to each other.

17 Decide on a distance at which to hold the composing frame in which you like the abstract forms created by the light and dark shapes. The edge of the composing window will serve as reference for the edge of the sheet of paper you are about to draw on in your sketchbook. If you are using a sketchbook with rectangular sheets mark with crayon a large rough square that goes almost to the edge of the rectangle and use that square to represent the composing window.

18 Use your dark crayon to map out the dark shapes, making the heaviest, densest marks (as heavy an dense as before when you were testing out the crayon's range of marks) where you see the darkest shadows in your composition through your composing window (Figure 4.19). Leave white paper showing through only where you have the lightest shapes. Draw right to the edge of your paper.

19 Step away from your still life, taking your drawing with you. From a distance hold up your drawing and look back and forth between it and your still life. See how successful you have been in capturing tonal relationships and shapes. Does your drawing really capture the depth of tonal range. Are your deepest shadows really deep?

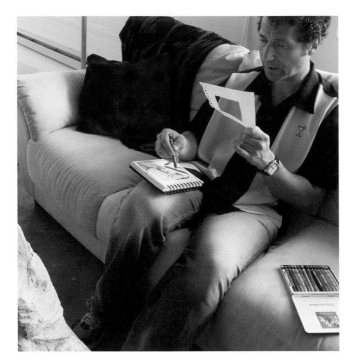

Figure 4.19 Sketch a still life using the square cut out (Photo by Peggy Gyulai).

20 Return to sit down with your composing window and make any adjustments as a result of what you observed when you stepped away.

21 Repeat this process until you are satisfied you have a strong tonal representation of the shapes you see in your composing window.

As a further exercise try using a mid-tone paper (you could use one of the colored papers in the Canson Mi-Teintes Muted Colors pack) and a light colored crayon for highlights and a dark crayon for shadows. Make sure you press down heavily with each crayon in the lightest and darkest areas. In Chapter 6 *Going for it With Color* you will build on this still life exercise with a digital still life assignment where you work with depicting lights and shades in color.

Paint a Self-Portrait

1 Position a small mirror next to your computer screen angled so that you can see yourself.

2 Place a small lamp near you so your face is illuminated.

3 Open Painter.

4 Open the patterns image you saved as TxtrPtrnExpt-yy-patternplay.rif in your TxtrPtrnExpt project folder (Chapter 3).

5 Choose Shift-Cmd-S/Shift-Ctrl-S (File > Save As).

6 From within the Save As window, make a new project folder inside your PXC Projects folder. Call this new project folder "03 DesignCmpstn"

7 Save the file in your 03 DesignCmpstn project folder as SqSelfP-01-abstract.rif.

8 Choose a brush in Painter you'd like to paint with. Paint a large rough square over your abstract.

9 Choose Shift-Cmd-S/Shift-Ctrl-S (File > Save As).

10 Save the file in your 03 DesignCmpstn project folder as SqSelfP-02-squ.rif.

11 Hold the composing window in your non-favored hand (if you draw with your right hand hold the frame in your left hand) between your eyes and the mirror.

12 Move the composing window back and forth between your eyes and the mirror. Half close your eyes. Note the shapes of light and dark and how those shapes intersect the edge of the composing window frame. Try to disconnect yourself from the fact you are looking at your face. Focus on observing the lights and darks and how they relate to each other.

13 Decide on a distance at which to hold the composing frame.

14 Looking back and forth between the mirror and your screen, and without undoing or erasing anything, paint a self-portrait on top of your abstract. Paint to the edge of the rough square you painted earlier (Figure 4.20).

Figure 4.20 Paint a self-portrait using the square cut out (Photo by Peggy Gyulai).

15 Remember to Save As regularly as you build up the self-portrait, adding a new sequential version number each time.

16 Regularly step back and compare your tones.

17 Experiment with the Equalize (Cmd-E/Ctrl-E) and see if that helps extend your tonal range.

18 When you feel you have reached a point of completion choose Save As, add the next version number, and after the version number add the note "FINAL", for example: "SqSelfP-zz-FINAL.rif", where zz is whatever version number you are up to, and save it in your 03 DesignCmpstn project folder.

5

Painting from a Photograph

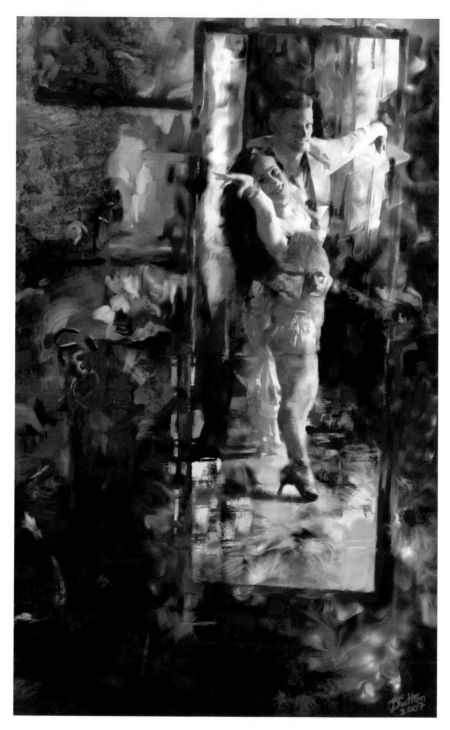

Figure 5.1 *Dancing in the Mirror,* 2007, 36 inches × 60 inches.

In this chapter we consider ways that you can use a photograph as a basis for creating an expressive painting. Before diving into techniques let's examine the difference between a photograph and a painting, and understand the benefits of transforming a photograph into a painting.

Why Paint from a Photograph?

Photographs can be beautiful works of art in themselves and don't necessarily need any modification or transformation to enhance their power or beauty. Fine art photographs taken with long or multiple exposures, soft focus and so on, can look more painterly than photographic. In these cases it may not be appropriate or beneficial to use such photographs as a launching pad for paintings.

In many cases creating a painting based on a photograph dramatically enhances the emotional impact, power and beauty of the image and transforms a good photographic image into a magnificent work of fine art. Paintings can have a much greater and richer range of color, tone, detail and contrasts than is present in a photo. Through paint you can shape, fine-tune and control the focus, the story, the message. Creating paintings from your photos is a great opportunity to expand your creativity, as well as have fun!

Photographs and paintings present two quite different ways of depicting the world—one involving the capture of a fleeting moment through the use of film or a charged couple device (the detector in most digital cameras) and the other involving the continual transformation and development of imagery over time through the build up of paint. Here is how these differences typically manifest themselves and what a painting can offer that goes beyond a photograph:

- Generally a photograph presents us with a constrained single point of view compared to a painting that can capture multiple points of view. Our perception of the world is made up of a continually moving frame of reference and multiple points of view. It is this perceptual experience that can be emulated more closely in a painting than in a photograph.

- The photograph captures light at one moment in time whereas a painting can capture light as it changes over time.

- The photographic image reflects a focal plane and spherical aberration determined by a given lens and aperture setting. The artist has complete freedom in a painting to pick and choose what is in focus and out of focus and what sort of distortion is placed on the view. Generally there is a lot more detail in a photograph compared to a painting and compared to what we see in the world. The human visual perception system only sees a small region of the world in focus at any one moment. A painting can better engage the viewers' imagination through suggestion than a photograph.

- The film or charge couple device determines the physical size and aspect ratio of a photographic image (or at least the raw data). A painting can be made to any size and aspect ratio.

- The film or charge couple device determines the limited range of color and tone in a photograph, which is significantly less than the richness of the color and tone range possible with paint, which in turn is less than what we see in nature.

153

Does Use of Photography and Digital Technology Devalue a Painting?

The confluence of digital photography and digital painting has created the perfect storm of exciting possibilities. Today it is easier than ever to harness photography as a basis for painting. As with all technological advances in the fine art field, you may come across the notion that the use of the latest technology, and even the use of photography at all, is cheating and lessens the value of the art. That notion belies a lack of understanding about the historic synergistic relationship between artists and technology. Ever since Paleolithic artists used red ocher pigment to draw the local animals and placed their handprints on the walls of the Chauvet-Pont-d'Arc Cave in France over 30,000 years ago, humans have harnessed whatever pigments, tools and technologies lay at their disposal to make imagery.

Neither Leonardo da Vinci's use of the camera obscura in the fifteenth century (Figure 5.2) to project scenes onto a flat surface to get accurate proportion and perspective in his

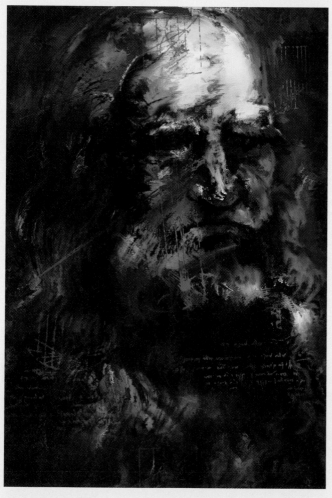

Figure 5.2 *Leonardo da Vinci,* 2007.

154

paintings, nor Edgar Degas' use in the nineteenth century of photographic reference for some of his paintings, made their paintings any less legitimate, real or valuable. Da Vinci and Degar are just two of a multitude of Master Painters in history who have used optical devices and technology to mechanically transfer a depiction of the three-dimensional world onto a flat surface.

With the advent of almost every new art medium in history there has been initial resistance to its acceptance as a valid fine art medium. In his foreword to my book "Secrets of Award-Winning Digital Artists" (Wiley, 2002) artist Peter Max shared his experience: "During my second or third year of art school, new types of paint emerged on the scene. They were called acrylics. I remember the numerous debates and conversations about whether or not acrylic paintings would be considered fine art. I thought to myself that art is not so much about the medium it's done in than it is about the creativity. In acrylic paint I was able to paint thicker, and more spontaneously, with many layers. The paint dried faster, so it was an obvious advantage. The debate, however, raged on." The debate as to the acceptance of digital paint as a valid fine art medium is now waning as more and more prestigious galleries and museums (Figure 5.3) embrace this new paint medium. As John Derry points out in the foreword to this book, there is a maturing of both the medium and its proponents.

As with any new paradigm, there are issues of language, meaning and perceived value in making and selling digital fine art paintings, or art that mixes digital and non-digital media.

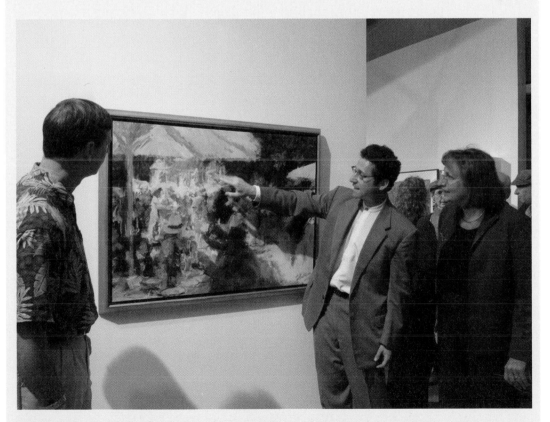

Figure 5.3 *Summer Afternoon* on display at the di Rosa Preserve: Art & Nature, Napa, California. (All in the Family IV Group Show, 2005.)

What is the "original" of a digital painting? How do you describe a digital painting once it is output on canvas and traditional media has been added? How do you decide whether to make identical multiples or varied multiples (each with different post print treatments) and what do you call them? How do you verify a limited edition from a file that doesn't degrade? These issues are still ironing themselves out.

There is no need to apologize for any tools or media you use. It is not whether you use oil or acrylic or Painter or a mix of media that counts, but what you bring of yourself into your art. As the big band swing song (Figure 5.4) performed by Jimmie Lunceford (written in 1939 by Sy Oliver and J. Young) goes: "T'ain't what you do, it's the way hatcha do it. That's what gets results."

Figure 5.4 *Swing Out*, 2005, 40 inches × 52 inches. This painting depicts Lindy Hop swing dancing, a dance that captures the spirit of the big band swing music.

Ways to Paint from a Photograph

There are many ways to use a source photograph as a basis for creating a painting. Many of the ways use the source photograph merely to accurately reproduce the proportions and perspective of the composition, sometimes at a larger scale, in the painting. They often leave the painting details to the artists' eye rather than mechanical transfer. Historically there have been a panoply of drawing devices and image transfer optical systems. Here are some contemporary examples of techniques for

translating imagery from a photograph to a painting (I use the term "traditional" to signify applicability of the technique to non-digital media):

1 Freehand Painting (Traditional or Digital)—Stick a print of the photograph next to your canvas or have it visible on your computer screen while you paint, and look back and forth between the photograph and your canvas as you paint.

2 Grid Painting (Traditional or Digital)—Place a grid over your photograph and a grid of the same number of divisions over your canvas, and paint square by square (or rectangle by rectangle), looking back and forth between the photograph and the canvas. On a traditional canvas you may lightly draw the grid on with pencil. In Painter you can use the Layout Grid.

3 Projection Painting (Traditional and Digital)—Projecting a photographic source image (or a hand sketch) onto a painting surface, using either an opaque projector (for projecting from a hard copy print) or a digital projector (for projecting from a digital image).

4 Over Painting (Traditional or Digital)—Literally painting directly onto your photographic print, in the traditional world, or over a photographic image in the digital world.

5 Image Transfer Over Painting (Traditional Only)—Transfer a laser color copy or inkjet print of the source photograph onto another substrate using appropriate solvents or transfer medium and then paint over the transferred image.

6 Tracing (Traditional or Digital)—Using tracing paper to transfer detail from the original photograph to your canvas. Traditionally you may reverse the tracing paper and rub off the pencil marks, or push hard to transfer the indents into your drawing paper, or push pins through the tracing paper at critical reference points, or use the tracing paper itself as your final painting substrate and paint over the tracing. Digitally, in Painter, you could use File > Quick Clone and paint while seeing the source image depicted in digital tracing paper.

7 Cloning (Digital Only)—Creating a clone copy in Painter and using cloning brushes to pick up color from the source photograph while you paint into the clone copy canvas.

Within any of these different technical ways to translate and refer to source imagery, there are also many different artistic approaches to building up a painting. For example, some artists carefully map out the entire composition in pencil and then fill in with color while others dive right in with bold color fields and develop detail later.

I encourage you to experiment with and combine techniques. Whatever combination of techniques you choose to use, treat your photo as a catalyst for exploration.

Principles of Painting from Photos in Painter

1. Establish consistent P-V-N file naming convention

Starting with your original source photograph, use the Save As command and give all your files for any given project meaningful, organized and consistent names with the P-V-N (Project-Version-Notes) structure introduced in Chapter 1:

[Project]-[Version]-[Notes].rif

Keep the project name short, preferably eight or less characters. Make the version number two digits, starting with 01, 02, 03 and so on. In Notes make abbreviated code for the brushes you use, for instance "jmmscmbl" for Jeremy Faves 2 > Jeremy's Mish Mash Scumble. Save all your project files, including your renamed original source photograph, in a common project folder.

2. Paint on a copy, not your original

Whenever you are working from a photograph in Painter, always work on a clone copy, not on the original image.

3. Rename clone copies right away

Rename your clone copies as you generate them, using Save As, deleting the "Clone of" (including the space after "of") and following the same consistent P-V-N file naming convention as outlined above.

4. Regularly do a "Save As"

At least every 10–20 minutes use the Save As command to save sequentially numbered versions of your work in progress as RIFF files, following the same consistent P-V-N file naming convention as outlined above. Always do a Save As prior to dropping layers.

Whatever you do to your photographs with Painter's breadth of tools, effects, art materials and brushes, I recommend following these general organizational principles and the suggestions in Chapter 4 on Design and Composition.

An Expressive Approach to Painting

The way I work from photographs in Painter has four main stages:

I Prepare the Source Image

II Create a "Muck Up" Underpainting

III Selectively Reveal the Subject

IV Further Develop the Painting

I shall explain these four main stages in more detail and then review ideas for generating variations.

I Prepare the Source Image

Select and Observe the Source Image

1 Select a source image that calls out to you to be painted. The photograph (shown in previous chapter, Figure 4.2) I used as a basis for *Summer Afternoon* called out to me as soon as I saw it. There was no doubt in my mind that I had to create an impressionist painting from it. For this exercise I'd like you to give yourself permission to create a painting for yourself, not for a client, relative or friend. I want you to be asking yourself what you think of your painting, not speculating what someone else thinks and whether they'll like what you've created. Select a photograph that moves you and motivates you.

2 If your source file is a RAW file open it in your RAW browser (see sidebar on Preparing an Image in Photoshop), or if a JPEG open it in Painter.

Preparing an Image in Photoshop

- If you opened a RAW image in Adobe Photoshop:
- Choose Layer > New Adjustment Layer > Levels.
- Adjust the Levels black and white points to increase contrast.
- Choose Layer > New Adjustment Layer > Hue/Saturation.
- Increase the saturation slider slightly.
- Choose Shift-Cmd-S/Shift-Ctrl-S (File > Save As).
- Save a layered RGB Photoshop file with name ProjectName-00-adjlyrs.psd in a new project folder called "04 ProjectName", within the PXC Projects folder, where ProjectName is whatever project name is appropriate for your image subject.
- Choose Flatten from the Layer menu.
- Choose Shift-Cmd-S/Shift-Ctrl-S (File > Save As).
- Save as a flat RGB TIFF file with name ProjectName-01-srcimg.tif.

3 Choose Shift-Cmd-S/Shift-Ctrl-S (File > Save As).

4 Save this source file as a flat RGB TIFF file with the P-V-N file naming convention (ProjectName-01-srcimg.tif) in a new project folder called "04 ProjectName", within the PXC Projects folder, where ProjectName is whatever project name is appropriate for your image subject.

5 Mount your selected source image on your screen in either Photoshop or Painter (Photoshop: click the F key twice to mount against black; Painter: choose Cmd-M/Ctrl-M).

6 Choose Cmd-0/Ctrl-0 (i.e., the numeral zero "0", not the letter "o") to zoom to fit.

7 Choose the tab key to hide all palettes, and, if needed, Cmd-R/Ctrl-R to hide rulers.

8 Get out of your chair and step away from your computer. Look back at your screen from at least 10 to 15 feet away. Half close your eyes and see your source image in terms of lights and darks only. Slowly walk back towards your screen. Stop periodically and contemplate your image. Tune into the feeling of the picture.

- What do you get from it?
- What emotion and mood does it convey and do you want your painting to convey?
- What story does it ask you to tell?
- Vision where you want to go with this image.
- Identify your main point of interest and where you want to direct the observer's attention.
- What do you see standing out and what do you want to stand out in your painting?

Crops and Composition

1 Open your source image (ProjectName-01-srcimg.tif) in Painter if it isn't already.

2 Choose the Rectangular Selection Tool in the Toolbox (click on the "R" key).

3 Drag the Rectangular Selection Tool in your source image. You are going to use this selection tool as a convenient means of experimenting with cropping options. Drag the Rectangular Selection Tool over a region of the source image you wish to crop.

4 Choose the Selection Adjuster Tool (click on the "S" key).

5 Click in the rectangular selection. You'll see control handles appear.

6 Drag on the control handles to adjust the selection.

7 When you are satisfied with the positioning of the selection choose Cmd-C/Ctrl-C (Edit > Copy, also a button on the JeremySupaDoopa custom palette).

8 Choose Edit > Paste into New Image (Figure 5.5) or click the Paste into New Image button on the JeremySupaDoopa custom palette. You'll see the selected portion of the image appear in a new window (Figure 5.6).

Figure 5.5 Using the Rectangular Selection tool with Copy and Paste into New Image.

Figure 5.6 Selection pasted into new image.

9 Choose Cmd-"–"/Ctrl-"–" (Window > Zoom Out), reduce the crop window size and move it to one side of your screen.

10 Click on the full size source image and repeat this process a few times until you have a selection of possible crop options to compare. I call this technique of cropping the Paste into New Image Crop. Do some really close crops. When you've generated a few options place them side-by-side on your screen. On a Mac you can choose F10 and see all the images open in your current application displayed at once (Figure 5.7).

11 Review the section "Choose Your Boundary" in Chapter 4 Design and Composition.

Figure 5.7 Multiple crops side-by-side.

Composition Tools

Painter offers compositional tools that can help you make boundary decisions:

a. *Divine Proportion*—A temporary reference overlay that allows you to experiment with the classical divine proportion, also known as golden section. This divine proportion can be helpful in offsetting your subject from the center.

b. *Layout Grid*—A temporary reference overlay that allows you to superimpose a grid dividing up the sides of the canvas by any number you specify (one standard grid option is the Rule of Thirds 3×3 grid).

c. *Perspective Grid*—A temporary reference overlay that provides arrays of lines that converge on a vanishing point.

d. *Canvas Size*—Allows you to add extra canvas of any color (which you need to specify in terms of pixels) around your image.

The shipping version of Corel Painter X includes a small plastic wallet with the three compositional overlays printed on clear plastic so you can hold them up in front of you and use them as reference independently of the computer. The bottom-line, whether you make use of guidelines and grids or not, is simply does it look good to you. I suggest you let your intuition inform you which crop looks best before using composition tools like the Divine

Proportion. Trust your eye. It may be that you decide that no crop (that is the original uncropped source image) looks best and that is fine. Generate the comparison files anyway.

12 With one of your crop options as the active file in Painter, choose Window > Show Divine Proportion.

13 Check the Enable Divine Proportion in the Divine Proportion palette. You will see an overlay appear on the current active image.

14 Choose the Divine Proportion Tool (keyboard shortcut '>').

15 Experiment with the size and orientation of the Divine Proportion overlay. Compare the aspect ratio (height to width) and points of interest you chose by sight to the Divine Proportion overlay (Figure 5.8). You can use the Divine Proportion overlay to guide a further crop either using

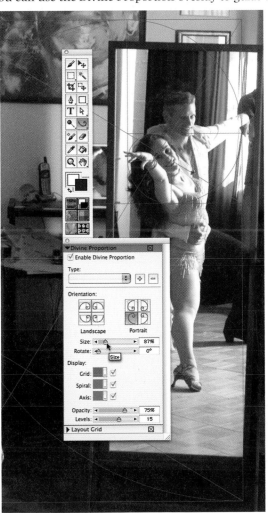

Figure 5.8 Viewing the Divine Proportion overlay.

the Rectangular Selection tool with Paste into New Image or using the Crop tool. The Crop tool keyboard shortcut is "C". Click within the crop dancing ants to complete the crop.

16 Repeat this for all the crop options.

17 Decide which crop option you feel works best. Uncheck Enable Divine Proportion.

Adding Extra Canvas

Follow these steps if you wish to add canvas to any image:

 i. Choose the Dropper Tool in the Toolbox (click on the "D" key).
 ii. Click in your image to pick up a color which you'd like to use for the extra canvas.
 iii. Choose Canvas > Set Paper Color. This will set any new canvas to be your current color for this particular image (it only applies to the active image).
 iv. Choose Canvas > Canvas Size. See the pixel dimensions of the current image in the Canvas Size window. Use those dimensions to estimate how many pixels you may wish to add in any direction.
 v. Type in the number of pixels in the appropriate direction.
 vi. Click OK.
 vii. If the amount of canvas you added is too much choose the Crop Tool (click on the "C" key), drag in the image and click inside the crop area to complete the crop operation. If the amount of canvas added is too little repeat the process.

18 Click on each crop option image in turn and choose Shift-Cmd-S/Shift-Ctrl-S (File > Save As) and save them all with consistent sequential file names, such as ProjectName-02-srcimgcrop1. tif, into the "04 ProjectName" folder. They will be useful for you to look back on later.

19 Name the image you decide to work with ProjectName-aa-chosencrop.tif where aa is whatever version number you are up to. Whenever you do any Save As always add the next sequential version number.

File Size

A digital image is saved as a file of digital information. File size can mean the following:

 a. The total *number of pixels* in the file. Pixels are the basic building blocks of a digital image. The pixel file size is usually measured in units of megapixels.

 b. How much *computer memory* the file occupies. Computer memory is normally measured in mega-bytes (MB or Meg), or gigabytes (GB or Gig).

 c. The *physical dimensions* of the file as determined by the density, or resolution of the pixels. In the US, with the physical dimensions measured in inches, the resolution of the file is in pixels per inch.

File size affects how the fast the brushes respond in Painter; how large the brushes can be relative to the size of the image; the final print dimensions and the quality of the printed artwork. The following steps describe how I determine file size and resolution in Painter.

1 Choose Shift-Cmd-R/Shift-Ctrl-R (Canvas > Resize).

2 Set the units of Width and Height to be Inches if they are not already (you can set this as default in the Preferences > General).

3 Make sure Constrain File Size is checked.

4 Set the Width and Height dimensions to be the final printed dimensions you are aiming for (Figure 5.9). The Resolution will change to keep the total number of pixels constant.

Figure 5.9 Setting the physical dimensions with Constrain File Size checked.

Think Ahead

Think ahead to what print dimensions you wish to end up with. This will then determine what file dimensions to start with. If you are not sure what final dimensions you want I suggest aiming at something at least roughly 16 inches×24 inches. Most of my work ends up being printed at approximately 38 inches×50 inches. The 38 inches dimension comes the fact that my Epson 9600 printer accepts 44 inches wide canvas rolls and I allow 3 inches or so of extra canvas around my final image for gallery wrap stretching, where the painting is wrapped all the way around to the back of the stretcher bars. My choice of dimensions, besides utilizing my in-house printing technology to the maximum dimensions it can offer me, is also a scale at which I find my paintings work well.

It is not unusual for the dimensions of paintings to be the result of materials that artists happened to have on hand. Dutch artist Rembrandt van Rijn used three standard width horizontal strips of canvas sewn together to make his famous painting The Night Watch (The Company of Captain Frans Banning Cocq and Lieutenant Willem van Ruytenburch), 1642, 11 feet 3 inches × 14 feet 4 inches. French painter Édouard Vuillard frequently painted on used cardboard, taken from the bottoms of boxes used by his mother to pack the dresses which she made and sold. Moreover, as Jacques Salomon pointed out, "He remained faithful to this type of support for a long time, both for the sake of its absorbent qualities and because of the ocher or gray tone which it provided as a base for his color harmonies; later he used tinted paper for this latter purpose" (quoted from the National gallery of Australia web site www.nga.gov.au). Fellow French artists Pierre Bonnard and Toulouse Lautrec also painted on recycled cardboard supports from shirt boxes and these supports determined the physical dimensions of many of their paintings.

File Resolution

With multiple variables to contend with—physical dimensions in inches, file resolution in pixels per inch and the file size in megabytes—deciding what resolution to set, and the relationship between the three variables, can be a little confusing. My approach is to first set your end goal in physical dimensions (inches) with file size constrained. See how large your file size in MB is without changing resolution. If it's large enough there is no need to change it and add more pixels at this stage. There is no fixed rule as to how large is large enough. Many factors come into play: if your working file size is too big you will find your brushes respond slowly and the file refresh time gets too long. You will also find that as your file size gets bigger, you reduce the maximum size of your brushes relative to the size of your image (since brush sizes are set in pixels). Early in the painting process I like to be able to paint large, loose, fast responding brush strokes and therefore I do not want my file size to be too big.

Conversely if your file is too small you'll find pixilation when you zoom in. This limits, for instance, the fine detail you can add in the eyes of a portrait. Also if your file is too small and you later resize to a much larger size you'll see softening and degradation of image quality. This balance must be struck. You may need to initially do some experiments and find out from trial and error what file size works best.

To help you I will share a couple of real life examples and the decisions I made.

Case Study 1: Anna Mazzucchi Freiman

The original source photograph I used for my portrait of Anna Freiman (Figure 5.10), one of my 2006 San Francisco Bay Area Women of Style Series (exhibited in the Nordstrom Couture Department), was the equivalent of 36 inches×54 inches at 65 pixels per inch resolution. This was a TIFF file and occupied about 24 MB on my hard drive.

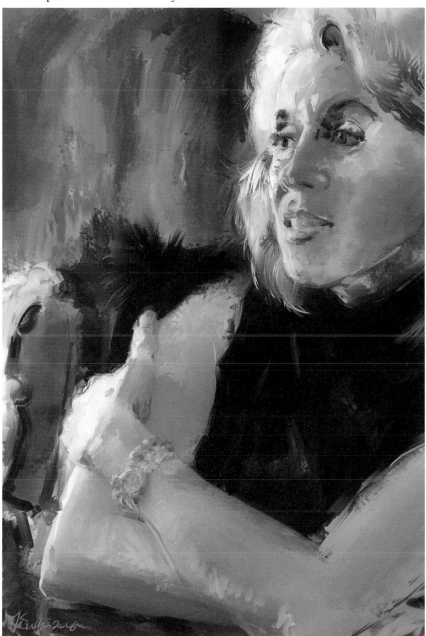

Figure 5.10 *Anna Freiman*, 2006, 36 inches × 54 inches.

After setting the dimensions to 36 inches × 54 inches I then changed the resolution from 65 to 100 pixels per inch, making a file 3600 pixels × 5400 pixels. In the Resize window, next to New Size, it indicated this would be a 75MB image file. In fact the working file never exceeded 56MB when saved as a TIFF and 46 MB when saved as a RIFF. This was a comfortable file size to handle for my Macintosh Dual 2 Ghz PowerPC G5 desktop computer.

When I came to print the portrait of Anna Freiman I resized the file up to 150 pixels per inch. I usually print from a file between 150 and 180 pixels per inch at final size. With painted images you can get away with lower resolution than with detailed graphics or photographic imagery.

Case Study 2: Dancing in the Mirror

This is the project I am using as the main example in this section. The original photograph is of professional dancers and performers Angie Major (www.angiedance.com) and Patrik Gallineaux (www.patrikpresents.com). My original file was a 7.6 MB Raw file from my Canon 20D. I opened this with the Photoshop CS2 Camera Raw plug-in. In the Camera Raw window I set the size to be the maximum which is 6144 pixels height × 4092 pixels width. This is then the pixel dimensions of the file I end up opening in Painter.

By the time I cropped the image my pixel file size ended up at 2780 pixels width × 4686 pixels height. The file size in MB of the cropped image saved as a TIFF on my computer was 32 MB though the New Size in Painter's Resize window said 50 MB (the Resize window estimate of file size always seems to be about 20–40% higher than actual). When I put in the dimension 40 inches wide in the Resize window the height was 67.4 inches (just determined by the aspect ration of height to width) and the resolution, with Constrain File Size checked, became 69.5 pixels per inch (Figure 5.9).

I was satisfied with the size of the file and left it at those settings until I was ready to print at which time I resized up (in Photoshop) from 69.5 pixels per inch to 150 pixels per inch. The resulting print was fine. I continued painting on the print and further developing the artwork.

These two examples show how much leeway you have with file size and resolution.

5 Set the Resolution such that your total file size in MB does not exceed an amount that your computer and Painter can handle comfortably.

6 Choose Shift-Cmd-S/Shift-Ctrl-S (File > Save As).

7 Save your image in TIFF format with a name that follows the P-V-N convention and includes the size and resolution in the notes section of the file name. For instance "Mirror-03-40x67at69.tif". Save the file in the appropriate project folder called "04 ProjectName", within the PXC Projects folder.

Increase Contrast and Saturation

1 Choose Cmd-E/Ctrl-E (Effects > Tonal Control > Equalize).

2 Click OK. You'll see an enhancement of the contrasts in your image.

3 If the Underpainting palette is not already visible choose Window > Show Underpainting.

4 Increase the Saturation slider in the Underpainting palette from 0% to about 50%. See the effect in your image. The goal is to warm the image up and boost the color saturation.

5 Choose Apply in the Underpainting palette.

6 Choose Shift-Cmd-S/Shift-Ctrl-S (File > Save As).

7 Save your image in TIFF format with origeqlzsat added in the notes section of the file name.

Get Rid of Photographic Grain

1 In the Underpainting palette move the Smart Blur slider to about 25%. It may take some time for the effect to be applied—it is a memory intensive effect. Smart blur is a new feature in Corel Painter X that blurs the image while maintaining edges.

2 Then try 50% (Figure 5.11) and 75% Smart Blur and see which gives a result that preserves detail while loosing the photographic grain.

Figure 5.11 Applying Smart Blur.

3 Set Smart Blur to the setting that works best and click Apply.

4 Choose Shift-Cmd-S/Shift-Ctrl-S (File > Save As).

5 Save your image in TIFF format with origsmrtblr added in the notes section at the end of the file name.

Turn Your Source Image Upside Down

1 Choose Canvas > Rotate Canvas > 180 (Figure 5.12) or click the 180 button in the JeremySupaDoopa custom palette. This turns your image upside down.

Figure 5.12 Rotating the image by 180 degrees.

2 Choose Shift-Cmd-S/Shift-Ctrl-S (File > Save As).

3 Save your image in RIFF format with orig180 added in the notes section at the end of the file name. I suggest RIFF format since you are about to start painting and it is simpler to consistently save RIFFs than wonder at every step whether you need to save as a RIFF or not.

Though it may seem odd at first to be working from an upside down source image, it has the benefit of disconnecting us from being attached to what we know things are, such as noses, mouths and so on, and allows us to see better what is actually there in the image, such as lights and darks and shapes of color.

170

Make a Clone Copy

1 Choose File > Clone (or use the clone button in the JeremySupaDoopa custom palette).

Cloning Explained

Cloning is a relationship between a source and a destination which allows certain brushes (those from the Cloners category, and brushes from other categories when the Clone Color icon activated in the Colors palette) to derive their source of color from whatever is the current clone source and apply it into a destination image. You can see what the current clone source is at any time by looking at File > Clone Source. The default clone source in Painter is the current pattern.

The destination image can be the same as the clone source image, as in point-to-point cloning, where you clone from one place in an image into another place in the same image. There is a dedicated Rubber Stamp tool (shortcut is the apostrophe key) specially for this type of operation. It can be found seven icons down on left of the Toolbox sharing a fly-out with the Cloner tool. You can set the clone source start position when working with the Rubber Stamp tool by clicking once holding down the Option or Alt key. You will see a green dot with a "1" above it, signifying the clone start position.

When starting with a source image, the clone operation, File > Clone, will generate a flat duplicate image, exactly the same size as the file you cloned from, with "Clone of " added to be beginning of the file name of the duplicate image. The Clone operation automatically sets the source file you cloned from to be assigned as the current clone source. Your clone copy is the destination image. The clone source setting is only temporary and is not a property of either the source or clone copy image. If you close Painter and return to it later and reopen the source file and the clone copy file, the source file will not be automatically clone source. You will have to manually reset it to be that (using the File > Clone Source menu).

As you saw in Chapter 2, the File > QuickClone operation does a number of operations in one. These are defined Preferences > General. By default the QuickClone will duplicate the source image (creating a Clone Copy), set the source image to be Clone Source, clear the duplicate image, turn on Tracing Paper (which allows you to see the clone source superimposed over the destination image provided they are the same size) and select the last used Cloner brush.

2 Choose the Dropper tool in the Toolbox (shortcut is the "D" key).

A Good Reason to Use the Dropper Shortcut "D"

When you have a non-clone brush active the Option/Alt key turns your current brush tool cursor into a Dropper tool which you can use to pick color from within the current image. However when the current brush is a Cloner brush, or any other brush with the Clone Color icon active in the Colors palette, then the same shortcut becomes the shortcut for resetting the clone start position, mentioned in connection with point-to-point cloning. Since it is so easy to accidentally reset the clone start position when you mean to select the Dropper tool, I suggest you use the "D" key to change your tool to the Dropper tool when you need it and the "B" key to return to the Brush tool afterwards. If you do accidentally reset the clone start position go to File > Clone Source and reset the clone source back to the source file you want it to be. If you find the registration (positioning) of your cloning is offset choose the Cloners > Soft Cloner and click the Restore Default Variant icon (left of Property Bar).

3 Click in your image with the Dropper tool and select a mid-tone color.

4 Choose Cmd-F/Ctrl-F (Effects > Fill).

5 Make sure the Fill window is set to Fill With: Current Color.

6 Choose OK.

7 Choose Shift-Cmd-S/Shift-Ctrl-S (File > Save As).

8 Delete the "Clone of" (including the space after "of") at the front of the clone copy file name.

9 Set the version number to be the next number in sequence.

10 Add "bkgnd" in the notes section at the end of the file name, adding the color you've chosen if you like (Figure 5.13).

11 Save as a RIFF file in your 04 ProjectName project folder. This file will be your working image.

Figure 5.13 Saving your image.

The "Small-Big" Arrangement

1 Choose Tab and hide your palettes.

2 Click on your source image so it is the active image in Painter (you can also select it by going to the Window menu and selecting its name from the bottom of the menu where you see a list of all files open in Painter).

3 Click and drag the title bar at the top of your source image window and move the image window so the top left of the window is neatly aligned with the top left of your Painter desktop.

4 Click and drag on the bottom right corner of your source image window and align it along the bottom of the Painter desktop.

5 Drag the bottom right corner of your source image window leftwards until it is about a fists' width from the bottom left corner of your computer screen.

6 Choose Cmd-0/Ctrl-0 (where "0" is numeral zero, Window > Zoom to Fit).

7 Hold the Space bar while you move the source image up to the top of its window frame. You should now see the source image in the top left of your screen.

8 Click on your working image so it is the active image in Painter.

9 Click and drag the title bar at the top of your working image window and move the image window so the top left of the window is neatly aligned along the top of the screen and over lapping the right side of the source image window so you don't see source image window frame icons.

10 Drag the bottom right corner of your working image window down and to the right until it is neatly tucked into the bottom right corner of your computer screen.

11 Choose Tab so the palettes show again.

12 Hold the Space bar while you move the working image to a position where it is unobstructed by palettes (Figure 5.14).

13 Make sure you can see all four edges of the working image. Zoom out (Cmd-"–"/Ctrl-"–") if needed.

Figure 5.14 Arrange your source and working images in a "Small Big" arrangement.

This "Small Big" arrangement of your source and working images allows you to conveniently work on your working image while maintaining visual reference to your source image at all times. It is the virtual equivalent of taping a small photo to the top left of your canvas.

II Create a "Muck Up" Underpainting

The goal of a "muck up" underpainting is to capture the raw energy, mood and movement of your composition. The muck up should be able to stand alone as an abstract, even while being loosely based on a photo. Treat this stage as providing a lively backdrop onto which you can develop as much detailed depiction of your subject as you like. At this early stage we completely let go of all detail.

1 Choose a brush with bold textured brushstrokes. Examples include Jeremy Faves 2 > Sherron's Blender Wood or Jeremy's MishMashScumble or modern art in a can. I have grouped some of these types of bold brushes on the left of the JeremySupaDoopa custom palette.

2 Make some test brush strokes in your bkgndcolor file. Leave these test brush strokes on your canvas. From this point on do not use the Undo command (refer back to the seven principles in Chapter 1). Adjust the brush size so that your brush is relatively large (not looking like a fine line). If you are able to paint fine details with your brush then it's too small!

3 Using your own color choices, not clone color, rapidly make large, expressive, energetic brush strokes that follow the basic forms and movement of your source image. Have fun with this stage. Don't get too attached to any marks or try to get anything looking perfect. This is about rapidly filling your canvas with loose brush strokes. In choosing colors allow yourself to pick colors that evoke the mood of your subject, not just what colors happen to be in the photo. By departing from the photo color you'll end up with a much more interesting painting. Vary your colors regularly. Avoid too much uniformity as you fill the canvas.

4 Choose Shift-Cmd-S/Shift-Ctrl-S (File > Save As).

5 Set the version number to be the next number in sequence.

6 Add a note of the brush you are using in the notes section at the end of the file name.

7 Save as a RIFF file in your 04 ProjectName project folder.

8 Try out other brushes.

9 Repeat Save As regularly as you change brushes.

10 Half close your eyes and look back and forth on your screen between the source and working image. Look at how the overall darks and lights vary and contrast in your source image. Start putting in some brush strokes into your working image that show you roughly where the lightest lights and darkest darks are.

11 Add a variety of types of brushes and brush marks. You can add some narrower crisp, clean and distinct accent strokes but don't get into any details of your subject at this stage. You can apply brushes that blend and distort (for instance Distortion > Pinch and Jeremy Faves 2 > Artists Palette Knife).

12 Choose Shift-Cmd-S/Shift-Ctrl-S (File > Save As).

13 Set the version number to be the next number in sequence.

14 Add a note of the last brush you used plus the word "muck" in the notes section at the end of the file name.

15 Save as a RIFF file in your 04 ProjectName project folder.

Do this muck up stage quickly and with gusto (Figure 5.15). The whole muck up paint process need not take longer than a few minutes. If you go beyond 15 minutes there is a chance that you may overdo the muck up and produce a mush up instead.

Figure 5.15 A muck up underpainting created using Jeremy Faves 2 > Sherron's Blender Wood followed by JeremyGuestFaves4 > David's Sui Riu.

III Selectively Reveal the Subject

1 Choose a brush with an oily texture such as Artists > Sargent or Jeremy Faves 2 > Den's Oil Funky Chunky.

2 Reduce your brush size to a scale where you can start defining the main shapes of your subject and compositional elements.

3 Activate Clone Color in the Colors palette (keyboard shortcut "U").

4 Turn brush opacity up to 80–100%.

5 Make enough brush dabs and strokes in your working image muck up to help define where the main structures of your composition are. You will see that you bring in color from your source image. Don't bring back too much detail. At this stage you may notice how dull the clone colors are that you bring into your image are compared to the non-clone colors you've added and built up.

Bringing in Details Without Getting Too Photographic

At a certain point in your painting process you may find it beneficial to use one of your painted versions of your image as clone source instead of the source photograph. Doing so will enliven your colors and ensure you don't lose the painterly quality of the image. The Cloners > Camel Oil Cloner is a good brush for cloning detail with an oily brush stroke.

Figure 5.16 Creating a Soft Clone layer.

Another approach to bring back clone source detail in a painterly manner is to:

a. Generate a new transparent layer (Shift-Cmd-N/Shift-Ctrl-N, Layers > New). Make sure Preserve Transparency is unchecked.

b. Choose Cloners > Soft Cloner.

c. Set brush to low opacity.

d. Paint in your detail areas into this Soft Clone layer (Figure 5.16).

e. Apply a good oily brush such as the Cloners > Camel Oil Cloner or Artists > Sargent Brush or Jeremy Faves 2 > Den's Oil Funky Chunky onto the Soft Clone layer. These oily brushes do not work on transparent layers but do work on imagery already on a layer.

f. Choose Save As and save the file as a RIFF file.

g. Choose Layers > Drop All.

h. Now you can apply blending and distortion brushes to blend everything together.

6 As soon as you can return to using non-clone color (keyboard shortcut "U" toggles between clone and non-clone) and build up more of your subject with your own color.

7 Look for where you your main point of interest is in the composition and work into this area with more detail and a finer brush size.

8 As you start working into detail around your main point of interest in your working image, choose Cmd-+/Ctrl-+ (Window > Zoom In). For instance if you are working in an eye zoom in so the eye fills most of your screen (though don't change the Small Big window frame arrangement). After zooming in on the working image do the same for the source image so that too shows the source eye in close up. Make full use of magnification. You can always choose Cmd-0/Ctrl-0 (Window > Zoom to Fit) anytime you wish to return to seeing your whole image. You can click on the Navigation icon (looks like a pair of binoculars) at the bottom left of the window frame to locate where your zoomed in view is vis-à-vis the complete image.

Engage the Viewer Through Selective Detail

One of the biggest challenges of working from photographs is the strong temptation to include too much detail just because it's there in the original photograph. Oscar-winning sound and picture editor Walter Murch, who worked with Francis Ford Coppola on the film "Apocalypse Now", explains eloquently in his book *In the Blink of an Eye: A Perspective on Film Editing* (Silman-James Press, 1995) why less detail engages the viewers' imagination more than too much detail:

"You may not always succeed, but attempt to produce the greatest effect in the viewer's mind by the least number of things on screen. Why? Because you want to do only what is necessary to engage the imagination of the audience. Suggestion is always more effective than exposition. Past a certain point, the more effort you put into wealth of detail, the more you encourage the audience to become spectators rather than participants."

As you work at this stage of your painting see how little detail you can bring back into the painting from the source photograph to evoke the subject. Continuously compare tonal relationships as you do so. Look back and forth between the source image and your working image. Use the Underpainting palette Saturation slider to test how your painting is working in grayscale.

IV Further Develop the Painting

1 Step away from your painting. Take a break.

2 When you return from your break choose Tab (Window > Hide Palettes).

3 Choose Cmd-M/Ctrl-M (Window > Screen Mode Toggle).

4 Choose Cmd-0/Ctrl-0 (Window > Zoom to Fit).

5 Choose Cmd-"–"/Ctrl-"–" (Window > Zoom Out).

6 Stand back from your computer and look at your painting.

7 Ask yourself what is working and not working.

8 Choose Cmd-M/Ctrl-M (Window > Screen Mode Toggle).

9 Choose Tab (Window > Show Palettes).

10 Return to painting and resolving what you observed wasn't working.

11 Repeat this process until the image lights up for you and works.

The Cigarette Lighter Theory

The painting process is one of "it's not working, it's not working, it's not working, it's not working ..." followed by "... aah, that's it!" This bumpy and imperfect process is beautifully described in the cigarette lighter theory that film director Francis Ford Coppola shared with his kids (as described by him in an interview on the National Public Radio Forum program):

"Something I always tell my kids, great films have as many flaws and bad things about them as bad films. I could take you through Citizen Kane, or any number of films, and just point out all the flaws and give notes on all that's wrong with them. The difference is the good films light up, the illusion works, so when you see them you're not looking at the flaws. What it tells me when someone sees a film and says I don't like that, or it gets bad reviews, the film didn't light up for them, so that you tend to only see the bad things.

"I tell my kids it's the cigarette lighter theory: you have a cigarette lighter and that's your movie. You try to light it and you flick it and it doesn't light. Then you pull the wick out and do it and it doesn't light. Then you pour more fluid and you put too much and it doesn't light. You dry it off with a hairdryer and it doesn't light. Then you pull the wick out some more and all of a sudden it lights! And once it lights all the bad things that didn't have the conditions of lighting go away because it's lit. That's what a movie is like. You have this thing and it doesn't work. The audience comes out and they just talk about the bad things. But then you change it, you move it around, you move it here, you do this and you tweak it a little. And when it lights all the bad things go away. They don't go away. But you don't look at them any more because you're lost in the illusion."

This story resonates with the seven principles mentioned in Chapter 1. Imperfection is part of the process and in the end adds richness to the end result. Many pictures go through one or more "ugly" stages where you feel like giving up. The key quality is to have persistence, keeping painting and trust in the process.

Back to Right Way Up

1 Choose Canvas > Rotate Canvas > 180 (or click the 180 button in the JeremySupaDoopa custom palette). This turns your image the right way up. It can be a great pleasure to see what you created upside down now seen the right way up.

2 Choose Shift-Cmd-S/Shift-Ctrl-S (File > Save As).

3 Save your image in RIFF format with "rightwayup" added in the notes section at the end of the file name.

4 Choose Tab (Window > Hide palettes).

5 Choose Cmd-M/Ctrl-M (Window > Screen Mode Toggle).

6 Choose Cmd-0/Ctrl-0 (Window > Zoom to Fit).

7 Choose Cmd-"–"/Ctrl-"–" (Window > Zoom Out).

8 Stand back from your computer and look at your painting.

9 Ask yourself if there any final touches needed. If there is work on addressing whatever you feel is needed.

10 Choose Cmd-E/Ctrl-E (Effects > Tonal Control > Equalize).

11 Click OK. See if it helps your painting. If so keep it, if not either fade it back (Shift-Cmd-F/Shift-Ctrl-F, Edit > Fade) or undo it (Cmd-Z/Ctrl-Z, Edit > Undo).

12 Choose Shift-Cmd-S/Shift-Ctrl-S (File > Save As).

13 Set the version number to be the next number in sequence.

14 Add "final" in the notes section at the end of the file name.

Adding a Border for Printing

Usually I add a 2 inch painted border for printing so I can stretch the painted image around the stretcher bars. In the case of Dancing in the Mirror I decided to use some of the painting that was already there as a border.

1 Choose Cmd-A/Ctrl-A (Select > All).

2 Choose Cmd-C/Ctrl-C (Edit > Copy).

3 Click on the "D" key. This chooses the Dropper Tool.

4 Click in the final image near an outer edge and pick a color for a border.

5 Choose Canvas > Set Paper Color.

6 Choose Canvas > Canvas Size.

7 Add the number of pixels to all sides corresponding to 2 inches. Thus if my file resolution is 100 pixels per inch I would add 200 pixels all the way round (use the tab key to toggle between each input box). If the resolution were 150 pixels per inch I would add 300 pixels all the way round.

179

8 Hold the Space bar down and click once. This centers the image in the image window.

9 Choose Cmd-V/Ctrl-V (Edit > Paste). This pastes the main image centered over the one with the border added.

10 Choose Shift-Cmd-S/Shift-Ctrl-S (File > Save As).

11 Set the version number to be the next number in sequence.

12 Add "brdr" in the notes section at the end of the file name.

13 Save as a RIFF file.

14 Make the background canvas active (click on Canvas in the Layers palette).

15 Choose one of the non-Cloner brushes you used in the paintings which can move a lot paint. Jeremy Faves 2 > Sherron's Blender Wood works well.

16 Make sure Clone Color is not activated.

17 Use the Option/Alt key to select colors near the border and then drag paint out into the border (Figure 5.17).

Figure 5.17 Painting the border of *Flamenco Jam*, one of my Dance series.

18 Work your way around filling the border with paint. You will see a border where the edge of the pasted layer is.

Softening the Edge (Optional)

a. Choose the layer in the Layers palette so it is highlighted.

b. Click on the Layer Mask icon (rightmost of the six small icons at bottom of layers palette).

c. Choose Chalk > Square Chalk 35.

d. Make the brush size relatively small.

e. Pick black in the Main Color swatch.

f. Gently paint in the Layer mask around the edge of the layer. It'll make the harsh edge disappear (Figure 5.18).

Figure 5.18 Softening the edge of the layer by painting into the layer Mask with black Square Chalk 35.

19 Choose Shift-Cmd-S/Shift-Ctrl-S (File > Save As).

20 Set the version number to be the next number in sequence.

21 Add "paintedbrdr" in the notes section at the end of the file name.

22 Save as a RIFF file.

23 Choose Layers > Drop All (or click the Drop All button in the JeremySupaDoopa palette).

24 Choose Shift-Cmd-S/Shift-Ctrl-S (File > Save As).

25 Set the version number to be the next number in sequence.

26 Add "paintedbrdrflat" in the notes section at the end of the file name.

27 Save as a TIFF file.

Printing and Painting on the Print

You have many choices when it comes to printing—whether to print in-house or use a service bureau, the type of printing technology to use, what substrate to print onto and so on. For in-depth discussion of digital printing issues and options see dedicated books such as "Mastering Digital Printing" by Harald Johnson (Muska & Lipman, 2004).

If my file size is smaller then 150 pixels per inch at final size I resize in Photoshop up to 150 or 180 pixels per inch. I usually lighten the image in Photoshop and add a little saturation. I print out of Photoshop using the Print with Preview option. If you are using a service bureau always get a hard copy proof print for color proofing.

I use my in-house Epson Stylus Pro 9600 wide format inkjet printer (see www.espon.com) with UltraChrome pigment inks and print onto 44 inch wide Water Resistant Matte Canvas from Digital Art Supplies (see www.digitalartsupplies.com). Canvas offers a tough durable support that I can keep working on with acrylic paint and other media. If your work is more delicate and resembles a

Figure 5.19 Acrylic paint on the canvas print of *Dancing in the Mirror*.

watercolor you may wish to consider printing onto a fine art paper. Likewise if your image remains more photographic than painterly you may wish to print it onto a smooth paper.

When the canvas print emerges from my printer I leave it to "breathe" overnight. I then spray it with PremierArt Print Shield fixative, a lacquer based spray designed specifically for all inkjet prints (see www.inkjetart.com). I spray on three coats, alternatively spraying vertically and horizontally across the print for each coating, in a well-ventilated environment and using a protective mask. Always fix your print before applying any other media (including PremierArt Eco Shield). If you are trying out a technique for the first time try it on a proof print rather than risk ruining your final print. I apply Gloss Acrylic Medium & Varnish (see www.Utrecht.com). This adds texture and also serves as a base onto which to add acrylic paints (Figure 5.19) and other physical media.

Generating Variations

Rather than treat the creative process as a linear journey starting with a source image and working on it until it is finished, I recommend a parallel non-linear process in which you generate a series of variations based on the same source image. Each variation can then be used as a clone source from which to paint from. Here are some ideas for you to try out as a means to generate different types of imagery based on a common source image. You will find these techniques useful for overcoming blocks as well as for expanding your creative possibilities and thus enriching your final artwork. Each variation technique can be applied the result of an earlier variation technique. The possibilities are endless. I often end up with extensive series of variations which I mix and match, like a disc jockey sampling and overlaying musical tracks.

Auto-Painting: Great for Getting Going

The first three variation techniques utilize the Auto-Painting palette. Auto-Painting offers a great way to generate a painterly start to an underpainting. It guarantees that you eliminate photo grain and have a paint brush stroke structure throughout your canvas. Any automatic paint filter, however sophisticated, does not have the faculty of the human visual perception system to adjust brush strokes, color, tone and contrasts to reflect the importance of different areas of the composition. An Auto-Painting, even with Smart Stroke brushes and settings, will not have the variety of brush stroke that you can apply by hand. And, most important, Auto-Painting or filtering of any kind, does not express your individual creativity and vision that makes your work uniquely yours. For all these reasons I see Auto-Painting as a valuable tool for getting going but not as an end in itself.

Auto-Painting with Default Brush Strokes

1 Open an original source image in Painter.

2 Choose File > Clone.

3 Choose the Dropper Tool (keyboard shortcut "D").

4 Pick a color from within the image.

5 Choose Cmd-F/Ctrl-F (Effects > Fill).

6 Make sure Fill With is set to Current Color.

7 Choose OK.

8 Choose Window > Show Auto-Painting if the Auto-Painting palette is not already visible (it may be minimized and out of sight below the Underpainting palette).

9 Choose Jeremy Faves 2 > Jeremy's MishMashScumble.

10 Activate the Clone Color icon (keyboard shortcut "U") in the Colors palette so that the current variant uses clone color.

11 In the Auto-Painting palette make sure that Smart Stroke Painting is unchecked.

12 Choose Squiggle from the Stroke pop-up menu.

13 Click the green Play arrow at the bottom of the Auto-Painting palette.

14 Sit back and watch your image transform or get up from your computer and go and pour yourself a cup of tea! The Auto-Painting function will rain brush strokes one stroke at a time onto your canvas (Figure 5.20). What I like about this feature is the randomness of the stroke sizes and orientations. This gives an organic feel to the resulting painting.

15 Stop the Auto-Painting at any time by clicking in the image or by choosing the square Stop button to the left of the Play button.

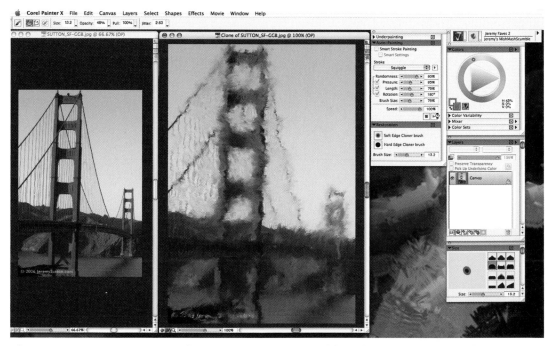

Figure 5.20 Auto-Painting with Jeremy's MishMashScumble and Squiggle brush stroke.

16 Reduce the Length and Brush Size sliders in the Auto-Painting palette and play the Auto-Painting again over what has already been painted. This will give you even more richness of brush strokes.

17 Choose Save As. Save your image into a project folder using the P-V-N naming convention.

18 Repeat these steps experimenting with different brushes (any brush that paints color will work) and preset brush stroke types. Some brushes may be slower than others but they will all give interesting results.

Auto-Painting with Custom Brush Strokes

1 Open a source image in Painter.

2 Choose File > Clone.

3 Choose the Dropper Tool (keyboard shortcut "D").

4 Pick a color from within the image.

5 Choose Cmd-F/Ctrl-F (Effects > Fill).

6 Make sure Fill With is set to Current Color.

7 Choose OK. The clone copy canvas will fill with your current color. (Alternatively you could choose QuickClone instead of Clone and have a white background.)

8 Choose Window > Show Auto-Painting if the Auto-Painting palette is not already visible. Make sure that Smart Stroke Painting is unchecked.

9 Choose the Artists > Sargent Brush.

10 Choose Record Stroke from the small Auto-Painting pop-up menu immediately to the right of the Stroke menu in the Auto-Painting palette.

11 Make a love heart shape with a single brush stroke on your canvas.

12 Choose Save Stroke from the Auto-Painting pop-up menu.

13 Call the stroke "loveheart".

14 Activate the Clone Color (keyboard shortcut "u") in the Colors palette if it is not already activated.

15 Choose loveheart in the Stroke menu in the Auto-Painting palette.

16 Choose the green Play arrow to set the Auto-Painting going.

17 Sit back and watch your image transform.

18 Stop the Auto-Painting at any time by clicking in the image or by choosing the square Stop button to the left of the Play button.

19 Reduce the Length and Brush Size sliders in the Auto-Painting palette and play the Auto-Painting again over what has already been painted.

20 Choose Save As. Save your image into a project folder using the P-V-N naming convention.

21 Repeat these steps experimenting with different brushes (any brush that paints color will work).

Auto-Painting with Smart Stroke Brushes

1 Open a source image in Painter.

2 Choose File > Clone.

3 Choose the Dropper Tool (keyboard shortcut "D").

4 Pick a color from within the image.

5 Choose Cmd-F/Ctrl-F (Effects > Fill).

6 Make sure Fill With is set to Current Color.

7 Choose OK. The clone copy canvas will fill with your current color. (Alternatively you could choose QuickClone instead of Clone and have a white background.)

8 Choose Window > Show Auto-Painting if the Auto-Painting palette is not already visible.

9 Make sure that both Smart Stroke Painting and Smart Settings are checked. This automatically changes the current brush category to the Smart Stroke Brushes.

10 Choose Smart Stroke Brushes > Acrylics Captured Bristle.

11 Choose the green Play arrow to set the Auto-painting going.

12 Sit back and watch your image transform. Although you can stop the Auto-Painting at any time by clicking in the image or by choosing the square Stop button to the left of the Play button, I recommend you let the Auto-Painting run its course. It will come to a stop naturally. You'll see how the brush strokes respond to the forms in the image and how the brush size automatically reduces over time.

13 Choose Save As. Save your image into a project folder using the P-V-N naming convention.

14 Repeat these steps experimenting with different brushes such as the Artists > Sargent Brush (Figure 5.21).

Apply Surface Texture

The Apply Surface Texture effect is a great way to emboss your existing brush strokes, adding a three-dimensional relief. To do this you have to set the Using menu to Image Luminance. This is the way I normally work with this effect. It can also be used to superimpose an embossment of the current paper texture (Using: Paper, the default setting), or the current clone source (Using: Original Luminance). The Using menu determines the source of data used to calculate the effect. The effect looks at changes in the luminance (lightness and darkness) of the source image and uses that information to apply highlights and shadows in the destination image to which the effect is being applied.

1 Choose Effects > Surface Control > Apply Surface Texture.

2 Set the Using menu to Image Luminance.

3 Set the Shine slider to 0%.

4 Set the Amount slider about 20% (Figure 5.22).

Figure 5.21 Auto-Painting with Sargent Brush and Smart Stroke settings.

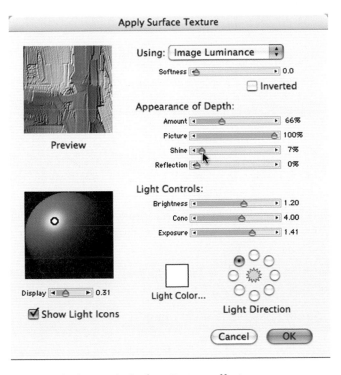

Figure 5.22 Embossing with the Apply Surface Texture effect.

5 Click OK. You will see the embossment effect applied to your image (Figure 5.23).

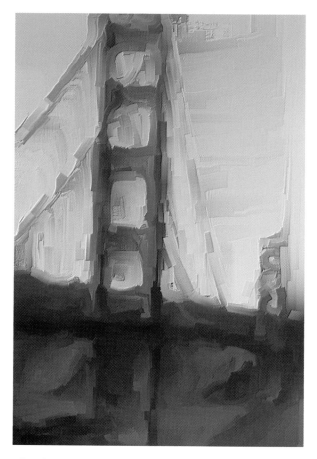

Figure 5.23 Embossed Golden Gate Bridge.

6 If the effect is too strong choose Shift-Cmd-F/Shift-Ctrl-F (Edit > Fade) and fade back the effect to any extent from 0 to 100%.

Woodcut Effect

The Woodcut effect is a fabulous way to transform your image into a dramatic graphic poster style image.

1 Open a source image in Painter. This effect can work well on an image that you've generated using the Auto-Painting.

2 Choose File > Clone.

3 Choose Effects > Surface Control > Woodcut.

4 Experiment with the Woodcut sliders and with checking and unchecking the Output Black and Output Color check boxes. You can see the effect of these settings in the Woodcut preview window (Figure 5.24).

5 Click OK.

6 Choose Save As. Save your image into a project folder using the P-V-N naming convention.

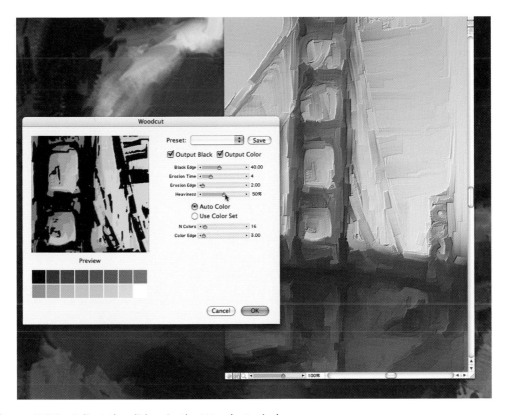

Figure 5.24 Adjust the sliders in the Woodcut window.

Transposing Colors Using the Match Effect

The Match effect, a new feature in Painter X, allows you to grab colors from one image (source image) and apply them in another image (destination image). You need to have both images open at the same time. The Match palette will apply the effect to the active image in Painter. I recommend experimenting with your already painted images as both source and destination images.

1 Open an image (destination image) in Painter that you wish to paint but whose colors you'd like to change.

2 Choose File > Clone.

3 Open a second image (source image) which has colors you wish to use in your first image.

4 Make the destination image the active image in Painter.

5 Choose Effects > Tonal Control > Match Palette.

6 In the Source, pop-up menu in the Match Palette window you'll see all files that are currently open in painter listed. Choose the source image, or any other image that is open that you'd like to use as a source for matching colors.

7 Increase the Color slider to make the effect more dramatic (Figure 5.25).

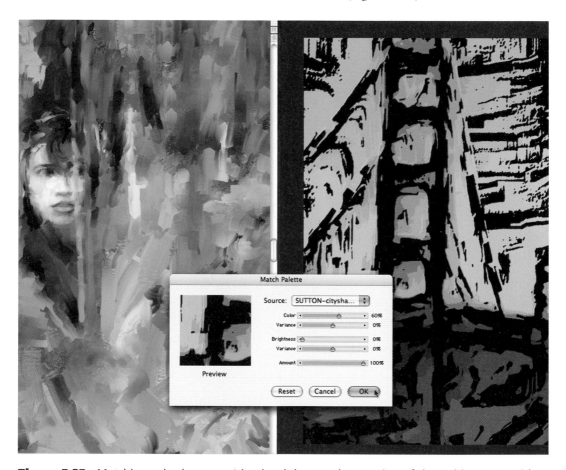

Figure 5.25 Matching color between *Island* and the woodcut version of the Golden Gate Bridge.

8 Click OK. You will that see your destination image (Figure 5.26) now has colors transposed from your source image.

9 Choose Save As. Save your image into a project folder using the P-V-N naming convention.

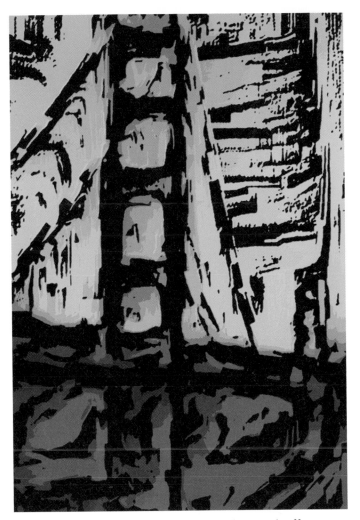

Figure 5.26 The Golden Gate Bridge after applying the Match effect.

Color Schemes

Another way to alter colors in an image is to apply one of the color schemes from the Color Scheme pop-up menu in the Underpainting palette. A Painter color scheme is a preset color adjustment that will be applied to your current image. Color schemes are a valuable tool for enhancing your source photographic imagery prior to painting as well as creating interesting variations of your paintings.

1 Open an image in which you wish to try out different color schemes.

2 Choose File > Clone. It is always a good idea to apply effects like this on a clone copy rather than your original image.

3 If the Underpainting palette is not visible choose Window > Show Underpainting.

191

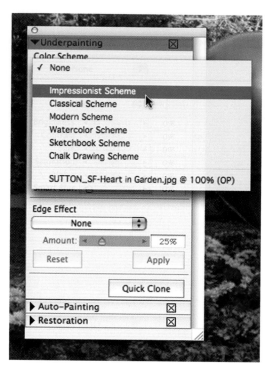

Figure 5.27 The Color Scheme menu.

4 Select different color schemes in the Color Schemes pop-up menu (Figure 5.27) at the top of the Underpainting palette. As you select each one you'll see its effect applied on the current image.

Increasing Contrast in Color Schemes

Certain color schemes give a low contrast effect. While this may work for some styles, I prefer a more contrasty image to paint from. If needed, I apply the Equalize effect (Figure 5.28) by choosing Cmd-E/Ctrl-E (Effects > Tonal Control > Equalize).

Figure 5.28 Applying the Equalize effect to an Impressionist color scheme.

192

5 When you see a color scheme you like choose Shift-Cmd-S/Shift-Ctrl-S (File > Save As). Rename the file (using the P-V-N convention).

Here is a summary (Figure 5.29) of the color schemes applied to the SUTTON_SF-Heart in Garden.jpg image that you'll find in the PXC Resource Disc > Jeremy Tutorial Images.

Figure 5.29 Summary of the different color schemes, including some with Equalization applied.

Here is an example of the Sketchbook color scheme in action on a photograph of Glenn and Amy. Since the Sketchbook color scheme gives a sepia tone effect I decided to combine it with one of the edge filters in the Underpainting palette. You can follow along this demonstration using the file SUTTON_Portrait-Dncrs.jpg in the Jeremy Tutorial Images folder.

1 Open the file SUTTON_Portrait-Dncrs.jpg from the Jeremy Tutorial Images folder on the PXC resource Disc.

2 Choose File > Clone.

3 Set your original and clone copy in the "Small Big" arrangement.

4 If the Underpainting palette is not visible choose Window > Show Underpainting.

5 Select Circular Vignette from the Edge Effect pop-up menu (Figure 5.30) in the Underpainting palette. This option creates an oval vignette that fits the dimensions of your file.

Figure 5.30 Choosing the Circular Vignette Edge option.

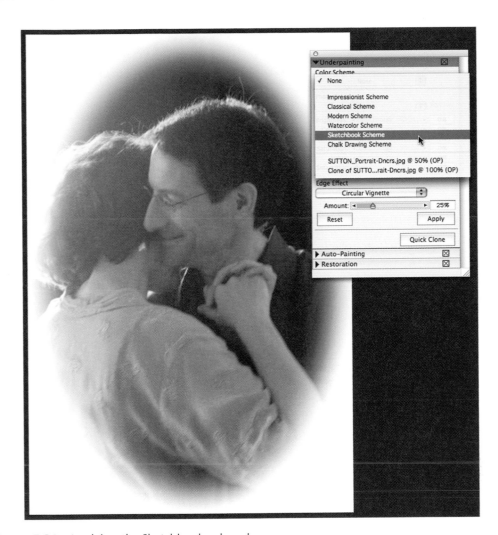

Figure 5.31 Applying the Sketchbook color scheme.

6 Select Sketchbook Scheme from the Color Scheme pop-up menu (Figure 5.31).

You now see the resulting sepia tone image (Figure 5.32).

If you want more contrast you could add the Equalize effect by choosing Cmd-E/Ctrl-E (Effects > Tonal Control > Equalize). However in this case I preferred the more faded look.

One Brush Painting

Stick to one brush for an entire painting. Explore the full dynamic range of mark-making possibilities that the brush has to offer, adjusting settings in the Property Bar. Make the most use of the "Dynamic Duo": opacity and size in opposition—high opacity with small size and vice versa. Allow

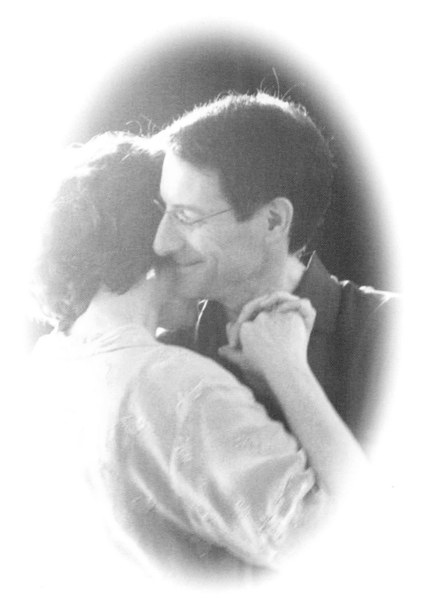

Figure 5.32 The resulting image with the old sepia photograph look.

at least 60 minutes for this exercise. Here is an example of a live portrait that I made using only the Jeremy Faves 2 > Jeremy's SumiPollock Splash brush.

This exercise is an excellent discipline that helps you make the most of your brushes. You'll be amazed at what range of marks you can make with a single brush just by making adjustments to the Property Bar sliders and varying the way you apply the brush strokes.

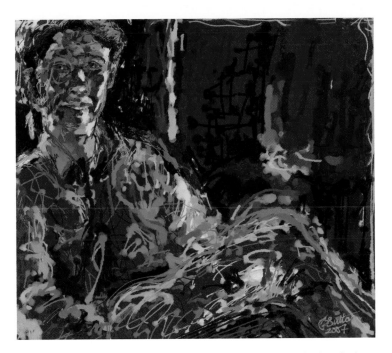

Figure 5.33 One brush painting of Bob using only Jeremy's SumiPollock Splash.

The Grid Painting System

The Grid Painting system is an excellent way to loosen up your brush strokes and treat your composition as an abstract by breaking it down into a series of small square or rectangle grid sections. The Layout Grid, new in Painter X, allows you to determine the number of divisions into which the sides of your image are divided into to create a reference grid overlay. This is different to the properties of the standard grid which is turned on and off by the Toggle Grid icon on the top right of the canvas window frame (see Canvas > Grid > Grid Options) and which can only be defined in terms of actual grid size, not number of divisions.

I recommend you combine this technique with an upside down clone source and filling your clone copy (working image) with a background color before starting to paint. I used this technique to break through my own barriers when I found myself stuck on the *Dancing in the Mirror* painting. I was leaving the figures too photographic and the upside down grid painting enabled me to move through that block.

1 Click on your source image so it is the active image in Painter.

2 Choose Window > Show Layout Grid.

3 Check Enable Layout Grid in the Layout Grid palette. You'll reference grid lines superimposed over the source image.

4　Set the Horizontal and Vertical Divisions to each be 4 (type in 4 over the default 3 in each division box).

5　Click the "+" symbol to the right of the Type menu near the top of the Layout Grid palette.

6　Call your Layout Grid Type "4 × 4 Grid". It will now be saved in the Grid layout Type menu for future reference (Figure 5.34).

Figure 5.34　Setting up a 4×4 grid on the source image.

7 Zoom in on your source image and move it (hold the Space bar as you click and drag in the image) so the top left grid section fills the width of the window on the left of your screen.

8 Click on the working image so it is the active image in Painter.

9 Check Enable Layout Grid in the Layout Grid palette. You'll see 3×3 reference grid lines super-imposed over the source image. Note that the Layout Grid settings are a property of each file and do not universally apply to every file.

10 Choose "4×4 Grid" in the Layout Grid Type menu.

11 Zoom in on your working image and move it (hold the Space bar as you click and drag in the image) so the top left grid section can be seen unobstructed by palettes.

12 Paint inside the grid on the right, in your working image, while looking at the same grid in the source image on your left (Figure 5.35). Treat the contents of the grid as an abstract. Liven up the color! Paint with your own colors rather than clone color. Focus on the shapes of tone and color and use them to strengthen the tonal contrasts.

Figure 5.35 Painting within the grid.

13 Choose Shift-Cmd-S/Shift-Ctrl-S (File > Save As).

14 Set the version number to be the next number in sequence.

15 Add "grid 1–1" in the notes section at the end of the file name. The code means first row–first column.

16 Save as a RIFF file in your 04 ProjectName project folder.

17 Hold the Space bar down and move the source image to the left so you see the second grid square along the top row (corresponding to "grid 1–2": first row–second column).

18 Hold the Space bar down and move the working image to the left so you see the second grid square along the top row.

19 Paint inside this second grid square.

20 Continue this process moving one grid section at a time, zigzagging across the first row left to right and then back along the second row right to left and so on until you have completed all 16 squares (Figure 5.36).

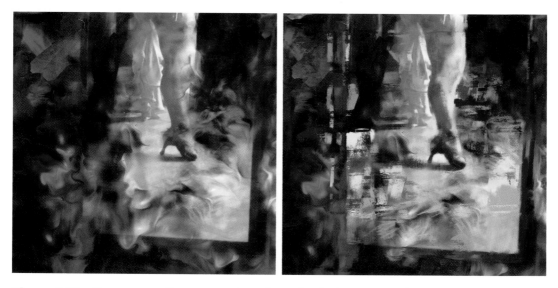

Figure 5.36 Here you see the same section of *Dancing in the Mirror* before and after grid painting.

The ideas shared in this chapter are just scratching the surface of what is possible in Painter. After trying these, go into areas and effects you haven't explored and see what you what further variations you can generate.

6

Going for it with Color

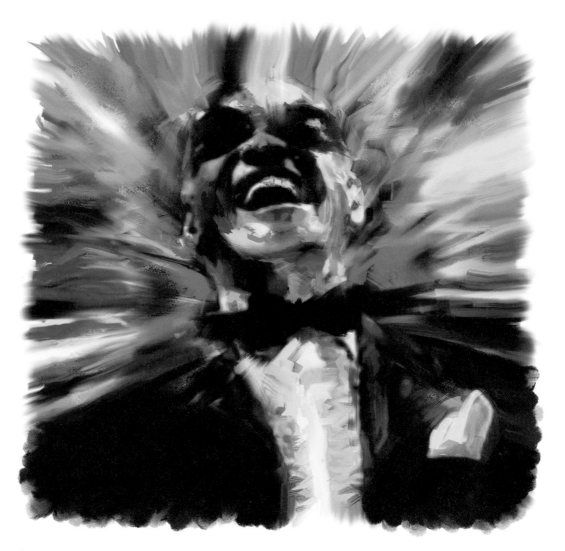

Figure 6.1 *Brother Ray*, 2005, 40 inches × 40 inches. A portrait of the legendary musician Ray Charles that is bursting with color.

"The notes are right underneath your fingers, and all you gotta do is take time out to find the right note. That's what life is, we all got notes underneath our fingers and we gotta take time to find the right notes, to come up with our own music."

This advice, that the late great musical legend Ray Charles (Figure 6.1) gave Jamie Foxx in preparing for the film "Ray", applies equally to colors as to musical notes.

The exercises in this chapter will help you make confident, bold color decisions and realize the full power of color in expressing yourself and your impression of your subjects. This chapter builds

on what you have already learnt in earlier chapters on how to choose color using the basic color palettes in Painter: Colors, Color Variability, Mixer and Color Sets (Chapter 1) and how to transform colors by applying the Underpainting, Auto-Painting and Matching palettes and the Woodcut effect (Chapter 5).

About Color

Color is a Perception

Sir Isaac Newton (Figure 6.2), the Seventeenth century scientist and mathematician who made profound discoveries about the nature of light, wrote: "To determine . . . by what modes or actions Light produceth in our minds the Phantasms of Colours is not so easie." Color is not a physical entity like light. Color is a perception.

The color we perceive when we focus our gaze on a specific region in our visual field reflects how our brain processes information about the wavelength, intensity and luminance (value) of light from that region as well as the influence of the light from surrounding regions.

Hue, Saturation and Value

Colors can be categorized by many different schemes. One scheme that is used within Painter and is commonly used by artists, is that of hue (the named color independent of luminance), saturation (brightness/dullness) and value (luminance or lightness/darkness). Pure black or pure white or pure grays are luminance in the absence of hue and are rarely observed in nature.

Primary Colors

"Because most of us have three types of cones (color sensitive cells in our eyes), three suitably chosen primaries (primary colors) can generate all other colors. Because our cones have broad absorption ranges (and therefore respond to a broad range of wavelengths of light) we are not too particular about which colors are primaries". Margaret Livingstone (Vision and Art: The Biology of Seeing, Abrams, 2002)

Thus, the phenomenon of there being three primary colors from which all other colors can be made is a result of our biology. Exactly what those primaries are is not set in stone. Red, yellow and blue are typically primaries in connection with paint pigment and red, green and blue are typically primaries in connection with light. The use of primaries in a painting can help create a dramatic, strong mood. An example of this is my painting *Brother Ray* (Figure 6.1), where red, green, blue and yellow are all dominant colors in the composition. This compares with *Summer Afternoon* (*Figure 4.1*) in which cyans, teals, magentas and oranges are dominant.

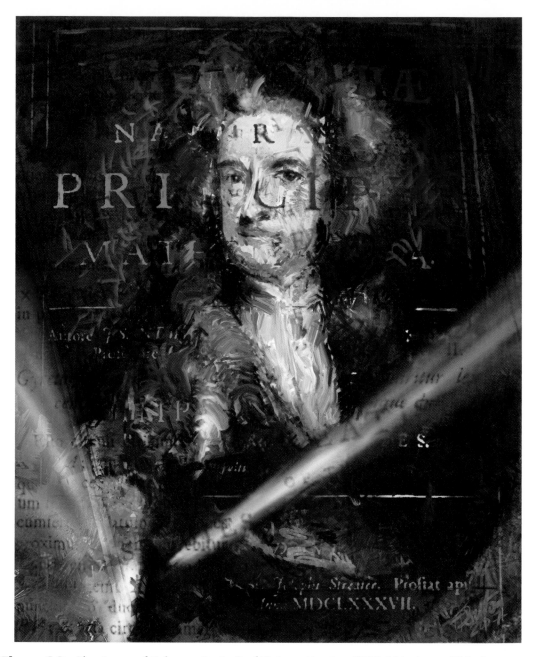

Figure 6.2 *Phantasms of Colours—Portrait of Sir Isaac Newton*, 2007, 24 inches × 30 inches.

Color Wheel

A traditional artist's color wheel is an arrangement of colors designed to help artists choose, combine and mix paint colors effectively. It is typically created by initially placing dabs of the three

Figure 6.3 *Hue Ring*—Corel Painter X's equivalent of the artist's color wheel.

primary colors—red, yellow and blue—equidistant around a circle. Adjacent primary colors are then mixed to create secondary colors (for instance, yellow and blue are mixed to create green). Dabs of the secondary colors are placed half-way between the primary colors from which they are made. This process is continued with tertiary colors made up by mixing primary colors with secondary colors around the wheel and so on until there is a continuous range of colors around the wheel.

Painter's Hue Ring (Figure 6.3) is a color wheel based on the primary colors associated with light—red, green and blue. These three colors are equidistant around the wheel. The secondary colors on this Hue Ring are cyan, magenta and yellow.

As you may gather from this description, Painter's Hue Ring is not exactly the same as a traditional artist's color wheel but can serve a similar purpose. Rather than get caught up in color theory, I suggest you simply make use of the Hue Ring by choosing colors you like and, when juxtaposing colors, try out colors connected by simple geometric relationships such as dividing the Ring in half (pairs of complementary colors that are on opposite sides of the Ring, or colors from the warm red orange yellow side versus colors from the cooler blue green side) or thirds (triads of colors that are equidistance around the Ring). I often find myself choosing colors from a limited band of adjacent colors on the Hue Ring (analogous colors) and accenting them with a complementary color from the across the Ring (a scheme known as Split Complementary).

Complementary Colors

Two colors are complementary when they are exactly opposite each other on the color wheel. When juxtaposed adjacent to each other on a painting, complementary colors can have a powerful effect

on one another, bringing out a vividness in eachother. As painters we can take advantage of the fact that our eyes naturally seek to balance any given color by its complementary color. When the complementary color is not present, the eye spontaneously generates the complement. We can use combinations of complementary colors in a work to provide harmonious balance, as well as bring attention to specific areas of the image. See the use of complementary colors to emphasize a point of interest in *Island* (Figures 6.4 and 6.5). This image is included in the PXC Resource Disc < Jeremy Tutorial Images. If you open it in Painter and use the Dropper tool (short cut "D") to pick colors you can see for yourself where adjacent colors are from on the Hue Ring.

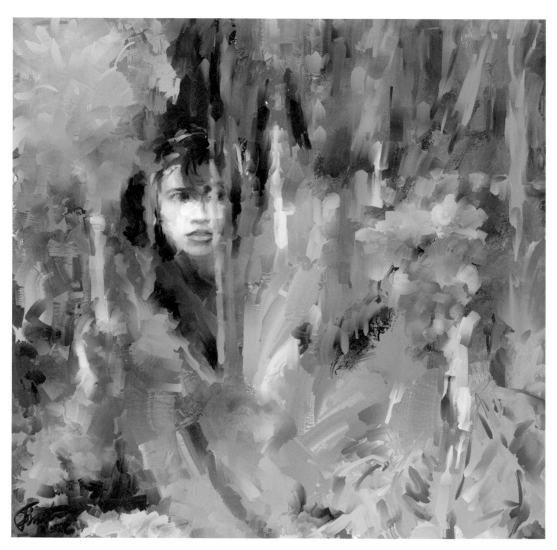

Figure 6.4 *Island*, 2006, 40 inches × 40 inches. This painting, which shows modern dancer Tiffany Barbarash moving in the Yerba Buena Gardens, San Francisco (part of the Cityshapes series, an artistic collaboration between Tiffany and I).

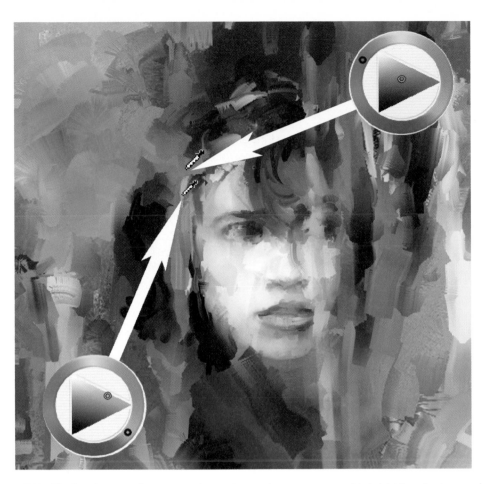

Figure 6.5 Notice the use of two complementary colors, orange and bright blue, juxtaposed close to Tiffany's face, the main point of interest in the painting.

Harmonious Color Schemes

Some examples of color wheel based schemes are:

1 Analogous—any three hues that are adjacent to each other on the color wheel (including their tints and shades, which are created by adding white or black, respectively).
2 Complementary—direct opposites on the color wheel.
3 Secondary—combining the secondary hues of orange, green and violet.
4 Split Complementary—a hue plus the hues on either side of its complement.
5 Tertiary Triad—consist of three tertiary hues that are equidistant from each other on the color wheel (red–violet, yellow–orange and blue–green is one of the tertiary triads).

Figure 6.6 *The First Dance—Portrait of Annette and Roman*, 2006, 24 inches × 36 inches, notice the Tertiary Triads in the accent strokes on Annette's dress.

My approach to color is not to over analyze or theorize but to follow my intuition and trust my eyes. Remember you're in the driver's seat and, irrespective of theories and schemes, you have the freedom to combine any colors you want!

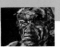

The Dependence of Colors on One Another

"Although one can determine the hue and brightness of a color physically by wavelength and luminance, there is no such objective constancy to the perceptual experience. Depending on its neighbors, a color undergoes startling changes in appearance. In a painting by Matisse the deep purple of a robe may owe much of its saturated redness to a green wall or skirt bordering on it, whereas in another area of the painting the same robe loses much of its redness to a pink pillow or even looks quite bluish in response to a bright yellow corner. Depending on what local association one is looking at, one sees a different color". Rudolf Arnheim (New Essays on the Psychology of Art, University of California Press, Berkeley, 1986)

As Arnheim so eloquently explains, the underlying issue in perceiving color is color relationships. Every color is influenced by every other color around it. You can use this phenomenon, known as the color surround effect, to your benefit when applying color in a painting. A touch of color here and there can affect the whole mood and feel of the painting.

You can see an example of color surround effect in my live portrait of Jan Di Nuoscio (Figure 6.7) where a single brush stroke of a secondary color, magenta, in the lower right corner changed the color dynamics of the whole portrait, which is largely primary reds, yellows and blues.

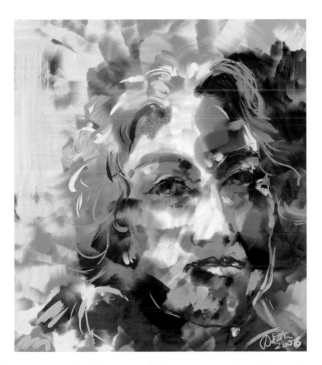

Figure 6.7 *Jan Di Nuoscio*, 2006, 30 inches × 34 inches, note the effect of the magenta brush stroke in the lower right corner.

Perceived Tone

Colors have inherent perceived tone, also referred to as value or luminance, which simply means relative lightness and darkness. For instance, yellow has an inherently lighter tonal value than blue. The inherent value of a color is independent of the value adjustments you can make in Painter's Saturation/Value Triangle to lighten or darken or saturate or desaturate, a color. Every color we paint on our canvas creates a perceived tonal value, which relates to the hue as well as the actual value of the color.

Still Life Exercise

The ability to see and paint tone is the key to freeing you up to go for it with color. This is an exercise about seeing the world in terms of tone.

1 Set up a simple still life (Figure 6.8) with a single object next to your computer screen. You can progress to more complex still life compositions with more objects but start simple. Light your object enough so that it has interesting shadows but not too harshly.

Figure 6.8 Still life.

2 Choose Cmd-N/Ctrl-N (File > New). Keep the size within about 1500 pixels in the maximum dimension initially, though you can apply this technique at any resolution.

3 Choose Cmd-M/Ctrl-M (Window > Screen Mode Toggle) to mount the canvas.

4 Choose Window > Zoom to Fit.

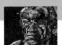

5 Zoom out slightly using the Cmd-"−"/Ctrl-"−" command, to suit your screen size and palette arrangement.

6 Hold down the space bar and drag your canvas into a convenient position on the screen.

7 Choose a mid-tone background color in the Colors palette, or from a Color Set, and fill your canvas (Cmd-F/Ctrl-F) with current color.

8 Select the Acrylics > Opaque Acrylic 30 brush.

9 Look carefully at your subject with half-closed eyes and identify which regions which are the lightest and which are the darkest. Use tints (colors near the white corner of the Saturation–Value Triangle) to depict your lightest regions. Use shades (colors near the black corner of the Saturation–Value Triangle) to paint the darkest regions. Paint in the main big blocks of tone until you have filled your canvas with paint. Work rapidly and loosely. Don't get attached to details (keep your brush size relatively large), or try to get perfectly accurate colors, or try to make a likeness of your subject.

In this first stage (Figure 6.9) you are reducing the subject to the minimum number of colored tonal areas that will convey the essence of the subject. You are reducing the complex array of colors, tones and textures into a few simple light and dark color spots or regions. The most important aspect of this exercise is getting used to seeing beyond the surface color of your object and seeing your object in terms of tonal values. Half close your eyes regularly and see if the tone of the colors you have applied suit the appropriate tonal value of the section of the portrait you are painting.

Figure 6.9 First stage.

10 Intermittently zoom out (Cmd-"−"/Ctrl-"−" repeated) and see what your painting looks like when it is postage stamp size on the screen.

11 Intermittently apply the gray-scale "cheater" technique of temporarily turning your color painting into a gray-scale image. If your Underpainting palette is not visible choose Windows > Show Underpainting.

12 Set the Saturation slider in the Underpainting palette all the way to the left (−139%). After you've Examine the gray-scale image (Figure 6.10) and note any areas that need darkening or lightening. Temporarily desaturating your image in this way does not take account of the effect of perceived color tone so you still have to look at your color image and decide if there are any colors that stand out unintentionally and just look wrong.

Figure 6.10 Desaturated version of first stage.

13 Select Reset in the Underpainting palette.

14 When you have completely covered the canvas with paint and have captured the essence of the subject in your first color statement choose File > Save As and save it with a P-V-N convention file name indicating that it is the first color statement into an appropriate project folder.

15 Select the Acrylics > Captured Bristle brush.

16 Now look more carefully at your subject and observe the subtler changes in tone and colors. Observe the smaller blocks of tone and color within the regions that you painted as large rough blocks in the first color statement. Paint over the large blocks with these smaller blocks, making your brush size a suitable size. This is your second statement (Figure 6.11), which is more detailed than the first and conveys more subtle differences in tone and color. If you are working from a photograph you could use some clone color at this stage.

Figure 6.11 Second stage.

17 Choose File > Save As and save the image with a file name indicating that it is the second color statement.

18 Continue this process with smaller brush size, developing a series (Figure 6.12), each one progressively more detailed.

Try this same exercise using your sketchpad and crayons. Then try applying it to the way you paint from a photograph.

Figure 6.12 Third stage.

Expressing Tone Through Color

In the previous exercise you used tints (towards the white corner of the Saturation–Value Triangle) and shades (towards the black corner of the Saturation–Value Triangle) to sculpt your form. In this exercise you will do the opposite—you will be restricted to painting from the mid-tone section of the Saturation–Value Triangle and will need to covey light and dark and sculpt your forms without using tints and shades.

1 Open a source image (Figure 6.13) in Painter. In the example shown here I increased the Saturation slider in the Underpainting palette and applied the Effects > Tonal Control > Equalize command to increase contrast.

Figure 6.13 Source photograph of Gerry before and after saturation and contrast have been increased.

2 Choose File > Clone.

3 Choose the Dropper Tool (keyboard shortcut "D").

4 Pick a mid-tone color from within the image.

5 Choose Cmd-F/Ctrl-F (Effects > Fill).

6 Make sure Fill With is set to Current Color.

7 Choose OK. The canvas fills with current color.

8 Limit yourself to non-clone colors whose luminance (tone or value) is restricted to the central horizontal band across the middle of the Saturation–Value Triangle, that is the mid-tone (mid-gray) tonal range (Figure 6.14). The colors can be any hue. Thus you cannot depict lights or darks by pulling the Saturation–Value Triangle cursor into the white or black corners. You're only color variables are hue and saturation. Using just these two color variables, and any brushes, create a painting based on your photograph (use the Small Big view outlined in Chapter 5). Note that since perceived color is affected by surrounding colors you will need to continuously look back and forth between your painting and the source image to determine whether your brush stroke color needs to be adjusted to work in the composition.

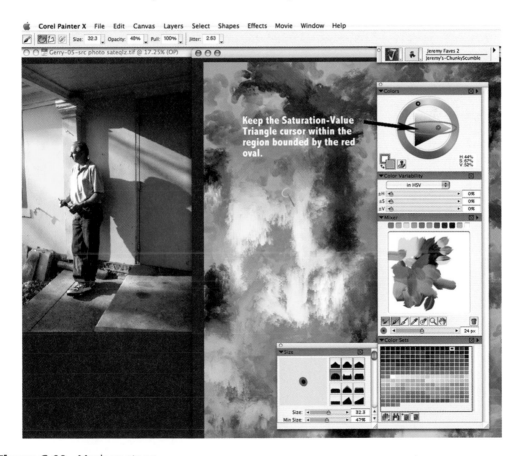

Figure 6.14 Muck up stage.

9 After you've spent at least an hour developing your painting with this color restriction (Figure 6.15), take a further 20 minutes or so to complete the painting with the restriction lifted to help express the extreme lights and darks.

10 Choose Save As. Save your image into a project folder using the P-V-N naming convention.

Figure 6.15 Showing the transition from muck up to depicting tonal contrasts by varying the hue rather than the value of the brush stroke colors.

Wild Color!

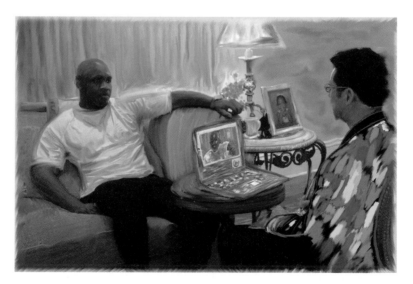

Figure 6.16 "Jeremy Painting Barry Through Multicolored Glasses" by Gisele Bonds. You can see the painting I created of Barry on this occasion at http://jeremysutton.com/chillin.html.

This exercise is about letting go of rules and restrictions. The colors you choose need not bear any relationship or resemblance to the actual colors you see. It's as if you've been giving some special

multicolored glasses, as depicted in Gisele's picture (Figure 6.16) of me painting Barry, which expand your color horizon and permit you to see a vastly increased range of colors in the world. Be free from worry about what color should be where. Trust that you will find them.

Allow yourself to step outside the lines and improvise. The colors in painting *Groovin'* (Figure 6.17) evolved in an improvisational way that mirrored the improvisation of the Lindy Hop swing dancers depicted in the painting.

Be bold, be daring, be crazy, be wild! Play with different combinations of colors next to each other. Test out the effect of juxtaposing complementary colors from opposite sides of the color wheel.

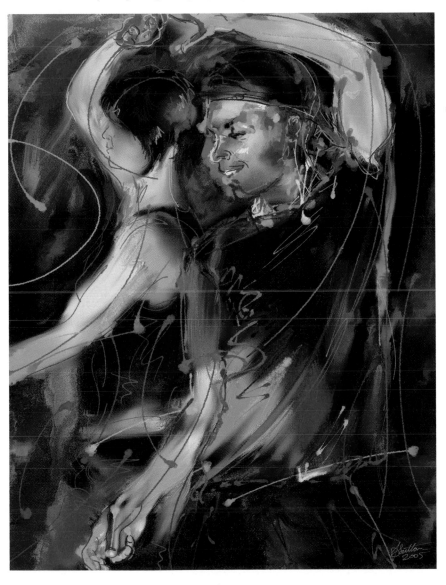

Figure 6.17 *Groovin'*, 2005, 38 inches × 50 inches.

Paint in a way that you may not have dared to before. Use whatever brushes you like. This is an exercise where you are being given permission to step out from being safe. Your canvas is a laboratory for experimentation. Make the most of it and enjoy!

Ideas for Experimentation

Emulate Different Artists' Styles

1 Choose three different artists who have distinct artistic styles and ways of using color. Ideally visit museums and galleries and see the artists' works in person. Otherwise consult books that have good reproductions of artwork.

2 First choose one painting from each artist. Using Painter and visual reference only, without using any cloning, clone color or Tracing Paper, paint copies of the three paintings. For example, I chose to create a copy of Henri Mattise's "*Femme au Chapeau*" (Figure 6.18).

Figure 6.18 *Copy of Henri Mattise's "Femme au Chapeau", 2004, 36 inches × 50 inches.*

3 Then create three original paintings based on your own photographs or from observation or imagination, each of which emulates the style of one of the three artists. I created a painting (Figure 6.19) of my mother, Margaret, based on the style Matisse used in "*Femme au Chapeau*".

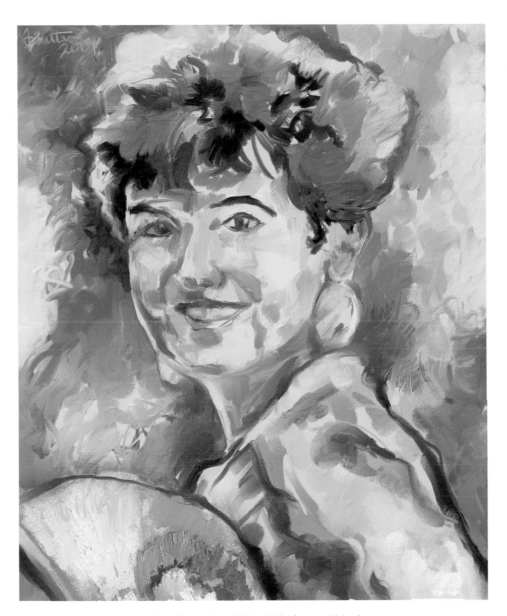

Figure 6.19 *Mum—in the style of Matisse*, 2005, 38 inches × 50 inches.

Create "Just for Me" Paintings

Whenever you are creating a painting for someone else, whether a paid client or not, in addition to making a version you think they will like, make a habit of making a "Just for Me" version in which you have fun, experiment, go for it with color, push the boundaries, and don't care what others will think. Show your client/subject both versions and let them choose the one they like best. As I mentioned in Chapter 1, Pennsylvania photographer Linda Huddle Martin wrote to me after taking my Painter Panache Master Class. "Going for it with Color!". She said: *Just wanted to let you know that since our class this year, for every Painter image I have sold, and it has been about 12, I have done 2 versions, one the way I was doing them last year and one with more color added. In every single case my client has chosen the one with more color in them. I would never have predicted that*".

If you're creating artwork for others I recommend you follow Linda's example. It's a win–win approach that ensures you get to grow and be nourished as an artist and that your clients end up with wonderful artwork.

Hidden Gem: Retrodot Pointillism

I shall conclude this chapter with a portrait of John (Figures 6.20–6.23) showing how I used the Jeremy Faves 2 > Retrodots brush to juxtapose colors and create visual texture. By overlaying Retrodots of different colors (and sizes) and against contrasting backgrounds you can build up

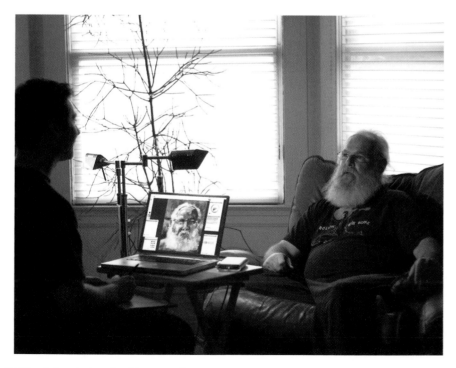

Figure 6.20 John sitting for his portrait.

Figure 6.21 Applying Jeremy Faves 2 > Retro Dots in the background.

Figure 6.22 Applying the Jeremy Faves 2 > Paulo's Goodbrush in the face.

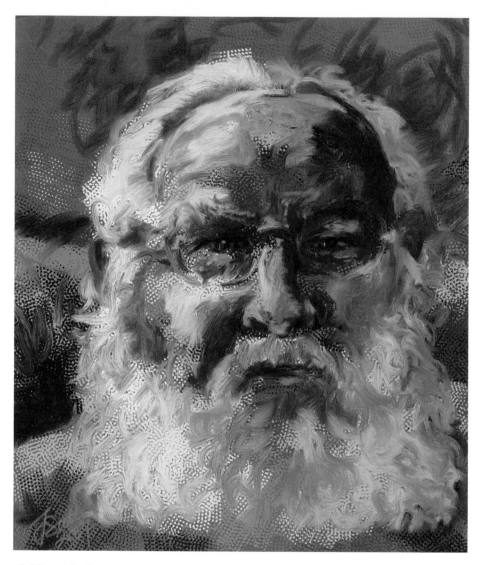

Figure 6.23 "John".

vibrant effects similar to those achieved by the Pointillists, such as Georges Seurat, who used small dots or strokes of contrasting colors in their paintings. From a distance we perceive the small dots as merging into a uniform field of color that shimmers as our eyes respond to the color contrasts within the field of dots.

You can see in this example how I mixed and contrasted the bristly oiliness of Jeremy Faves 2 > Paulo's Goodbrush with the graphic dots of the Retrodots. Try combining contrasting types of brushes in your work and see how that can enrich the texture and create a more interesting painting.

Mastering color, like all skills, takes time and practice. The more practice the better. Try out ideas. Be bold, experiment and have fun. Every step taken with use of color adds to your mastery of paint.

7

Collage Portraiture

Figure 7.1 *San Francisco Heart.*

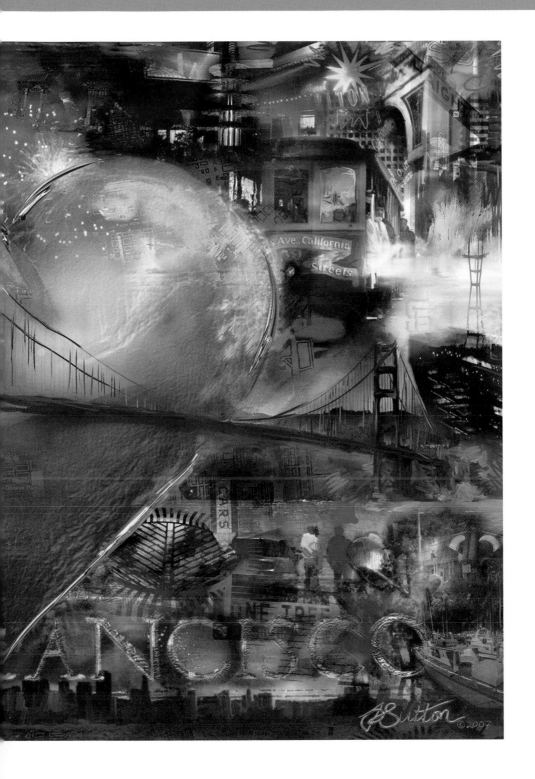

This chapter is a case study on how I used Corel Painter X to create *San Francisco Heart* (Figure 7.1), a Collage Portrait of San Francisco. The principles, strategies, workflow and techniques shared here can be applied to creating a Collage Portrait of any subject such as a person, a family, an animal, a vacation or trip, a place, an event or a city. My goal in sharing the creative path that led to this artwork is to inspire and empower you to create your own personal Collage Portraits.

My Collage Portrait workflow varies with every portrait I paint. Sometimes, as in *San Francisco Heart*, I create a complete photographic collage and then transform it into a painting. Other times I transform my foundation image into a painting first and then add collage elements. There are no rules. Don't restrict yourself by following strict formulae or recipes. The most important aspect of your Collage Portrait is not your choice of media and techniques; it is what you say in your art, what you express about your subject, the story behind the painting, the passion you share.

What is a Collage Portrait?

The term "Collage Portrait" refers to a portrait painting of a subject in which there is usually one main foundation image interwoven with a multitude of subsidiary images, some more subtle than others, but all contributing to the whole in a harmonious and meaningful way. A Collage Portrait is distinct from a photo-collage, a montage or an array of juxtaposed images where each image is of similar size, maintains its integrity as a distinct image and is more photo-realistic than painterly. In a Collage Portrait each subsidiary image relates to the portrait subject. The artwork tells a story about the subject that bridges space and time. Space is bridged across the canvas as well as geographically with the places shown and time is bridged through use of historical photographs and documentation, bringing the past into context with the present.

San Francisco Heart was inspired by my experience of living in San Francisco and wanting to express my appreciation for the beauty, diversity, creativity, excitement and richness of this City by the Bay. In preparing for this collage project I went on photo shoots around the city at different times of the day and night, and, in addition, drew upon thousands of photographs I have taken over the last 10 years. From all these images I selected a few favorite source images that formed the basis for this collage. This collection of favorite source images is included in the PXC Resource Disc that accompanies this book. This will allow you to follow along with the techniques I share. I picked out a foundation image (the Golden Gate Bridge which serves as an internationally recognized symbol of the city) and selected a few other favorite images that I felt would be good for use as subsidiary images. In Corel Painter X I created a working image template, used the Underpainting palette to enhance my source images, Selection Tools to select portions of images, and, after applying Copy and Paste commands, I worked with a combination of Layers, Free Transforms, Layer Masks, Cloning, Paper Textures and Brushes to complete the artwork.

Acquire Source Images

My Collage Portraits can take anywhere from days to years to create from start to finish. Initially there is an idea, an inspiration, a vision. I recommend you take your time. Allow the idea to gestate as you gradually seek out and acquire imagery.

In this case I wanted to create a portrait of San Francisco, an iconic image that symbolized the many facets of the city. I first created a project folder (07 SFHeart) within which I created three sub-folders (SFHeart-Source Images, SFHeart-Working Images and SFHeart-Painter Data). Having a good project folder structure and organization is essential for any collage project you undertake. Every file must have its home on your computer. This allows you to always easily and quickly locate your files and in turn frees you up to be more creative.

My main tool for acquiring imagery for this collage was the Canon 20D digital SLR. Besides looking back into my archives I also went out on several photo shoots specifically to acquire imagery. I end-edup with 66 Source Images and grouped them by theme into three separate Source Image folders.

A Word About Copyright

Collage by its very nature encourages the use of found images: cuttings from magazines, images from the Internet and so on. Most such found images are copyrighted and may not be used without permission. You can learn about the U.S. Copyright laws, including how to protect your own works, from the United States Copyright Office web site (http://www.copyright.gov/help/faq/). I recommend whenever possible work with your own photographs, obtain model and location releases, and respect other people's copyright as you would expect them to respect yours.

Choose Foundation, Secondary and Subsidiary Images

Once you have acquired and organized your Source Images the next step is to determine how you will use them in your collage composition, which will be the main compositional image (Foundation), which may support the main composition (Secondary) and which will be smaller and more subtly woven into the artwork (Subsidiary).

I used iViewMedia Pro to preview my Source Images and ended up settling on one particular image of the Golden Gate Bridge as my Foundation Image (Figure 7.2). The Foundation Image acts like a compositional anchor for the artwork, setting the main structure and framework onto which many other layers of imagery can be added.

I also selected one of the San Francisco hearts to be my Secondary Image (Figure 7.3). The heart sculpture was created when local artists were invited to paint large hearts that were placed around

Figure 7.2 The Foundation Image: The Golden Gate Bridge from Point Funston.

Figure 7.3 The Secondary Image: Heart at Chenery House.

the city and then auctioned off to raise funds for charity. I pictured weaving this heart into the Golden Gate Bridge. A Secondary Image will not be as dominant as the Foundation Image but will have more dominance than the Subsidiary Images. I do not always use a Secondary Image in my collages. In this case the heart seemed to fit in perfectly.

I selected a variety of Subsidiary Images (Figure 7.4) that reflected my personal experience and view of the city. This included landmarks and vistas like the city skyline (seen from Treasure Island), the City Hall, the AT&T Ballpark Coca Cola sculpture, the Mission Dolores, the Gates of China Town, the Palace of Fine Arts, the new de Young Museum tower, the SFMOMA roof, the Japan Town tower, the Transamerica Pyramid and the Twin Peaks antenna, as well as symbolic icons such as a trolley car, a cable car, the "One Tree" sign, the SF Giants logo, Nob Hill Café, the KFOG fireworks, fishing boats at Fisherman's Wharf, the North Beach "Condor" neon sign and a map of the city.

All my Source Images were captured in RAW and opened using the Adobe Photoshop CS2 RAW window. I then resaved them as TIFF files into the SFHeart-Source Images folder.

Figure 7.4 Viewing some of the Source Images in Painter X's browser window.

Prepare for Action

In preparing for a collage project, just as with any art project, it is important that you (1) have the right tools for the job and (2) prepare your tools for action. You will need a computer (Mac or PC) with as much hard drive space and RAM memory as you can afford, a pressure-sensitive graphics tablet (I recommend the Wacom Intuos3 6 × 8 or larger, or the Cintiq) and Corel Painter X software.

Once you have your tools in place take the preparative steps outlined in Chapter 1. Figure 7.5 shows the powerful new Painter X Workspace Manager (Window > Workspace > Customize Workspace).

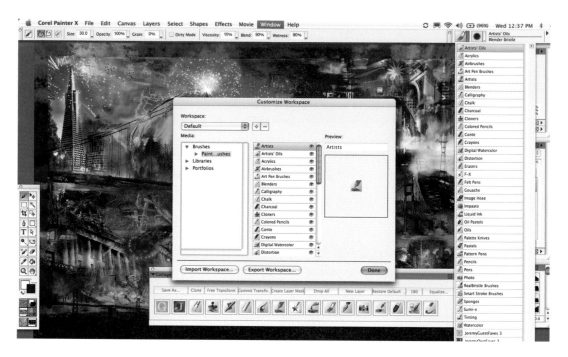

Figure 7.5 Rearranging Brush Categories in the Workspace Manager.

Create a Working Image Template

Once the Source Images have been chosen and saved into the appropriate folder, the next task is to create a Working Image Template. This Template serves as a basis for a consistent canvas size throughout the project, eliminating any confusion through the use of different size or resolution source files. This Template system is absolutely crucial to the entire collage working process. It is the key that simplifies everything. Without a consistent Template system you will find yourself getting very confused when you try to clone from multiple source images, all of different sizes and resolutions.

Open the Foundation Image in Corel Painter X and choose Canvas > Resize. Change the units from pixels to inches, uncheck Constrain File Size and adjust the image size to match the desired end result.

I resized the Foundation Image (Figure 7.6) to be 54 inches × 36 inches at 100 pixels per inch (ppi). I normally print at 150 dots per inch (dpi) but chose to work at a lower resolution to keep my file sizes down. In this case I used a resized version of the Foundation Image to generate the Working Image Template. In other projects I may crop as well as resize the Foundation Image, or start with a blank template and then paste the Foundation Image into it. The goal is to establish a Working Image Template size that you maintain for all your working images and Clone Source Template files for the remainder of the creative process in Painter, until the final stage when you may add a border and resize for printing.

230

Figure 7.6 Resizing the Foundation Image.

Choose Effects > Tonal Control > Equalize (Cmd-E/Ctrl-E) followed by Window > Show Underpainting > Photo Enhance > Saturate to enhance the image for painting. Increase the tonal contrast and saturation of painting source images beyond where you would go if you just wished to make a photographic print.

Choose File > Save As (Cmd-Shift-S/Ctrl-Shift-S) and name your Working Image Template with the following naming convention: short project name-two digit version number-short description of what this version contains or what effect was applied or which brush was used. Save as a RIFF file (the native format of Painter) to preserve all data and maximize the future editability of the file in Painter. Save your file into your Working Images sub-folder for the project. RIFF is the safest file format to use while working in Painter. An example of a file name following this convention would be "SFHeart-03-melangelyers.rif". Use Save As regularly throughout your creative process, saving sequential version numbers as you go. These versions, each with a small note in the file name, serve as a powerful tool for creativity. In making the San Francisco Heart I ended up saving 60 versions.

Add Subsidiary Image Using Select, Copy and Paste

The easiest way to introduce a Subsidiary Image into the Working Image Template is as follows:

1 Open the Subsidiary Image in Painter.

2 Choose Select > All (Cmd-A/Ctrl-A). There are many ways to make selections in Painter and you can use any of these to select portions of your image.

231

3 Choose Edit > Copy (Cmd-C/Ctrl-C).

4 Now make the Working Image Template the active image in Painter.

5 Choose Edit > Paste (Cmd-V/Ctrl-V).

6 You will now see the Subsidiary Image pasted over the Working Image Template as an Image Layer listed in the Layers palette (Figure 7.7).

Figure 7.7 Subsidiary Image pasted into the Working Image Template.

7 Double click on the Image Layer name in the Layers palette.

8 Rename the layer in the Layer Attributes dialog window to describe what the layer is.

Resize and Rotate Layer Using Free Transform Effect

You may wish to change the scale and orientation of the layer you introduce. The most flexible way to do this is as follows:

1 Select the layer in the Layers palette, making sure it is not locked (that the lock symbol does not appear next to the layer name).

2 Choose Effects > Orientation > Free Transform (Figure 7.8). This converts the Image Layer into a Reference Layer with faintly visible control handles (small squares) in the corners and half way along the sides. If the layer is larger than the background canvas the control handles may be situated beyond the edge of the image. You may need to put your image in Screen Mode (Cmd-M/ Ctrl-M) and zoom out (Cmd-"−"/Ctrl-"−") to see the handles (Figure 7.9).

Figure 7.8 Choosing Effects > Orientation > Free Transform.

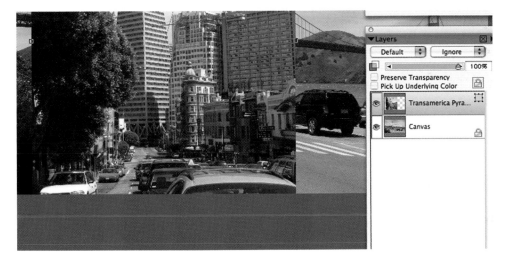

Figure 7.9 Free Transform control handles visible outside the image.

3 Hold the Shift key down while dragging in a corner control handle to resize the layer keeping the aspect ratio the same.

4 Hold the Cmd key (Mac) or Ctrl key (PC) down while dragging in a corner handle to rotate the layer.

Repeat this process for other Subsidiary Images. By default the Layers palette only lets you see four layers in the Layers List at one time. If you have more than four layers and wish to see them in the Layers palette all at once hold the tip of your cursor down on the last row of pixels along the bottom of the Layers List and then drag down. This expanded the Layers palette and allowed me to view all your layers at once. You can click and drag layers up or down in the Layers palette to determine their order, with the Background Canvas always being at the bottom.

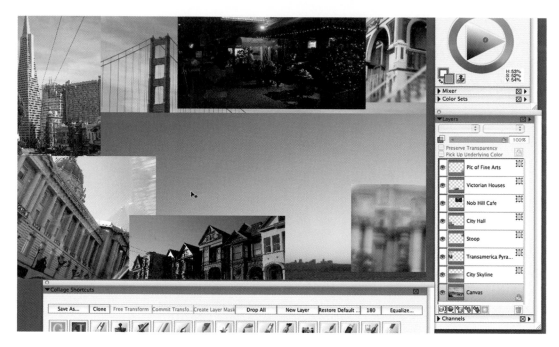

Figure 7.10 Multiple layers, each resized using Free Transform.

Control Layer Visibility with Layer Masks

Layer Masks allow you to create a finely controlled and smoothly blended visual transition between the edge of a layer and what lies underneath.

1 Make active the layer you wish to work with. You can do this either by clicking on the layer with the Layer Adjuster tool (top right of Toolbox) provided Auto Select Layer is checked (left of Property Bar), or by clicking on the layer in the Layers palette.

2 Choose Effects > Orientation > Commit Transform. This returns the layer from being a Reference Layer to being an Image Layer which you can paint on. If you don't do this step you will be asked to commit the Free Transform before you can use a brush on the layer orLayer Mask.

3 Click on the Create Layer Mask icon (last icon on right of row of six icons at the bottom of the Layers Palette). You will see a black square against a white background appear immediately to the right of the layer thumbnail in the Layers List (Figure 7.11).

4 In the brush Selector choose Airbrush category > Digital Airbrush variant.

5 In the Color palette take the Value Saturation Triangle cursor to the bottom left corner to select pure black as your Main Color (front square). If the Additional Color (back square) is not white then use the Color Swap Icon (small curve with arrow on either end situated between the Main and Additional Color squares in the lower left of the Color palette) to swap round the Main and

Figure 7.11 Layer Mask appears to the right of the Layer thumbnail.

Additional Colors, select pure white, then click once again on the Color Swap Icon to make black your Main Color.

6 Make sure that the Layer Mask is active (it will be bold in the Layers List) and then paint black onto the visible part of the layer in your image. You will see the layer image disappear (Figure 7.12).

Figure 7.12 Painting into the Layer Mask with black Digital Airbrush.

If you instead see black appear on the layer undo the brush stroke and reselect the Layer Mask. If you want to bring back any of the layer just click on the Color Swap Icon to make white your Main Color. Remember, as in working with Photoshop Layer Masks, black reveals what is underneath the layer and white conceals what is underneath.

Repeat this process with all your layers (Figure 7.13). You can always go back and forth between Free Transform and adjusting the Layer Mask if you wish. You always have complete flexibility.

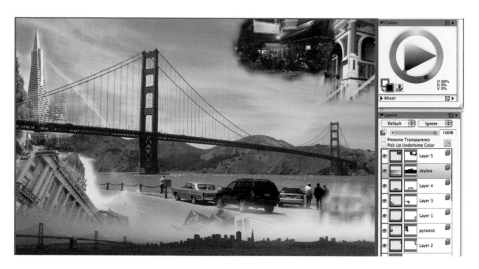

Figure 7.13 After creating and adjusting Layer Masks for all layers.

Group, Collapse and Lock Layers

You can group layers together by holding down the Shift key as you select them in the Layers List and then select Layers > Group. While the Group is closed in the Layers List you can only select or move the layers as a group. If you open the Group in the Layers List you can select and move individual layers. By selecting a closed group and then choosing Layers > Collapse you can collapse a group of layers into a single layer.

Once you have made adjustments to a layer and you wish to preserve those adjustments and avoid accidentally moving or changing the layer, it is a good idea to lock the layer (or group of layers). You do this by selecting the layer in the Layers List and clicking once on the right hand end of the layer beneath the layer type symbol. Clicking in this location toggles the lock icon on and off.

Experiment with Composite Methods and Layer Opacity

Composite Methods (accessed through the pop-up menu in the upper left of the Layers palette) control the way colors in a layer are affected by colors beneath the layer. Experiment with these Composite Methods. I find the Gel, Overlay (Figure 7.14) and Multiply often give good results. The

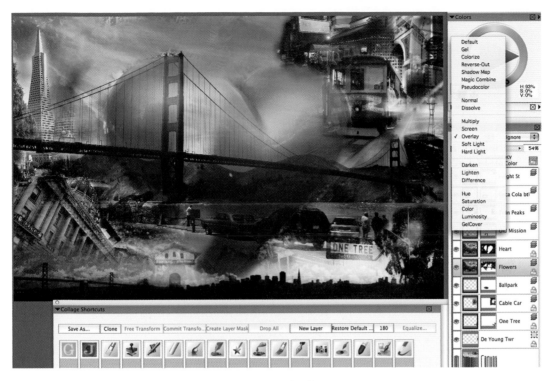

Figure 7.14 Choosing the Overlay Composite Method.

Overlay Composite Method works very well with adding textures to an artwork. I have included in the Jeremy Tutorial Images some examples of texture images (they have file names beginning with SUTTON_Texture-...) which you can use to experiment with.

Sometimes I lower the Layer opacity from 100% to 50% or 60% for a more subtle effect. To change the opacity of an entire layer first select that layer in the Layers Palette and then adjust the Layer Opacity Slider (situated above the Layers List).

Periodically Flatten and Paint

Once you have built up between seven and ten layers I recommend you flatten the image and, if you have more Subsidiary Images you wish to introduce, start building up a new set of layers. This strategy keeps your file sizes manageable and ensures you are always able to conveniently see all your layers at once in the Layers Palette when you do have layers.

Flattening your image also allows you to use brushes to paint over, blend, smear and distort your imagery on a single flat background canvas. For example, I used David Gell's wonderful Grainagashi brush variant on the heart (Figure 7.15) after flattening the image. David generously shares his fabulous custom brush categories on his web site at http://homepage.ntlworld.com/david.gell/pages/brushes1.html. I have also included a few of them in my JeremyGuestFaves 3 category that ships with my Art of Collage Portraiture DVD set.

Figure 7.15 Painting over the flattened image.

Create a Paper Texture Template

Paper Textures in Painter offer a versatile way to integrate into your collage imagery of all kinds, whether photos, musical scores or handwriting. In making *San Francisco Heart* I captured and applied custom Paper Textures of the San Francisco map (used here as an example), of the Giants logo and lettering from the Mission Dolores entrance.

To ensure that your custom Paper Texture is scaled correctly I recommend capturing custom papers from a Paper Texture Template of exactly the same dimensions as your Working Image Template. These are the steps I followed in the case of the San Francisco street map:

1 With the current Working Image active, choose File > Clone. This makes a flat clone copy of the working image. This Working Image Clone Copy will become the Paper Texture Template.

2 Open San Francisco map image.

3 Choose Select > All (Cmd-A/Ctrl-A).

4 Choose Edit > Copy (Cmd-C/Ctrl-C).

5 Now make the Working Image Clone Copy the active image in Painter.

6 Choose Edit > Paste (Cmd-V/Ctrl-V).

7 You will now see the map pasted over the Working Image Clone Copy as an Image Layer listed in the Layers palette.

8 Lower the layer opacity using the opacity slider in the Layers palette. This allows you to see through the map and observe how the map relates to the underlying collage (Figure 7.16).

Figure 7.16 Map layer at 50% opacity.

9 If the layer needs to be resized or rotated use the Effects > Orientation > Free Transform.

10 Once satisfied with the scale and position of the layer, return the layer opacity to 100% and save this file as a RIFF. This file could serve as a Clone Source Template at this stage. In other words, you could now return to the Working Image and clone from this file knowing the source image would be exactly the right scale and resolution.

11 With the layer selected in the Layers palette, choose Layer > Drop.

12 To make an effective Paper Texture it is best to have a high contrast black and white image. Choose Effects > Surface Control > Express Texture.

13 Experiment with the Express Texture sliders until you get a high contrast image that preserves details (Figure 7.17).

14 Choose Select > All (Cmd-A/Ctrl-A).

15 Choose Window > Library Palettes > Show Papers.

16 Choose Capture Paper from the Papers Palette pop-up menu (small solid black triangle in top right corner of palette). Name and save the custom paper. You will now see it appear in the Papers palette preview window (Figure 7.18).

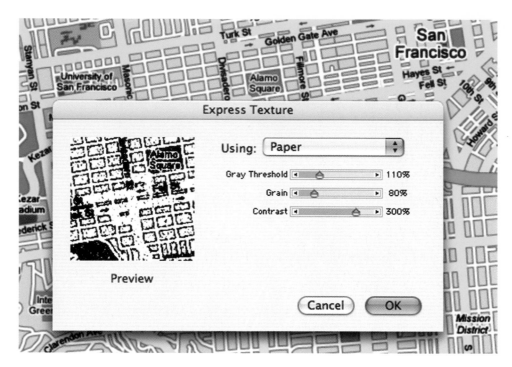

Figure 7.17 Applying Express Texture to the map.

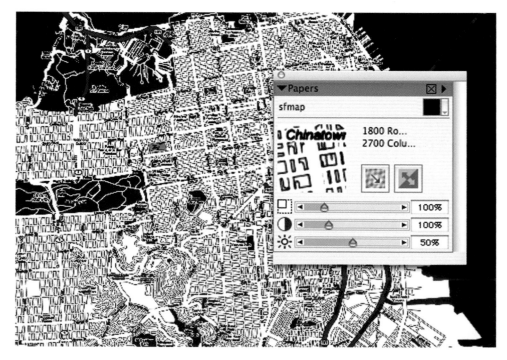

Figure 7.18 Captured Paper Texture of map.

240

If you find yourself unable to capture a custom paper it may mean your current Papers Library is full. Art material libraries in Painter have limited capacities. It is important to back up your custom papers into custom paper libraries that you create in the Paper Mover and that I recommend you save into a Custom Data sub-folder in your project folder. That way you keep all your custom textures with your project files. If your working image is large you may wish to reduce the size of your Paper Texture Template (using Canvas > Resize) to either 50% or 25% of the Working Image size before capturing the paper. Then when you apply the custom Paper Texture you set the scale slider in the Papers palette to 200% or 400%, respectively.

Paint Texture into a Layer

1 With the current Working Image open and active, choose the Chalk Brush Category > Square Chalk 35 variant (or choose any other grainy brush).

2 Choose Layer > New Layer. This is the Paper Texture Layer. Make sure Preserve Transparency is unchecked in the Layers Palette.

3 Pick a color you'd like to start painting in the texture with.

4 Start painting the texture into the Paper Texture Layer.

5 Click on the Invert Paper icon in the Papers Palette (right hand of the two icons to the right of the preview window).

6 Experiment with painting into the negative space of the paper texture (Figure 7.19).

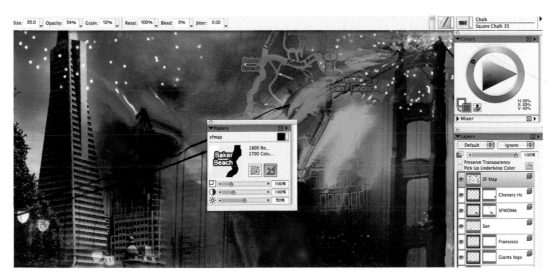

Figure 7.19 Painting into the Paper Texture Layer.

Paint with Liquid Metal

There are many hidden gems within Painter. One of them is Liquid Metal. You can see it used to accent the heart shape with brush strokes of metallic gold and also in my signature in the lower left corner. To get the gold effect I used an old Painter pattern called "Honey" that I include in my Jeremy's Extra Patterns Taster library that comes with my Painter Creativity book and the Art of Collage Portraiture DVD set. The default Liquid Metal (without using the Honey pattern) will give you a shiny chrome effect. Here are the steps I followed:

1 Have the most current Working Image open and active in Painter.

2 Choose Window > Library Palettes > Show Patterns.

3 Choose Open Library from the Patterns palette pop-up menu (top right corner).

4 Open the Jeremy's Extra Patterns Taster library.

5 Choose the Honey pattern from the Patterns palette selector menu.

6 Choose Layers > Dynamic Plugins > Liquid Metal. A Liquid Metal layer will appear together with a Liquid Metal dialog window.

7 Select Map: Clone Source in the Liquid Metal window.

8 With the brush icon selected in the Liquid Metal window start painting in the image. Experiment with the sliders.

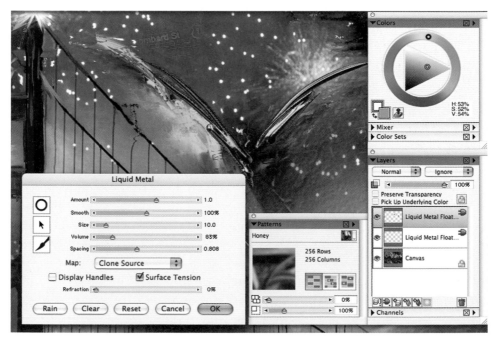

Figure 7.20 Painting with the Liquid Metal Dynamic Plugin.

For fun, select the circle icon and paint spheres of metal and then use the arrow icon to drag the metal spheres through other liquid metal. You'll see it exhibit surface tension and behave like liquid mercury.

You will not be able to access any other functions in Painter while the Liquid Metal window is open. Click OK to close the window and get out of Liquid Metal mode. Double click on the plug icon on the right side of the Liquid Metal layer in the Layers Palette to return to liquid metal mode and continue working in that layer.

Add Painted Border

Knowing when you are finished in Painter is not easy. I recommend that whenever you feel you have done enough to the image you then put it aside for a day or two and revisit it with a fresh eye. I often find that I keep developing work long after I originally thought I was finished.

At the point when you are ready to print your Collage Portrait flatten your image and resave it. I suggest you add a colored border and paint into it. This border can then be wrapped around a stretcher bar (gallery wrap). This avoids you loosing any of your main composition around the edge of the stretcher bars and also creates an attractive edge that enhances your painting and can be left showing in a final framed work by using a float mounted frame.

1 Open the flattened completed image in Painter.

2 Choose Select > All (Cmd-A/Ctrl-A).

3 Hold the Option key (Mac) or Alt key (PC) while choosing Select > Float. This generates a layer with a duplicate of the completed image, leaving the original in the background canvas.

4 Click on the eye icon at the left of the layer in the layers palette. This turns off the layer visibility.

5 Click on the background canvas in the Layers palette so it is active.

6 Use the Dropper tool to select a suitable border color from within the completed image.

7 Choose Canvas > Set Paper Color. The current Main Color is now set to be the Paper Color for the active image.

8 Choose Canvas > Canvas Size.

9 Insert the appropriate number of pixels to be added on all sides. I suggest adding the equivalent of 2 inches border all the way round. When you click OK you will see a border appear with the current Main Color.

10 Choose a suitable brush for pulling color into the border region. In this case I used the JeremyOwnFaves 3 category > Jeremy's SpeedyChunky. The Artists > Sargent also works well for this purpose.

11 Make sure the Clone Color is not on. Then use the Option key (Mac) or Alt key (PC) to turn the cursor into the Dropper tool and go round the edge of the image, selecting color near the edge and painting with that color beyond the edge into the border.

12 When you've worked your way all around the edge save the file as a RIFF. Then turn on the visibility of the layer. You will see the edge of the completed image showing up (Figure 7.21).

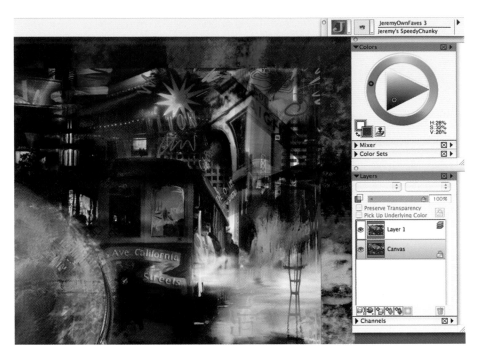

Figure 7.21 Painting the border.

13 Choose Layer > Drop (or choose Drop from the Layer Commands icon in the lower left of the Layers palette). Resave the file as a TIFF. It is now ready for printing.

Add Physical Media to the Print

I printed the digital file out of Adobe Photoshop CS2 onto canvas (WR Canvas from www. digitalartsupplies.com) at 38 inches high by 55 inches wide using my Epson 9600 Stylus Pro with UltraChrome pigment inks. I fixed the canvas using PremierArt Print Shield spray fixative and applied a clear Gloss Acrylic Medium & Varnish (from www.Utrecht.com), building up a physical brush stroke texture that followed the forms of the composition. I then added opaque colored acrylic paint with a brush and palette knife (Figure 7.22) to bring an extra level of life to the artwork. I ensured that I painted into the border area so the paint would reach around the edge of the image when stretched. I also added gold leaf and chin collé (glued paper). The addition of traditional media onto my printed canvas is an important step in achieving the relief, richness and impact that I want in my final artwork. The painted canvas was then stretched on stretcher bars. I like the way that a stretched canvas looks, feels and behaves and prefer it to dry-mounting the canvas onto a rigid board backing such as Masonite or Gatorboard. I framed this work with a half inch wide float mounting that allows the viewer to see the painted canvas wrap around the stretcher bar, and also creates the

244

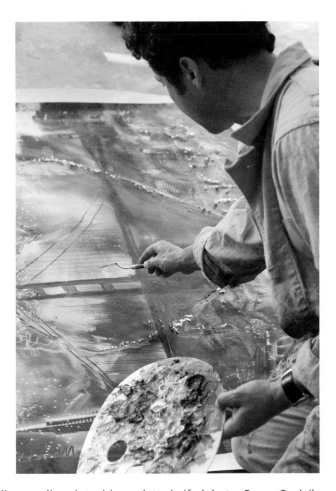

Figure 7.22 Adding acrylic paint with a palette knife (photo: Peggy Gyulai).

effect of a dramatic shadow outline around the canvas. I selected an Italian hand-distressed Roma frame molding that picked up the gold in the painting.

If you'd like to learn more about the mixed media aspects of this process you will enjoy disc three of *The Art of Collage Portraiture* DVD set which focuses on post-printing techniques.

Gallery

Here is a sampling of Collage Portraits I have created. Please also view the movie called *2-Roll That Boogie* which you'll find in the Jeremy Movies folder on the PXC Resource Disc. In that movie two of my subjects, former San Francisco Mayor Willie L. Brown and San Francisco iconoclast Robert C. Pritikin, share their reactions to their Collage Portraits. The following collages are also featured on my web art site www.jeremysutton.com where you'll learn the story behind each work. I have included appreciations with each work since each work is a creative collaboration and could not been created without the kind cooperation of the people mentioned.

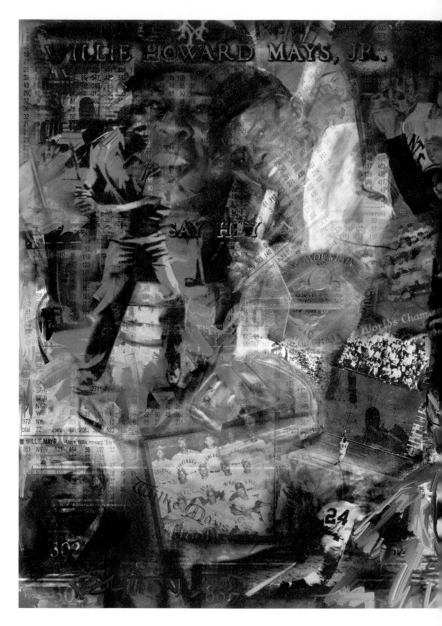

Figure 7.23 *Say Hey—Portrait of Willie H. Mays, Jr.*, 2005, 36 inches × 24 inches, with thanks to Barry Bonds and Willie H. Mays, Jr.

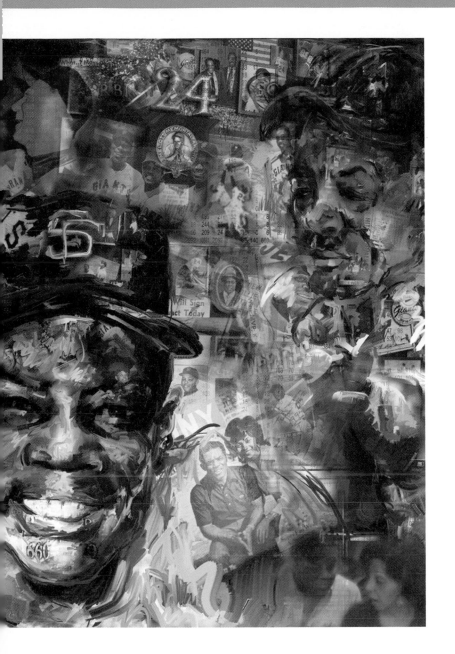

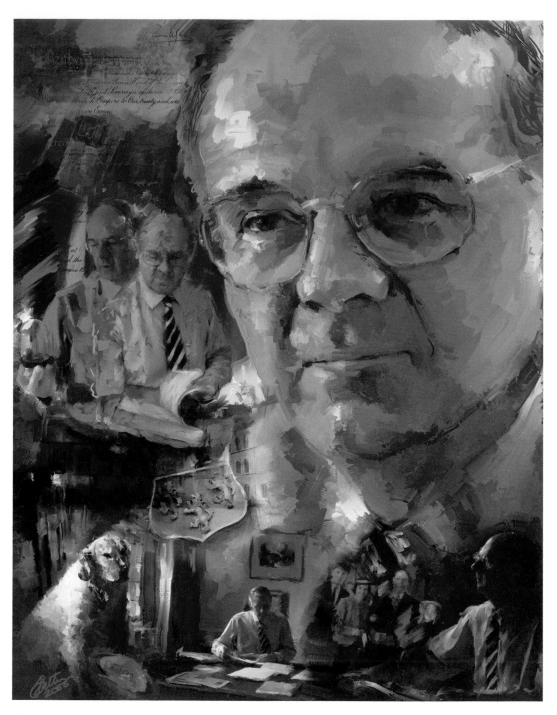

Figure 7.24 *Giles Henderson, Master of Pembroke College, Oxford University,* 2006, 30 inches × 40 inches, with thanks to Giles Henderson and the staff of Pembroke College.

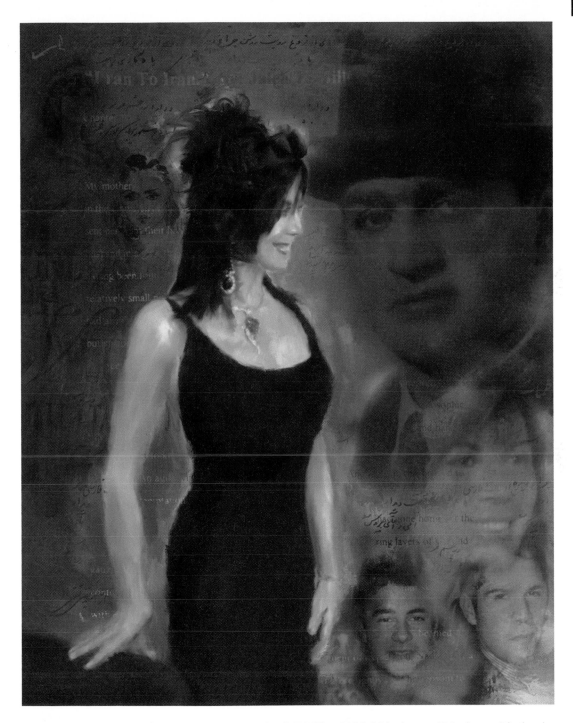

Figure 7.25 *Poems of my Father—A Portrait of JT Miller,* 2006, 30 inches × 40 inches, with thanks to JT Miller.

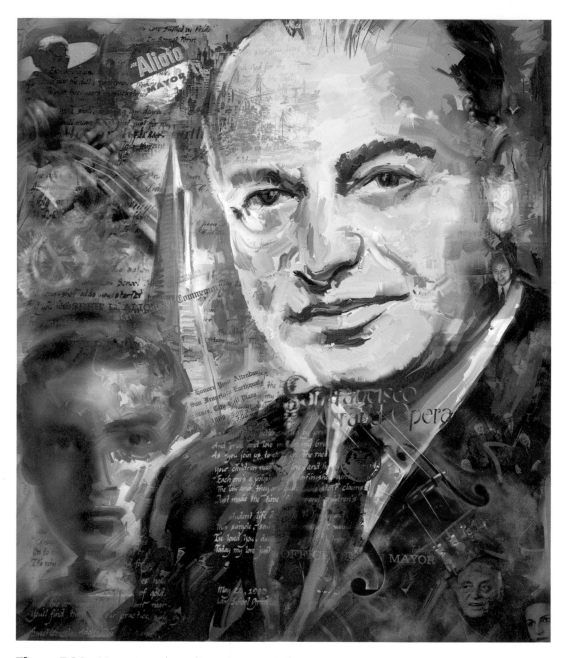

Figure 7.26 *Mayor Joseph L. Alioto, 2006,* 30 inches × 40 inches, with thanks to Angela Alioto.

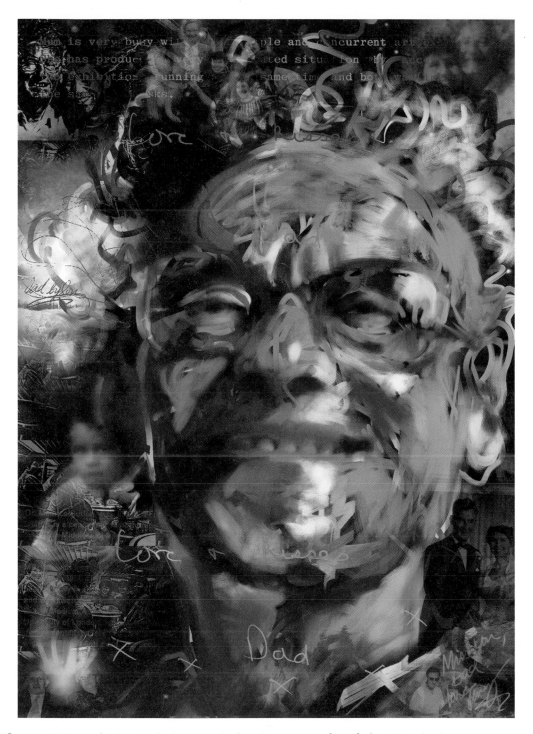

Figure 7.27 *Dad,* 2005, 24 inches × 30 inches, in memory of my father, Maurice Sutton.

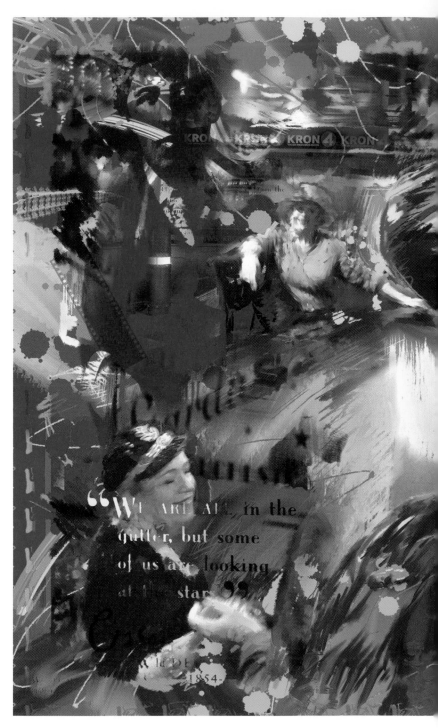

Figure 7.28 *Looking up at the Stars—Portrait of Jan Wahl,* 2006, 38 inches × 48 inches, with thanks to Jan Wahl.

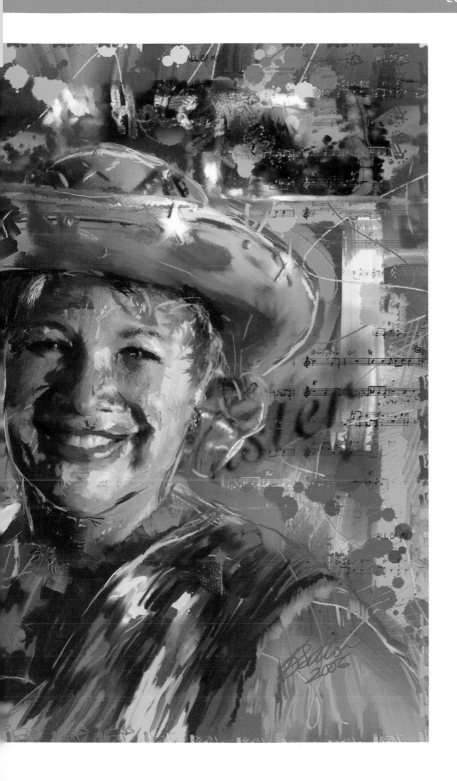

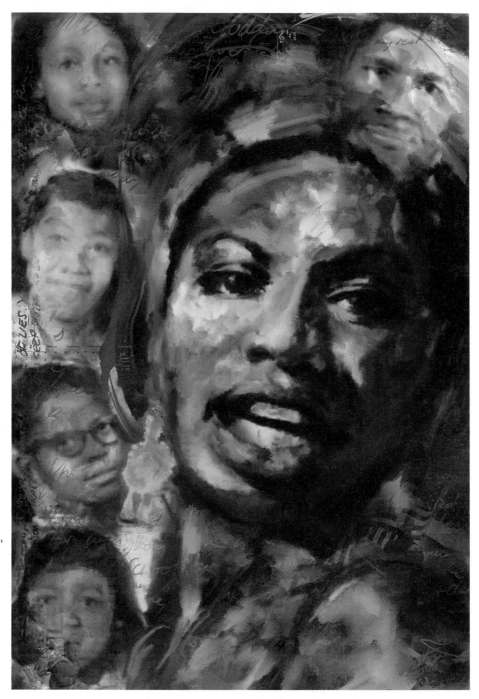

Figure 7.29 *Mississippi Goddam—Portrait of Nina Simone*, 2006, 38 inches × 57 inches, with thanks to Kim Nalley for inspiring this painting through her heart-rendering rendition of Simone's seminal protest song of pain and hope.

8

Replay

One of the unique benefits of working with digital paint is that you are able to record and replay your entire creative process from beginning to end. By seeing your painting evolve before your eyes, you can observe how your image transforms during your painting process. This capability is a powerful learning tool for you and for others. You can entertain, educate and inspire others by sharing the evolution of your paintings. Your painting process can be an end in itself, an ever-evolving experiment where you treat your canvas as a malleable liquid medium that undergoes continuous transitions, and where the process is more important than the "final" image.

Scripts: The Modern Day Music Roll

Painter achieves this replay ability by generating scripts. A script is a small text file that faithfully records your every move in Painter—which brush you've selected, what settings you've adjusted, what pressure you apply, where your brush stroke goes, any effects you apply, any saving of your file and so on. You can think of a script like the old music roll, a roll of paper with holes in it that represent the sequence of piano key depressions of a pianist playing a piece of music. When a music roll is fed into a Pianola (a self-playing piano designed to read music from rolls), the instrument plays the recorded piece of piano music with all the keys moving just as if there was a real person sitting at the piano. Likewise when you replay a script in Painter the same brush strokes occur (without any stylus input) in the same order and manner as when they were recorded. Scripts are small text files that just record sequences of commands and actions rather than actual imagery and therefore don't take up much space in your computer. The script playback is continuous, not frame-by-frame. The speed of the playback is related to the power of your computer, the size of your file and the memory-intensiveness of the actions being played back. Some brushes and effects take much longer to play back than others. The script doesn't record lack of activity. Thus you can take a break while recording a script without any effect on the script.

Powerful Tools for Working with Process

Scripts are a powerful tool for working with your process. They can act, in effect, as an "infinite Undo" since you can pause your playback at any point and save the image at that stage. Scripts allow you to generate unlimited variations of your paintings. For instance, you can replay a script against different backgrounds, at different resolutions, into different aspect ratios (stretched or squashed), or using different brushes (you can change the brush selections while pausing the script). QuickTime movies, AVI Movies, Animated GIFs or numbered files, can be generated from a script, allowing you to preserve, share and recycle your creative process as movies or slideshows. To generate these various movie formats you have to first generate a "frame stack". A frame stack is a special form of animation file that can only be played in Painter and that contains a series of separate frames. You can use the frame stack mode of Painter to paint on movies with Painter's brushes and apply Painter's special effects. You can combine and integrate your recorded painterly transitions into animations for film, TV, video or the web by exporting the movie files generated in Painter into

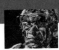

video editing and special effects applications such as Apple Final Cut Pro, Adobe Premiere, or Adobe After Effects.

Besides its use for replaying painting processes and making movies, scripting in Painter can be used rather like Actions in Photoshop, to record sequences of actions that you repeat regularly. In that circumstance the script acts as a shortcut when you wish to repeat that same sequence of actions.

With all these great capabilities you may ask what the downside is and why not record scripts all the time. Scripts do not work with all aspects of Painter, in particular cloning operations are difficult to replay accurately. In addition, since scripts remember every time you save and they repeat that command on playback, you stand the risk of accidentally over-writing your files with different imagery and thus losing work. For these reasons I advise caution and patience in making scripts, especially if recording an entire creative process over time, as opposed to using scripts as shortcuts for often repeated actions. Working with scripts requires taking a little extra time, being methodical and organized, and being careful to back up your work before you replay a script. It is well worthwhile investing that extra time and effort. You will be amply rewarded.

The full breadth of Painter's animation and video capabilities is explained in detail in the User Manual and also in an extensive Help > Corel Painter X Help available from within the program. My intention here is to share just one small part of these powerful capabilities with you, the part that relates to recording a painting process and converting that recording into a movie format that you can play and share outside of Painter. I also share one other aspect of scripts—the use of something called the "background script" (it is recorded in the background whenever you open Painter) as a last resort rescue.

In this chapter you will learn the following procedures:

I Recording a script.

II Replaying a script.

III Generating a frame stack from a script.

IV Generating a QuickTime movie from a frame stack.

V Generating numbered files from a frame stack.

VI Using background scripts as a last resort rescue.

The example I use to illustrate these operations is a portrait I created from a live sitting of Sigifredo Cruz.

I Recording a Script

When to Record a Script

I encourage you to get into the habit of recording scripts when your project involves painting directly on the background canvas, without use of clone color or layers.

Painter's scripting and animation capability was introduced in Painter 4 (1995) and, for the most part, has not changed much since that time (in Painter IX a small enhancement was added that

allowed a variable frame stack play rate). My experience is that, though scripts do work with layers and cloning, it is best to avoid layers, cloning or any interruptions to your painting process once you are recording and until you stop the recording. Conduct your recording in a single session of Painter.

The problem with working with clone sources and cloning brushes in a script is that your replay will tend to resort back to the current pattern as clone source, making it difficult to consistently reproduce a cloning paint process.

You are welcome to try scripts with cloning and layers and they may work perfectly for you. Just don't rely on being able to faithfully and consistently reproduce your exact artwork. My suggestion is to keep everything as simple as possible.

Starting a Script

It is easy to record a script. For maximum reliability always restart Painter afresh when you are about to begin a new script. Close your file and quit out of Painter when you've completed everything and after you've saved your script. The steps that follow are generic steps that you can apply any time you create any painting in Painter.

1 Choose Cmd-N/Ctrl-N (File > New). Open a new canvas to paint on and mount it in screen mode (Cmd-M/Ctrl-M). Make sure you can see the edge of the canvas on your screen. Fill with a ground color if desired.

2 Set up a palette arrangement that includes the Scripts palette (Window > Show Scripts) showing on your desktop.

3 Choose Window > Arrange Palettes > Save Layout.

4 Name the palette layout, something like "Recording Basics", I often add the screen resolution (e.g., "Recording Basics 1024 × 768 inches). This is helpful if you are doing presentations and need to adjust your screen resolution for a projector. You can then select the right layout to suit your current screen resolution (otherwise some palettes may seem to disappear beyond the edge of the screen).

5 Choose File > Save As.

6 Name the file with a name indicating this is your starting point and including a version number (e.g., subjectname-01-start.rif). You will be returning to this first version (-01-start) when you replay your script. Adding "-start" to the file name will help you immediately recognize the original background canvas when you want to open it for replaying the script.

7 Choose Cmd-A/Ctrl-A (Select > All). You'll see dancing ants surrounding your canvas. This is not necessary for recording a script but adds a whole level of extra flexibility in what you can do with the script (such as replay into a higher-resolution canvas or replay into any rectangular selection).

8 Click on the central dark red, solid circular record button in the center of the five script control buttons in the Scripts palette (Figure 8.1). The circle goes bright red (Figure 8.2), indicating that recording has begun. Make sure you have started the script recorder—it's easy to think you're

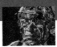

Figure 8.1 After selecting all, press the red record button in the Scripts palette.

Figure 8.2 Notice the red record button is bright red after being turned on.

recording a script when you're not. Avoid accidentally pressing any of the other script control buttons at this stage.

9 Minimize the Scripts palette by clicking once on the little triangle to the left of the word Scripts in the palette title bar. This is for safety to prevent you accidentally turning off the recorder before your image is complete. Alternatively, you could drag the Scripts palette down to the bottom of your screen so only a small part of it is showing.

10 Choose Cmd-D/Ctrl-D (Select > None). This gets rid of the selection and the dancing ants.

You have now started your script. Start painting.

While a Script is Being Recorded

Only have one canvas open in Painter while recording the script. Do not close your current image, or resize your canvas, or open a new canvas or start working on another canvas, while recording a script.

The replay of a script is not 100% reliable and should never be relied on as your means of saving an image, or as a substitute for saving sequentially numbered versions as you work. Regularly choose File > Save As and save sequentially numbered versions as RIFF files into the folder for this project. I recommend doing this as a safety backup, even though your script may allow you to go back to any intermediate stages.

When I know my painting is finished I add my digital signature inside the script recording before stopping the script. This is not only a good habit for protecting your artwork, but it also makes it easy

to see when your script replay is completed because you see your signature appear when the playback ends.

Stopping, Naming and Saving a Script

1 When you have completed your image and are ready to stop the recorder, open the Scripts palette.

2 Click on the black square button on the left of the five Scripts buttons (Figure 8.3).

3 In the Script Name window (Figure 8.4) you will see "Save As: Untitled". Untitled is highlighted.

Figure 8.4 Script Name window.

Figure 8.3 Press the stop button when you are ready to stop the recording.

Script Naming

Think carefully about your script name. You may find it useful to include the reverse date notation (YY.MM.DD). If you plan to create a second script to start where you left off then add a sequential version number to the end of the script name. Since the naming convention for scripts is very similar to the convention for naming the image files, you can save yourself time by copying the file name (excluding the file format tag) when you do a Save As (by highlighting the name and choose Cmd-C/Ctrl-C) and then pasting (Cmd-V/Ctrl-V) the name into the Script Name window.

4 Type in the name of your script, which will replace the default script name "Untitled".

5 Select OK. It is important not to accidentally select Cancel. You cannot undo Cancel. You will have lost your script forever if you do select Cancel.

Save a Final Backup Version of Completed Image

After you have saved the script, choose File > Save As again. Save one last version of your image. It will be exactly the same as your previously saved version, which was saved within the recording. Name this final version with a different, higher version number, and add the letter "F" for final. The "F" helps when you are looking to print the image to know immediately which was your final version that was saved outside the script recording and therefore won't have been accidentally altered during script replay.

Make a Backup Copy of All Your Saved Versions

Scripts record every time you save a file. Thus if you play back a script and make any changes to the process as you do so (e.g., different background, brushes, dimensions), or if the script doesn't perfectly reproduce your image, you run the risk of accidentally modifying all your original saved versions. The replay will not show you any window asking if you wish to save changes, it'll just replace your original files! Before replaying a script, locate the folder on your computer hard drive where you saved all the versions of your image and copy those files into a back-up folder in a different location. On a Macintosh you would drag your cursor over the files to select them and then, holding down the Option key, drag the files into the back-up folder. On a PC select your files in My Computer and copy them across to a back-up folder.

Close Painter

When you've completed a recording and backed up your files, close Painter (Cmd-Q/Ctrl-Q).

II Replaying a Script

Basic Replay

1 Open Painter.

2 Open the original background canvas (version -01-start) that you started with prior to recording the script.

3 Choose Cmd-M/Ctrl-M (Window > Screen Mode Toggle).

4 Select your script from the Scripts selector menu in the Scripts palette (Figure 8.5).

5 Select the black triangular play button, second from the left of the five Scripts control buttons (Figure 8.6). When you click on the triangle, it goes bright green, indicating that you are now replaying the currently selected script.

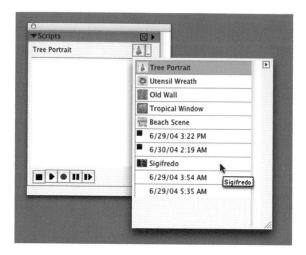

Figure 8.5 Select your script in the Script Selector.

Figure 8.6 Press the play button.

You should now see your painting process replay seamlessly and continuously (Figure 8.7). Note that to get an authentic replay of exactly what you originally created you will need all the same libraries in Painter. If any of the Brush Variants or Art Materials are missing, or have different names, you'll be prompted to locate them.

Figure 8.7 Replay your process.

6 The replay will continue until the end, at which time the green triangle button will become black again. If you did a concluding signature at the end of your session, you can also look out for that signature to appear as an indication of when the replay is complete.

Pausing during Replay

During replay you may see a stage of your painting that you'd like to take time to look at. You may wish to save the stage or to recall which exact brush settings you were using at that moment in the creative process.

1 To pause the replay at any time, just click the pause button (two vertical black lines, the second button from the right). You'll see the pause button go bright orange (Figure 8.8), and all action will halt. During this pause you can choose Save As to save that stage, or look at all the palettes to find out exactly what Brush Variant settings and Art Materials you were using at that moment. This can be useful when you want to remind yourself of a great brush you used at a certain stage of the painting process.

Figure 8.8 Pausing your replay allows you to do a Save As at any stage of your process.

2 When you wish to continue your replay, you just click the pause button once again (or click the play button) and the replay continues where it left off.

Changing Background on Replay

1 Open the original background canvas (version -01-start).

2 Fill the canvas with a different background.

3 Choose File > Save As.

4 Rename this new beginning canvas.

5 Replay the script (following instructions above).

Changing Brushes during Replay

1 Click the pause button to pause the replay.

2 Change the selected brush variant. You can also alter the current color at this time.

3 Click the pause or play buttons and the replay will continue with the new brush variant (Figure 8.9).

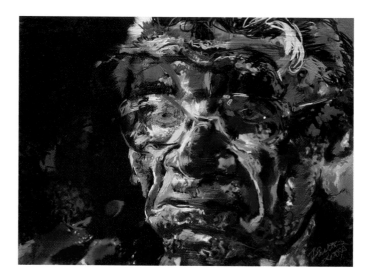

Figure 8.9 Modified portrait of Sigifredo generated by replaying script and using different brushes from those originally used to paint the portrait.

Once you have generated a series of variations based on the same recorded painting session, you can then mix and match them by treating them all as alternative cloning sources (using File > Clone Source to go between them all). Use the Soft Cloner variant in the Cloners category to clone them together. I recommend making a master working file the same size as the clone sources (the easiest way to do this is to just pick one image and choose File > Clone).

Distorting Your Image on Replay

You can stretch or squash your replayed image either vertically or horizontally, provided you remembered to "select all" immediately prior to starting the recorder. Distorted replays can lead to interesting results.

1 Open your original background canvas (version-01-start).

2 Make a rectangular selection in your canvas using the Rectangular Selection tool (keyboard shortcut "r"). Make the selection wide and short or thin and tall for the most noticeable results.

3 Replay your script as normal. You will see it replay into the selection, no matter how different the shape of the selection to the original canvas (Figure 8.10).

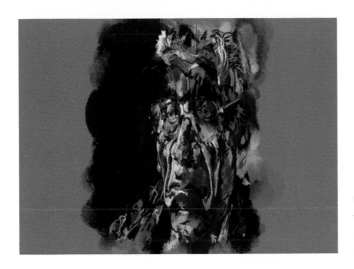

Figure 8.10 Distorted version of the Sigifredo portrait generated by replaying the script into a tall, thin rectangular selection.

Besides the convenience (and fun) of being able to make Alberto Giacometti or Amedeo Modigliani versions of your paintings (i.e., stretched out and thin), there is another benefit to this technique of replaying into rectangular selections. If the selection contour is smaller than the size of your canvas, then the edge of your replayed painting can have wonderful, organic forms because the replayed brush strokes can extend beyond the selection area.

Playing Back at Higher or Lower Resolution

One of the powerful practical benefits of the Select All prior to the recording is that you can paint a quick gesture sketch on a small canvas with small, fast responsive brushes and then replay the same painting onto a large high-resolution canvas for printing. You can also replay a large painting into a very small canvas (as I did in preparing the frames for the flipbook images you see in this book). The key thing when playing back into a larger or smaller file is keeping the aspect ratio (width to height) constant. Otherwise you distort your image.

1 Open your original background canvas (version-01-start).

2 Choose Canvas > Resize.

3 Uncheck the Constrain File Size check box in the Resize window.

4 Set your Width and Height units to inches (the default unit is pixels).

5 Change the resolution from 72 ppi to 300 ppi.

6 Click OK.

7 Make any changes you wish to the background.

8 Choose Cmd-A/Ctrl-A (Select > All).

9 Replay the script. It will replay into the larger file.

If you forget to do the Select All just before you replay the script, the script will replay at the original pixel size, aligned in the top left corner of the canvas.

Replaying into Smaller Area

If you are playing back into a smaller file or a smaller selection area, you may come across the error message "Insufficient Memory to Complete Operation." This error appears every time your brush size becomes less than 1.0. To overcome this error hold your cursor over the pause button in the scripts palette, click on the Return/Enter key and immediately afterwards click on the pause button. Then change the brush size to 1.0. Press the pause button again and the script continues playing (until the next time the brush size becomes less than 1.0).

III Generating a Frame Stack from a Script

To do something with your recorded painting process outside Painter, you will first need to convert the script, which is a continuous record of all your actions, into a series of individual frames. That is achieved by creating, in Painter, a special file known as a frame stack, which, as the name suggests, is a file containing a stack of frames or images. Frame stacks can be very large files. Their size is simply the addition of all the images that make up the frames. So if you have a frame stack with 450 frames, each frame being about 1.5 Megabytes if saved as a RIFF file, then the frame stack will be about 675 Megabytes. Frame stacks with hundreds of frames can easily exceed a GB in size. Make sure you have plenty of free hard drive space (I recommend at least 5 Gigabytes of free space) at the location where you are saving the frame stack. Before you begin generating frame stacks check how much memory you have available in your computer and, if needed, clear some extra space. If you can, maximize the RAM memory in your computer. I often save the frame stacks onto the desktop and then trash them as soon as I've saved my final movie in QuickTime format.

The frame stack can only be opened within Painter. If you make any changes to a frame stack and then close the frame stack, you will not be asked if you wish to save changes, like you are when you make changes to a regular image file. The changes will simply become part of the frame stack. This makes frame stacks vulnerable to unintended changes. Therefore treat the frame stack as a temporary transition state before saving the frames in a more versatile and stable format that can be opened in programs other than Painter.

The frames that make up the frame stack can either be saved as separate sequentially numbered images (each file name ending in a three digit sequential number like 001, 002 and so on) or as movie files (QuickTime is the most common format, although AVI movies and GIF animations are also options). Within Painter the word "movie" is used to denote both frame stack and conventional movie formats such as QuickTime and AVI. This can be confusing. I recommend you to always differentiate your file name for frame stacks by adding .ftk at the end and for QuickTime movies by adding .qtm at the end. This makes it clear from the file name whether you're dealing with a Frame stack or QuickTime movie.

1 Open the original background canvas (version-01-start) that you started with prior to recording the script.

2 Choose Cmd-M/Ctrl-M (Window > Screen Mode Toggle).

3 Open the Scripts selector pop-up menu in the Scripts palette and make sure the script you wish to convert into a movie is selected as the current script. When you close and then reopen Painter the current script defaults back to the one at the top of the scripts selector menu ("Tree Portrait").

4 Select Script Options from the Scripts pop-up menu that appears when you click on the small triangle in the top right of the Scripts palette (Figure 8.11).

5 Click on the Save Frames on Playback checkbox in the Script Options window. You should now see a check appear in that checkbox.

6 Leave the Record Initial State checkbox checked (the default state). The Record Initial State means that whenever the script is replayed, the program will look for the same Libraries as were present in Painter when the script was originally started.

7 In the Script Options window (Figure 8.12) type in a number of tenths of a second to determine how frequently Painter will save a snapshot of the image as the script is replayed. Each of these snapshots becomes a frame in the frame stack.

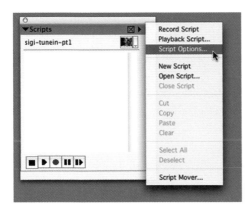

Figure 8.11 Select Script Options from the Scripts palette pop-up menu.

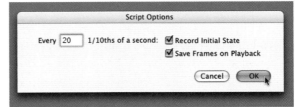

Figure 8.12 The Script Options window.

Understanding the Script Option Snapshot Rate

It is a common misconception that the figure that you type into the "Every … 1/10ths of a second" represents the frame rate (frames per second) of your final movie. This is not the case! The figure you type in has nothing to do with the frame rate of your movie. It is only going to determine how many, or how few, frames you end up with. The default figure, which is 10 ("Every 10 1/10ths of a second"), means that at intervals of 10 tenths of a second (i.e., every second), during the replay of a script, Painter will take a snapshot of the current image (assuming you have Save Frames on Playback checked). These snapshots become frames in the frame stack. If you doubled the figure from 10 to 20 ("Every 20

267

1/10ths of a second", i.e., every two seconds), then the interval between snapshots will be doubled, so the total number of snapshots will be halved.

Conversely, if you halved the figure from 10 to 5 ("Every 5 1/10ths of a second", i.e., every half a second), then the interval between snapshots will be halved and the total number of snapshots will be doubled. To get the most frames you'd make the figure 1 ("Every 1 1/10ths of a second", i.e., every one tenths of a second), whereas to get a very few frames you'd make the figure very large, e.g., 100 ("Every 100 1/10ths of a second", i.e., every 10 seconds). This is not exact science! The rate of replay of a script is determined by a number of factors, including what brushes or effects you used and how fast your computer is. Thus a slow computer, ironically, allows you to generate more frames than a super-fast one.

You may find yourself doing several trial runs in order to end up with a frame stack with the right number of frames. Painter's scripting and animation capability doesn't give you control over the speed of script replay or the total number of frames in a frame stack.

8 Click OK in the Script Options window.

9 Select the black triangular play button, second from the left of the five Script buttons. When you click on it the triangle goes bright green, indicating that it is replaying the selected script (Figure 8.13).

10 You will now see a window titled "Enter Movie Name" where you can name your frame stack and determine the location on your computer where the frame stack will be saved. Note that the use of the word movie here refers to frame stack, not QuickTime or AVI movie.

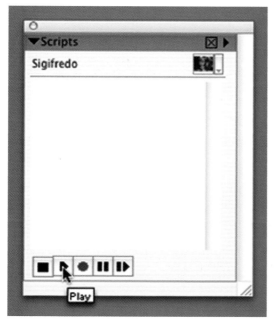

Figure 8.13 Click the play button to start the script replay.

Remember that you may make a few trial frame stacks; therefore, it is best to name them with an indication of the Script Option setting you chose for saving frames. Also, if you are on a Macintosh, add a file format tag at the end of the file name that indicates it is a frame stack (Windows systems do this automatically). Thus if you selected "Every 10 1/10ths of a second" in Script Options, then the frame stack name may be something like "subject-10tenths-01.ftk." Put this name where you see Save As: Untitled (Figure 8.14).

Figure 8.14 Naming your frame stack.

Frame Stack Vulnerability

Note that when you close a frame stack you are never asked whether you wish to save changes; any changes are automatically saved. This makes the frame stacks an unreliable, as well as unwieldy, format in which to save your animation. Frame stacks are vulnerable to unintentional modification. It is better to rely on your QuickTime movie as your means of saving your movie. The QuickTime movie has the advantage of being independent of Painter. The script will only work with the exact same brushes and art materials loaded in Painter as when you originally recorded the script. If you used custom brushes and libraries it is unlikely your script will still work when you upgrade to future versions of Painter and have different custom libraries and brushes.

11 After you've named the frame stack and determined where it will be located, click Save.

12 You now see the New Frame Stack window (Figure 8.15). Leave the defaults Layers of Onion Skin: 2 and Storage Type: 24-bit color with 8-bit alpha. Click OK.

13 The script will now replay (Figure 8.16). You will see a Frame Stack palette with small previews of the frames as they are saved.

When the script has replayed completely the frame stack is completed.

Figure 8.15 New Frame Stack window.

Figure 8.16 Replaying a script into a frame stack.

Capturing More Frames

You may find that your script plays back too fast and therefore doesn't allow you to capture a sufficient number of frames (e.g., you're recording your signature and it replays into a single frame) even on the 1/10ths of a second setting. Unfortunately in Painter there is no scripts replay speed control; the replay speed is a function of the speed of your computer and the memory intensiveness of your actions in Painter. In the situation where you can't capture enough frames, re-record your script on a much larger canvas (with same aspect ratio, width/height, as your original file) using Select All before you start the script. This will automatically slow the replay. You will then need to alter the movie frame size in a program outside of Painter.

IV Generating a QuickTime Movie from a Frame Stack

1 Choose File > Save As (Figure 8.17).

2 Select your option from the Save Movie window. If you are unsure of which option to use and you want to be able to replay your movie in slide shows and presentations, I recommend selecting Save Options: Save movie as QuickTime (Figure 8.18). The rest of these instructions will be based on that choice.

3 Click OK.

4 You now see the Enter Movie Name window (Figure 8.19). This is now referring to saving the QuickTime movie, not the frame stack. If you are on a Macintosh, name the QuickTime movie with a name ending in .qtm (Windows systems do this automatically) to identify it as a QuickTime movie. I recommend including resolution (pixel height and width) and total number of frames in your QuickTime movie name. This will be useful if you are experimenting with different file sizes and total number of frames.

Figure 8.17 Choose Save As.

Figure 8.19 Name and save your QuickTime movie.

Figure 8.18 Choose "Save movie as QuickTime" in Save Movie window.

Figure 8.20 QuickTime compression choices.

5 Choose where you wish to save the QuickTime movie.

6 Click OK.

7 In the Compression Settings window select Compression: Animation (the default is Video). You have many different compression formats (Figure 8.20) to choose from.

8 In the Animation Compression Settings window (Figure 8.21), select "Millions of Colors +" and move the Quality slider to the right (Best). I suggest leaving the Frames per second at 12 and

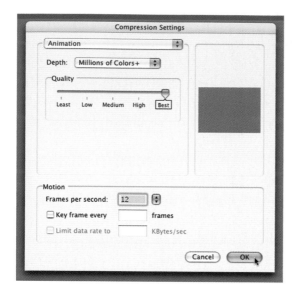

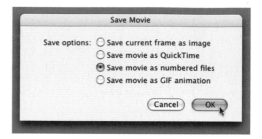

Figure 8.22 Choose "Save movie as numbered files" in the Save Movie window.

Figure 8.21 QuickTime Compression Settings window for Animation compression format.

unchecking "Key frame every ... frames", unless you have specific needs, such as a faster frame rate for video (typically 29.97 fps).

9 Click OK.

Congratulations! You've now succeeded in converting your script into a QuickTime movie. You can now play this movie on any QuickTime player, or integrate it into a movie or film or video, using other software such as Apple Final Cut Pro, or Adobe Premiere or Adobe After Effects. If you ever wish to re-create the frame stack without going to the time-consuming effort of replaying the script again, you can just open the QuickTime movie from within Painter and it will open as a frame stack.

V Generating Numbered Files from a Frame Stack

The flip book animation that you see in the top corner of the pages of this book is an example of the Sigifredo script converted into individual sequentially numbered files. Here's the procedure for saving as individual files.

1 Open the frame stack you wish to generate numbered files from.

2 Choose File > Save As.

3 In the Save Movie window select "Save movie as numbered files" (Figure 8.22).

4 Save your first file with 001 at the end of the file name (Figure 8.23). Save it into a dedicated folder.

Painter will now generate a series of individual files, each sequentially numbered (Figure 8.24).

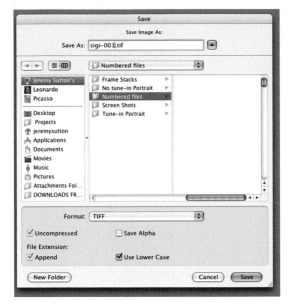

Figure 8.23 Save your first file with 001 at the end of the name.

Figure 8.24 Sequentially numbered files.

Opening Numbered Files as a Frame Stack

You can open a sequence of numbered files in Painter as a frame stack. Here are the steps:

1 Choose the regular File > Open command.

2 Check the Open Numbered Files check box in the lower right of the Open window.

3 Locate your folder with the numbered files in.

4 Choose the first numbered file. You will be prompted to do so by a message beneath the Open Numbered Files check box.

5 Choose the last numbered file (Figure 8.25). You will be prompted to do so by a message beneath the Open Numbered Files check box).

VI Using Background Scripts as a Last Resort Rescue

Last Resort Rescue

Think of Painter's background scripts as your lifeboat of last resort in the event of a disaster, such as a computer crash. Every time you start Painter, a background script is automatically recorded without you needing to turn on any recorder. The recording session continues in the background (hence the name "background scripts") until Painter closes (either because you quit out of Painter or

Figure 8.25 Choosing the last numbered file.

because the program or the computer crashes). This recording is saved as a background script that can be replayed. The background script contains everything you did from the moment you opened Painter to the moment it closed (with some exceptions: Painter's scripts do not work with all the plug-in dynamic layers). The background script can allow you to rescue a piece of artwork you had failed to save (of course, it's better to save meticulously and regularly and avoid the need for rescue). The background script can also allow you to replay a sequence of steps and pause the sequence so you can identify a particular brush you used at one point. But be cautioned: the background scripts do not always work. They are sometimes corrupted by a bad crash. Never rely on them for your back up. Always save methodically as you work.

Open the Painter General Preferences window (Edit > Preferences > General) and you will see "Auto-Save scripts for 1 days(s)." This means that each background script will be saved for 24 hours from the time Painter closes and the destroyed, unless you rename the script before that time. The purpose of destroying the scripts is to prevent your computer from getting clogged up with thousands of scripts. Close the Painter General Preferences window.

Playing Back a Background Script

1 Open the Scripts palette.

2 Select the appropriate script name in the Scripts selector pop-up menu. Background scripts are automatically named with the date and time that you initially opened Painter for that session (e.g., 4/17/07 9:49 AM). Their icons are plain white squares.

3 Click the play button (the black triangle second from the left in the row of Scripts control buttons). The play button turns bright green as the script replays.

4 Pause the script by clicking on the pause button (the two vertical black lines, second from the right in the row of Scripts control buttons). The pause button turns bright orange while the script pauses. This allows you to save the current image or look at the brush settings.

5 Click on the pause button a second time to continue the script replay.

Saving a Background Script

When your replay has finished, if you wish to save the background script from being destroyed automatically, you need to either save a copy of the script in a separate scripts library or change the script name. Both of those actions are achieved in the Script Mover.

1 Select Script Mover from the bottom of the scripts pop-up menu, which is accessible by clicking on the small triangle in the top right corner of the Scripts palette.

2 In the Script Mover, select the appropriate background script in the current script library. The default library name is Painter Script Data. On the left side of the Script Mover window you will see the little icons that correspond to all the scripts in the current script library. The background scripts have blank icons; they just look like white squares. Unfortunately, there is no drop-down menu with all the script names listed in the Script Mover. Thus you just need to identify the correct background script by trial and error, clicking on each one in turn to see what its name is. The name of each script you click on will appear in the center of the Script Mover window.

3 When you have selected the appropriate background script, click on the Change Name button

4 In the Change Script Name window, alter the background script name (Figure 8.26). This will prevent it from being automatically deleted.

Figure 8.26 Changing the name of a background script.

Saving Scripts into a Custom Script Library

You can also create a new script library, by clicking on the New button on the right side of the Script Mover window. Name your new custom script library. You can then drag any script across from the left to the right of the window. This makes a copy of the script in your new script library. If you wish to clear out any scripts from the default library just select the script and click Delete. Be aware that you can't undo the delete operation.
These instructions apply to any Mover in Painter. There are Movers for all libraries except the brushes library.

This chapter has just touched on the powerful creative potential offered by using scripts. Have fun experimenting with them. I hope they help you value your creative process as much as your final image. Placing value on your creative process will be a great asset in developing your painting skills and your unique artistic style.

This concludes our journey into the world of Painter X Creativity. Wishing you much joy in your continued explorations.

Happy painting!

Cheers,
Jeremy

Appendix I
Project Checklists

Start with the End in Mind

1 What is my goal for this project? What do I wish to say? What size is my final product going to be? What medium will I use? To what use will it be put?

2 What sort of border do I want to create? Do I want the paint to blend into white for printing on water color paper and float mounting, or do I want the paint to bleed off the edge for a matted print or framed canvas? Do I need to add extra pixels to my original source image?

3 Based on my goals, what size of file do I need to work on (dimensions and resolution)?

Organize

1 Have I restarted Painter afresh?

2 What is the folder location where I shall save my project files on my hard drive?

3 How will I group saved versions (e.g., by project or date or subject)?

4 What naming convention will I adopt for all files connected with this project (e.g., YY.MM.DD-subject-01-brushused.rif or subject-01-brushused.rif)? (Make sure all title data to the left of the version number remains the same for all files for a given project.)

5 Have I resaved my original image with a name that clearly defines the file as my original (e.g., subject-00-ORIG.tif)?

6 Have I made a clone copy of the original?

7 Have I renamed the clone copy, getting rid of "clone of" and "ORIG" and adding a version number 01 (e.g., subject-01.tif)?

8 Have I saved the final version as a TIFF or Photoshop file with the letter *F* after the version number to signify Final (e.g., subject-12F.tif)?

Apply Art Principles

Is there a visually satisfying abstract underlying the image? Is there enough asymmetry to make an interesting composition? Are there strong, simple, diverse shapes?

1 Does the painting have a focus?

2 Am I painting lines when painting masses (solid regions) might be more effective?

3 What details can be eliminated to strengthen the painting?

4 Can the value range be increased? Is the balance between lights and darks working?

5 Do the lights and shadows successfully describe the form?

6 Do edges need sharpening or softening, and contrasts increasing or decreasing, to draw the eye to the focal point? Are the edges dynamic enough?

7 Are the shadows warm enough?

8 Do the whites have enough color in them?

9 Are the colors working from the points of view of tone, temperature and contrast? Do my colors help generate the illusion of depth? Do my colors convey the right mood?

10 Is there enough variation in the texture of my paint? Is my choice of brushstroke length, thickness, shape, opacity, texture and direction adding to, or distracting from, the power and beauty of my painting?

Appendix II
Troubleshooting

The World's Greatest Troubleshooters

I would like to begin this appendix on troubleshooting by sharing a story from my friend and adventure guide Olaf Malver (explorerscorner.com) about the world's greatest troubleshooters, the Eskimos—the Inuit indigenous people of the Arctic.

Eskimos have survived living in the most stressful conditions of almost any peoples. Every day presents them with troubleshooting challenges, whether it is their boat outboard motor's stopping without a garage in sight or a sudden snowstorm and subfreezing temperatures. They have adapted to surviving and thriving in harsh conditions over thousands of years by following three rules. These rules are surprisingly relevant to surviving and thriving in Painter.

Eskimo Survival Rule 1: Be Alert

The Eskimo people are at all times fully aware of their complete environment. They are at one with nature and respectful of nature. They are constantly observing the land and the sky, seeing potential dangers near and far, sensing what weather is coming. They are also constantly in touch with their bodies, heading off any chance of frostbite or injury. They are alert inside and outside.

Be aware of the clutter and distractions in your environment and your Painter workspace, and, where possible, take actions to eliminate them. This will prevent many problems that arise out of confusion, such as hiding one palette behind another. Pay attention to giving meaningful names to files and layers; this saves a lot of time and effort trying to work out what's what. It's easy to get so absorbed on the computer that you lose track of time. Hours can pass with little body awareness or movement. Make sure you stretch and get fresh air regularly.

Eskimo Survival Rule 2: Be Practical

Eskimos live in desolate, isolated conditions. They cannot rely on technicians, mechanics, garages or repair shops to solve their problems. When anything goes wrong, no matter what it is or how simple or complicated, they repair it. They recycle almost everything and improvise constantly with whatever is at hand.

In our busy lives it is easy to become reliant on quick fixes and having someone else around to take care of practical matters. In Painter, try thinking like the Eskimo. When you run into a problem, improvise and experiment. See every problem as an opportunity. This is the essence of the creative process. You'll find that whatever the outcome of the improvisation and experimentation, you will always learn something along the way. You will deepen your understanding of Painter.

Eskimo Survival Rule 3: Have a Sense of Humor

When all else fails, when the Eskimo people are in a situation they can't fix, they *laugh*! They grab every opportunity offered by adversity to laugh. They are very jolly people despite great hardships. Humor is their emotional valve—their way of externalizing rather than bottling up.

When you run into a problem, just as *The Hitchhiker's Guide to the Galaxy* says, don't panic! Instead pause, relax, reflect and, if you feel totally lost, laugh! Don't give up in despair or frustration. If necessary, take a break, turn your computer off and come back to Painter later. It's amazing what a bit of subconscious processing, or just restarting your computer, can do to help solve problems.

Ounce of Prevention Is Worth a Pound of Cure

As the saying goes, "An ounce of prevention is worth a pound of cure." By thorough preparation and organization, and by following the troubleshooting precautions covered here, you'll be able to minimize the amount of trouble you need to shoot. Just like a trained streetwise martial artist is much less likely to be picked on than a naive head-in-map tourist, a well-prepared, organized Painter artist is much less likely to run into problems than an unprepared, disorganized one.

Structure

However prepared you are, it is almost inevitable that, at some time, you'll get stuck or confused by something that happens (or doesn't happen) on your screen. I encourage you to take risks and experiment. That means inevitably that at some time you will try something and what you expect to happen won't happen. That may mean that you try to paint a brushstroke and nothing appears on your canvas, or you try to clear your canvas and something's left behind that you don't want. Whatever form trouble takes, there are some simple steps to sorting it out. That's where this section comes into play. I've divided this section into five topics:

Precautions

Brush or effect not working?

Painter display not looking right?

Tablet not working?

Crashes and launch errors

Under Precautions I suggest some simple things to do before you run into problems. Each of the other topics has a list of suggested actions. Follow these actions in sequence. After the first action, each subsequent step can be thought of as being prefaced by "if you still have a problem ..." Some actions are repeated in different sections. Fortunately you'll find that 99% of problems are solved before you go through all the actions.

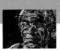

Precautions

1 *Close any non-essential applications.* As a general rule I suggest you close any other non-essential applications when working in Painter.

2 *Keep your system as clean and lean as possible.* Free up as much memory and hard drive space as possible.

3 *Reopen Painter with every new project.* Always start and quit Painter at the beginning and end of any project. This helps memory management and also allows you to conveniently use the background script to rescue unsaved artwork in the event of a computer crash (Chapter 10).

Troubleshooting Tips

Brush or Effect Not Working?

1 *Quit any other applications that are open.* If Painter is struggling for memory, it is worthwhile making sure you have no other applications running at the same time.

2 *Select a simple palette arrangement.* Make sure you can see the Tools, Property Bar, Brush Selector, Colors and Layers palettes.

3. *Check which file you're working on.* Go to the Window drop-down menu and check which file (at the bottom of the menu) has a check by it. This is the file that is currently active. If it is not the file you thought you were working on, drag down to the file name of the file you want to work on. If there are any files open in Painter that you are not using and that are not needed as clone sources, close them. Make sure that Painter is active and that you haven't accidentally selected the Finder or another application.

4 *Check your tool.* Are you using the tool you thought you were? If painting, make sure the Brush tool is selected (shortcut "b").

5 *Check for selections.* Is there a current selection on the canvas? It's possible that you may have accidentally created a tiny selection by brushing the Lasso tool on the canvas inadvertently. If you don't want a selection, then deselect with Cmd/Ctrl-D to be sure.

6 *Check Brush Category, Variant and settings.* Confirm the Brush Category and Variant. It may be that your variant settings have been changed. If in doubt, go to the Brushes palette and select Restore Default Variant from the pop-up menu.

7 *Check the Colors palette.* Look at the Main/Additional Color squares. What is the Main color? Make sure the Main color square (the foremost one) is selected. If in doubt, click on the Main color square. Are you painting white on white? Is the Clone Color icon in the Colors palette active? If so, do you want to be using Clone Color? If you are using Clone Color, reset the clone source in File > Clone Source (unless you want the current pattern to be a clone source, in which case just reselect the pattern in the Patterns section of the Art Materials palette).

8 *Check the brush Size in the Brush Property Bar.* How large is your current brush? Adjust the size if necessary.

9 *Check the Layers palette.* Carefully check what, if any, layers there are and which, if any, are selected in the Layers palette. One by one, go through all the layers and turn the eye of each one off so it disappears. Then reopen the eyes one at a time to make sure you know what each layer is. Now select what you want selected. If you do not want any layer or mask selected, click on the Canvas in the Layers section. Make sure any layer you want to affect has the padlock icon open. It's easy accidentally to lock a layer. Also check that the Preserve Transparency checkbox is unchecked. It is easy accidentally to check it or for it to be checked when you open Painter.

10 *Check for active Layer Masks in the Layers palette.* Check if any Layer Mask layer is selected. If you have an image layer selected, make sure the eye next to the image layer mask is closed.

11 *Clear the Tracker.* Choose Window > Show Tracker. Choose Clear All from the Tracker pop-up menu.

12 *Quit out of Painter.* Quit out of Painter File > Quit. If you are frozen in Painter, you can try a forced quit out of the program. To force quit out of Painter for Macintosh OSX users, choose Option-Cmd-Esc. To force quit out of Painter for Windows users, choose Ctrl-Alt-Delete and select the Task Manager. The Task manager will let you quit a program that's not responding. Choose the Applications tab and select Painter in the Task list and click the End Task button. It might take a few moments to quit Painter. If that doesn't work, then choose Ctrl-Alt-Delete a second time to reboot your system.

13 *Restart the computer.* Restart your computer (Mac users choose Ctrl-Cmd-Start to force a restart on the Mac; Windows users hit the power button or the reboot button, depending on what computer you have).

14 *Consult Help Topics.* Within Painter select Help > Help Topics. This gives you an onscreen version of the User Guide. Look up the topic of concern. The Help Topics are very thorough.

15 *Contact Painter technical support.* Within Painter select Help > Tech Support for a summary of support options.

16 *Post a message on the Painter List, Painter Forum, or other online Painter community.* See the resources link from www.paintercreativity.com. Describe your system, the exact symptoms and what you've tried as solutions.

Painter Display Not Looking Right?

1 *Change the color setting.* If you are using Windows and you see strange colors in the palettes, choose Start > Settings > Video Display (or similar) and change the color setting to 24-bit color or higher.

2 *Quit out of Painter.* Quit out of Painter File > Quit. Reopen Painter.

3 *Check all connections.* Check all connections between your monitor and your computer.

4 *Restart your computer.*

Tablet Not Working?

1 *Quit out of Painter.* Quit out of Painter File > Quit. Reopen Painter.

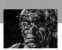

2 *Check the tablet Control Panel.* Open the tablet Control Panel. If the scaling is off, reset the scaling in the Control Panel.

3 *Restart the computer.*

4 *Install the latest driver.* Download the latest driver from the Web (Wacom users go to www.wacom. com). Install the latest driver and restart your computer.

5 *Contact tablet technical support.* Look in your tablet user guide or refer to the tablet manufacturer Web site for your local technical support contact information. Through the Wacom Web site (www.wacom.com), Wacom users can contact technical support, download the latest drivers and access a Frequently Asked Questions Web page.

Crashes and Launch Errors

1 *Force a quit out of Painter.* If everything has frozen in Painter, then force a quit out of Painter (Cmd-Option-Esc on the Mac).

2 *Restart the computer.* If your whole computer is locked, then force a restart (Ctrl-Cmd-Esc on the Mac).

3 *Eliminate possible conflicts.* If you continue to have persistent crashes or see an error message come up every time you launch Painter (e.g., "Profile Processor Error: File not found"), try to eliminate possible software conflicts.

4 *Regularly clean up and defragment the hard drive.* Mac users should regularly run a program such as Symantec's Norton Utilities, or something similar, to defragment their hard drive.

5 *Windows disk maintenance.* Clean up and defragment your hard disks to keep your system healthy.

6 *Restore defaults.* Reset all Painter custom data to defaults by holding down the Shift key as you start Painter. This will destroy any custom variants you created, so be careful to back up your custom data first.

Errors Opening a file in Painter

Unsupported Number of Bits per Channel. If you see this error message, open the file in Photoshop, choose Mode > 8 Bits per Channel.

Unsupported Effects/Adjustment Layers. If you see this error message, open the file in Photoshop, choose Layer > Flatten image, and resave file (Shift-Cmd-S/Shift-Ctrl-S or File > Save As) with new file name (next version).

Appendix III
Keyboard Shortcuts

Here are a few of the default keyboard shortcuts that you might find handy. Remember that you can customize keyboard shortcuts for almost all menu items and commands in Painter through Corel Painter X/Edit > Preferences > Customize Keys, in addition to which you can create your own short-cut buttons in a custom palette (Window > Custom Palettes > Add Command).

Tab	Hides/shows palettes
Cmd/Ctrl-O	Open file
Cmd/Ctrl-N	New file
Cmd/Ctrl-M	Mounts/unmounts your canvas on the screen
Cmd/Ctrl-0 (number zero, not letter "O")	Zoom to Fit
Cmd/Ctrl- "+"	Zoom in
Cmd/Ctrl- "−"	Zoom out
Shift-Cmd-S/Shift-Ctrl-S	Save As

Spacebar held down when the Brush tool is selected turns the cursor into a Grabber Hand that you can use to reposition your canvas (by clicking and dragging on the canvas).

Shift-Option-Cmd/Shift-Alt-Ctrl when Brush tool selected allows you to click and drag within image to resize brush.

Shift-x	exchanges the Main and Additional colors
]	increases brush size
[decreases brush size
b	Brush tool
d	Dropper tool
Option/Alt	turns the Brush tool into the Dropper tool if Clone Color not active
Option/Alt	resets clone source start position if Clone Color active
r	Rectangular Selection tool
c	Crop tool
f	Layer Adjuster tool (useful when you are working with layers in a photo-collage)
u	Toggle clone color on and off

The number keys adjust brush opacity (1 is the lowest, 0 is the highest).

Index

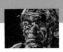

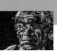

Author Biography

Jeremy Sutton (Photo by Lincoln Adler)

Born in London in 1961, artist and Corel Painter Master Jeremy Sutton has drawn since he was three. He studied drawing, sculpture and printmaking at the Ruskin School of Fine Art and Drawing while earning a degree in Physics from Oxford University. He continued his art studies at the Vrije Akademie in The Hague. His early career in physics research instruments sales and marketing brought Jeremy to Silicon Valley. It was there, in 1990, that he was introduced to the computer as an art tool and he has been exploring that medium ever since.

Jeremy's artworks have been displayed in galleries and museums, are collected worldwide, and he is known for his colorful and lively portraits. Jeremy is the author of four books and seven video tutorials. He is an inspiring and engaging instructor and speaker, and teaches seminars in his San Francisco-based Sutton Studios & Gallery. Visit **www.jeremysutton.com** to see examples of his art, learn about his books, DVDs and classes, and to enjoy articles, tutorials and other Painter resources.

Contributors

Listed here are people who have kindly and generously shared their artwork and their custom art materials (brushes and color sets).

Gisele Bonds
Positive Images
Oakland, California
(510) 832-3686
PImages@aol.com
www.positiveimages-portraits.com
Figure 6.16

John Derry
Overland Park, Kansas
derry@PIXLART.com
www.pixlart.com
Foreword

Scott Dupras
Lemon's Studio
Marquette, Michigan
(906) 228-9636
duprasinc@aol.com
Custom brushes

Andrew Galli
Studio Galli
San Francisco, California
www.studiogalli.tv
"Jeremy's Theme", featured on PXC Resource Disc > Jeremy Movies > "3-Jeremy Artwork. mov"

Peggy Gyulai
San Francisco, California
pegyulai@hotmail.com
Custom color set

Adrian Jost
Trio Garufa
San Francisco, California
www.triogarufa.com
"Valse Sans Nom", featured on PXC Resource Disc > Jeremy Movies > "1-Jeremy Studio Tour. mov"

Denise Laurent
London, UK
den@imagine.co.uk
www.imagine.co.uk
Custom brushes

Paulo Roberto Purim
CuritibaParaná, Brazil
(011) 55 41 3650123
paulo.purim@avalon.sul.com.br
www.jogodeluz.com.br
Custom brush

Sherron Sheppard
Ventura, California
(805) 647-4121
sheppardphotography@adelphia.net
www.sheppardphotography.com
Custom brush

Chris Siebert and Lavay Smith
Lavay Smith & Her Red Hot Skillet Lickers
San Francisco, California
www.lavaysmith.com

Order Form

Jeremy Sutton Educational Products

For more information please visit: www.paintercreativity.com

Learning Corel Painter X with Jeremy Sutton (DVD Tutorial) $65

This overview introduces you to the Corel Painter X interface, highlighting some wonderful new features and basic photo and collage techniques. Comes with tutorial images.

Expanding Your Creativity with Jeremy Sutton - The Art of Collage Portraiture (DVD Tutorial Set) $325

Four DVD tutorial set that teaches Jeremy's approach to creating Collage Portraits using Corel Painter and non-digital techniques. Includes JeremyFaves3 custom brushes, extra art materials and tutorial images.

How to Paint from Photographs using Corel Painter X: Creative Techniques with Jeremy Sutton (DVD Tutorial Set) $325

Learn creative painting techniques working from photographs. See projects taken through digital painting to completion with application of physical media to the printed canvas. Includes JeremyFaves4 custom brushes, extra art materials and tutorial images.

Painter X Creativity: Digital Artist's Handbook (Book, signed) $50

Get an extra copy of this book dedicated and signed by the author.

Sutton Studios & Gallery
1890 Bryant Street, Suite 306, San Francisco, CA 94121
Phone 415.641.1221 Fax 415.641.1648
jeremy@jeremysutton.com

Copyright License Page

The image on the front cover, "Summer Afternoon", is an impressionist painting by Jeremy Sutton based on a Gatsby Summer Afternoon at the Duinsmuir House in Oakland, California. See http://jeremysutton.com/summerafternoon.html for a more detailed description.

Jeremy Sutton
Sutton Studios & Gallery
1890 Bryant Street, Suite 306
San Francisco, CA 94110
Phone: 415 641 1221
Fax: 415 641 1648
Web: www.jeremysutton.com
www.paintercreativity.com

Warning and Disclaimer

This book is sold as is, without any warranty of any kind, either express or implied. While every precaution has been taken in preparation of this book, the author and Focal Press assume no responsibility for errors or omissions. It is further stated that the publisher and author are not responsible for any damages or loss of data or equipment that result from the use of information, instructions or the Painter X Creativity Resource Disc contents, contained herein.

Please note that while the extra brushes, art materials, custom palettes and workspaces contained in the Painter X Creativity Resource Disc have been successfully tested in Corel Painter X on Macintosh and Windows systems, they are supplied as is with no guarantee that they will work in your computer.

It is strongly recommended that you back up any sensitive, valuable or irreplaceable data on your computer before attempting to follow the instructions or installing the Jeremy Extras contained herein. It is also strongly advised that you regularly (every 5 or 10 minutes) do a Save As in Painter as you work, and especially before applying any effect or changing brushes.

Single User License Agreement

This is a legal agreement between you and Jeremy Sutton of Sutton Studios & Gallery. Please read the following terms and conditions carefully before using the Resource Disc that accompanies this book. Using the content of this disc indicates your acceptance of these terms and conditions.

1. LICENSE. This License Agreement ("License Agreement") governs the use of the contents of the Painter X Creativity Resource Disc by Jeremy Sutton, referred to as the "Licensed Product". The contents include: custom brush variants, typically comprising files with file format endings nib, stk, xml and jpg; custom brush categories, typically comprising a folder and jpg of the same name; custom color sets; custom palettes; custom nozzle libraries; custom paper libraries; custom pattern libraries; custom workspaces; QuickTime movies and tutorial images, comprising jpg files. All rights to the Licensed Product are proprietary; Jeremy Sutton of Sutton Studios & Gallery retains all copyrights and holds title to each copy of the Licensed Product. Jeremy Sutton, Sutton Studios & Gallery, ("Licensor") grants you, the licensed end user ("Licensee") a single, non-exclusive, non-transferable license to use the Licensed Product subject to the terms and conditions of this License Agreement.

 (i) Subject to the limitations specified in this Agreement, Licensee is permitted to use the custom materials, but not the Tutorial Images, to prepare works in finished designs for use in commercial projects such as advertising, promotional brochures, disposable packaging, newspapers and newsletters, web sites, multimedia projects, client presentations, fine art print editions, book and CD/DVD covers, video games and video or film productions.

2. RESTRICTIONS. You are not permitted to:
 (i) Use the Tutorial Images in any commercial product.
 (ii) Use the Licensed Product to enter into a competing business, whether directly or indirectly, or to create like or derivative products that substitute for or compete with Sutton Studios & Gallery products. This restriction includes sub-licensing, re-selling, renting or distributing this Licensed Product, or any part of it.
 (iii) RENT, LEND, LEASE, TRANSFER, DISTRIBUTE, GRANT OR ASSIGN ANY RIGHTS TO THIS LICENSED PRODUCT.
 (iv) Copy the Licensed Product except for the sole purpose of single user use and making an archival backup. All copyright and other notices must be reproduced and included with the backup copy. You are prohibited from making another copy of the Licensed Product.

 If you have questions regarding use of this software call Sutton Studios & Gallery at (415) 641-1221.

 This agreement shall automatically terminate in the event of unauthorized transfer, distribution or use of this licensed product.

3. GOVERNING LAW. This Agreement shall be governed by the laws of the State of California. If for any reason a court of competent jurisdiction finds any provision of the Agreement, or portion thereof, to be unenforceable, that provision of the Agreement shall be enforced to the maximum extent permissible so as to affect the intent of the parties, and the remainder of this Agreement shall continue in full force and effect.

 The licensee acknowledges that they have read and understand this agreement and agree to be bound by its terms. The licensee further agrees that this agreement is the complete and exclusive statement of the agreement between licensee and licensor, and supersedes any proposal or prior agreement, oral or written, and any other communications relating to the subject matter of this agreement.